PHOTOGRAPHING YOUR ARTWORK

PHOTOGRAPHING YOUR ARTWORK

RUSSELL HART

Drawings by Nan Starr

North Light Books
Cincinnati, Ohio

ABOUT THE AUTHOR

Former senior editor at *American Photographer* and *Popular Photography*, Russell Hart now writes regularly for various photography magazines including *Outdoor & Travel Photography* and *American Photo*, where he is contributing editor. He has also been a contributor to Petersen's *PhotoGraphic, Photo/Design*, and the *New York Times*, and has authored several books on photographic subjects, including the revised edition of *The New Joy of Photography*. Previously an editorial photographer whose clients included Polaroid Corporation and *The Boston Globe*, Hart has taught photography at Tufts University, Mount Ida College, and the School of the Museum of Fine Arts in Boston, has acted as a consultant to the Boston Museum's photography department, and has been the recipient of three Traveling Fellowships from the museum. As an exhibiting artist, he has extensive firsthand experience with the slide-submission aspect of *Photographing Your Artwork*.

Photographing Your Artwork. Copyright © 1992, 1987 by Russell Hart. Printed and bound in the United States of America. All rights reserved. No part of this book may be reproduced in any form or by any electronic or mechanical means including information storage and retrieval systems without permission in writing from the publisher, except by a reviewer, who may quote brief passages in a review. Published by North Light Books, an imprint of F&W Publications, Inc. 1507 Dana Avenue, Cincinnati, Ohio 45207; (800) 289-0963. Revised edition.

Other fine North Light Books are available at your local bookstore, art supply store or direct from the publisher.

99 98 97 96 95 7 6 5 4 3

Library of Congress Cataloging-in-Publication Data

Hart, Russell
 Photographing your artwork / Russell Hart.
 p. cm.
 Includes index.
 ISBN 0-89134-449-7 (paper)
 1. Photography of art. I. Title.
TR657.H37 1992
778.9'97—dc20 92-19586
 CIP

Edited by Greg Albert
Designed by Clare Finney
Drawings by Nan Starr

To my parents, for all the nights of running water.

ACKNOWLEDGMENTS

This book would never have happened if not for the desperate need expressed by artist-friends for such a resource. My thanks to all of them. I hope they never have to hire another photographer—at least until they get rich and famous.

A number of artists let me photograph their artwork for this book. Many others offered, or let me use slides I'd already made of their work. They include Susan Jane Belton, Charles Crowley, Diefo, Celie Fago, Gary Gilman, Ralph Helmick, Susan Mampre, Martha Maness, Joyce McDaniels, Susan Morrison, John Neprud, Pina, Hope Ricciardi, and last but not least, Dan Wills. (Thanks also to any I may have forgotten to mention!) Rob and Holly Emslie lent me my own work and put up with a bare spot for months. They weren't alone.

I'm grateful also to the deans of the School of the Museum of Fine Arts, Boston, including Bruce MacDonald and John Thompson, and especially to the late Gene Ward, former Dean of Admissions, for whom many of the photographs in the book were taken—and who let me borrow back the slides, including some of those on the cover. Jim Field, former director of the Museum School Gallery, gave advice and let the gallery be used for installation photographs.

Special thanks to Wayne Lemmon, former head of the photo studio at the Boston Museum of Fine Arts, a superb photographer who took a chance on me in spite of my "fine art" portfolio and taught me most of what I know about shooting artwork; to John Woolf and Tom Lang, who understand this stuff much better than I do; and to the rest of the folks in the Museum of Fine Arts Photo Services Department.

I owe a further debt of gratitude to Henry Horenstein, whose wisdom and experience have been invaluable in this and many other projects; to Dorothea Boniello, formerly of the Massachusetts Artists Foundation, whose early interest in the project encouraged me; to Nan Starr, whose illustrations keep technical material understandable and lively; and again to John Woolf, who read the manuscript and took pictures for me when I didn't have the time. Thanks also to David Lewis, editorial director of North Light Books, who saw the merits of the project when others didn't, to Greg Albert, my editor, whose understanding of artists' needs helped shape the book, and to Lynn Haller, who kept careful watch over all the changes in this revised edition.

Most of all, thanks and love to my parents, who let me turn a good part of their house into a studio when I was short of space, and to my wife, Rena, who loved me in spite of the craziness that such a project inevitably causes.

CONTENTS

INTRODUCTION

A good photograph of an artwork is almost always a revelation to the artist. Quite literally, it casts the work in a new light: With even illumination, a painting's rich color and detail are revealed after months of hiding in the chiaroscuro of a painter's loft; against a seamless background, the elegant lines of a sculpture are freed from the clutter of a dusty studio. Photographing artwork carefully might be worth the trouble simply for this kind of fresh perspective on it. But there are more compelling reasons.

WHY YOU NEED GOOD PHOTOGRAPHS OF YOUR WORK

If you've ever looked into showing and selling your artwork, you know that most art galleries, museums, and other exhibition facilities routinely ask to see slides before they'll look at the real thing. Agencies that administer arts programs also do their initial screening with slide submissions. Galleries keep slide files of work by artists they represent or exhibit, to show prospective buyers examples of work that can't be kept in the gallery itself, often because it is too large or cumbersome, or to take to clients unable to visit the gallery. And certainly, if you sell or make a gift of an artwork, you'll want a good photograph of it for your own records.

In an art world that depends so heavily on photography, good slides of your best work can help you get a show, win a competition, or make a sale. In the fickle arena of the professional artist or craftsperson, such photographs can even make the difference in a career. And in this era of such varied styles and schools, when a painting may be nothing more than a soft wash of color, accurate photographs are all the more important.

If you've ever tried to photograph your own artwork, chances are you've been disappointed with the result. Yet without the kind of information about materials and techniques this manual will provide, disappointment is inevitable. If you don't know how to match the proper film to your light source, your neutral gray field painting could end up as brown as an Old Master; if you don't compensate for the tendency of most cameras' exposure meters to render light subjects too dark, your pastel might lose its delicate highlights. Without a tripod, an etching's fine detail could succumb to camera "shake." The pitfalls are countless, but with this book at hand you can avoid them.

YOU CAN DO IT

After repeated and unhappy attempts at producing good photos of their artwork (and often courting further disaster by coaxing a more "knowledgeable" friend to help), many artists resort to hiring a professional photographer. The cost of this can turn an unsuspecting sculptor or painter into the proverbial poor, starving artist. And in spite of the expense, the results can be unsatisfactory for the simple reason that the photographer doesn't understand the character of your work as well as you do. The fact is that you don't need the professional's extensive knowledge to make your photographs true to your art. This manual will streamline the task of photographing your artwork, assuming little prior knowledge on your part.

WHAT YOU'LL NEED

The book will assume that you have access to a 35mm camera and that you have at least a passing familiarity with its operation. Preferably, it should be a camera that allows manual control over exposure, or one that at least offers an exposure override mechanism. The compact, fully automatic 35mm "point-and-shoot" cameras that have become so popular are not very well suited to photographing artwork. They offer little or no exposure control, and the relatively wide-angle lenses on less expensive models are more likely to distort the artwork. Some of the more advanced models with zoom lenses can be used in a pinch. But single-lens reflex (SLR) cameras with their customary 50mm lens—or with a zoom that includes focal lengths of 50mm through 80mm or 105mm—are much more appropriate.

You'll also need a tripod. Both tripods and cameras can be rented or borrowed, if necessary, and one is no more or less necessary in photographing artwork well than the other. The case for the importance of the tripod is made in Chapter One; I recommend purchasing an inexpensive model. It will cost you less than half the minimum fee that most professional photographers charge, and prorated over many years, its cost is modest indeed.

Most of the information in this book applies to both two- and three-dimensional media, so read it all. Exceptions to this are Chapters Three and Four, which deal respectively with two- and three-dimensional work. You can skip the chapter that doesn't apply to you; information that pertains to both kinds of work is repeated.

The book is primarily oriented toward making slides of artwork, as opposed to black-and-white or color prints, because nine times out of ten you'll be asked for slides. On that tenth occasion, a good color print can always be made from a slide. If you want to shoot color negative film and have a print produced from it, or if you need a black-and-white print for publicity purposes, refer to Chapter Seven, page 102, "Shooting Negative Film." This section will tell you what kinds of film to use, and how to go about having the prints made.

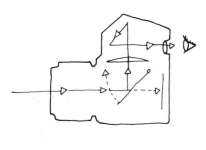

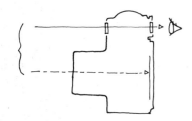

SLR VS. AUTOMATIC POINT-AND-SHOOT

The 35mm single-lens reflex (SLR) camera, at top, lets you view your subject through the lens that will actually take the picture. It does this by means of a complex light-management system involving a mirror, a focusing screen, a five-sided prism, and secondary lenses. When you take the picture, the hinged mirror that reflects the subject image to the eyepiece flips up out of the way, allowing light to pass through the open shutter to the film.

The fully automatic 35mm "point-and-shoot" cameras (bottom) that are so popular these days work in a very different way. The subject is viewed through a window above and usually to the side of the lens, which sometimes causes a considerable disparity between what is seen and what is actually recorded on film. This may become a problem at the closer working distances often required in photographing artwork, although it can be anticipated and corrected for when composing.

The 35mm camera is available in an overwhelming variety of models, makes and styles. Some let you view your subject through the camera's lens by reflecting its image off a hinged mirror to the eyepiece. In these cameras, called *single-lens reflexes* (SLRs), the mirror flips up out of the light's path when you push the shutter button to expose the film. Other cameras, such as today's popular 35mm "point-and-shoot" models, require that you view the subject through a separate window. These tend to be fully automatic in their functions, and, as mentioned in the Introduction, aren't as good for photographing artwork.

SLRs, on the other hand, range from manually controlled units to fully automatic ones, many of which will even focus for you. Most SLRs offer a system of interchangeable lenses, but some new models feature a non-removable zoom lens.

Such non-system SLRs tend not to offer the exposure control you need to photograph artwork. And certain older models may not even have a built-in light meter and thus require the use of a separate hand-held meter.

In describing the proper procedure for lighting an artwork and obtaining correct film exposure, I'll assume that you are using a camera with a built-in meter.

MANUAL VS. AUTOMATIC EXPOSURE

The ideal camera for photographing artwork is one which allows you to set independently both the size of the lens aperture—often called the "f-stop"—and the duration of the exposure, commonly called the "shutter speed." (This is called "manual" exposure control.) Many cameras will set one or the other automatically to obtain proper expo-

sure. In an *aperture-priority* automatic exposure mode, the camera sets the shutter speed after you choose the f-stop you want; in a *shutter-priority* mode, the camera sets the f-stop according to what shutter speed you've selected. Most single-lens reflex models, and even more point-and-shoot cameras, offer "programmed" exposure systems in which both aperture and shutter speed are set automatically.

In photographing artwork, several problems can arise with these kinds of systems. The most serious is that the camera must make certain assumptions about the tones in your artwork, assumptions which may be invalid. These assumptions can cause your camera to misrepresent your artwork, rendering it too dark or too light.

If your artwork conforms to an automatic exposure system's expectations, then you may get a perfectly exposed slide. But most of the time your artwork won't be so obliging, so as a matter of practice you shouldn't rely on your camera's automatic exposure modes. Many SLRs offer both automatic and manual exposure modes; always use the manual option. If you have to use a camera that gives you no manual exposure control, but offers "priority" autoexposure modes, the ways of overriding its settings will be explained in the sections on film exposure. NEVER shoot artwork with an SLR in a program autoexposure mode.

VIEWFINDER DISPLAYS

Cameras that permit manual exposure control will recommend exposure settings for your film in numerous ways. Most of these involve displays that are visible in the camera's viewfinder, although some models also have display panels on the outside of the camera as well. A

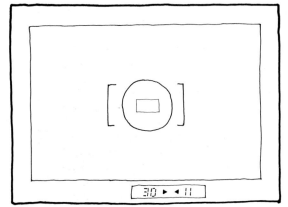

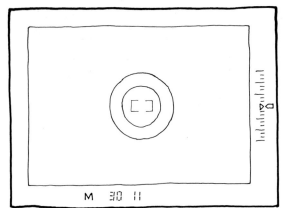

THE SLR VIEWFINDER

Most camera viewfinders display information about the aperture and shutter speeds being used, whether these are set manually or automatically. The design of such displays varies greatly, so refer to your camera manual for an explanation of how to interpret yours. In some cameras — particularly older models — "correct" exposure is obtained when you line a needle up on a site by adjusting the shutter speed and/or aperture controls. This style of exposure display is called *match needle*, and one version of it is shown at top. Newer models substitute an *LED* (light-emitting diode) or *LCD* (liquid crystal display), in which you typically adjust controls to make a dot light up, or center a flashing line on a calibrated scale, or make plus and minus symbols appear simultaneously. (Examples of such displays are shown at center and bottom.) In any of these systems, the shutter speed and/or aperture chosen are also displayed at the edge of the frame. Automatic exposure systems usually display settings in the viewfinder (bottom), but the camera chooses either the shutter speed, the aperture, or both automatically.

system common in older cameras is the *match-needle,* in which you adjust either the aperture or the shutter speed until a moving needle is centered in a site. (In a similar design, one needle moves in response to the subject's light level, and you align a second needle with it.) Newer cameras make use of *LED*s (light-emitting diodes) or *LCD*s (liquid crystal displays) to help you set the camera properly. Whatever type of display your camera uses, it's usually found just outside the right edge or bottom (or both) of the viewfinder frame. Displays may feature indexed scales, indicator arrows, plus and minus signs, and other symbols that change as you adjust the aperture or shutter speed controls — and thus guide you to what the camera thinks is the correct exposure. They also show you numerical values that represent shutter speed and lens aperture.

When you set the camera for automatic exposure, you lose the viewfinder's guide signals. But the numerical displays still tell you which aperture and shutter speeds have been set. In shutter priority, the camera will display the shutter speed you've chosen, along with the aperture it will set to obtain what it determines is correct exposure. In aperture-priority, the camera displays your chosen f-stop, as well as its automatically set shutter speed. In program exposure mode, you may or may not see both values — but then you shouldn't be using that mode to shoot your artwork anyway!

Keep in mind that any camera's notion of "correct" exposure is subject to error. With an artwork filling its viewfinder, a camera set manually by any of the systems described above may produce the same kinds of exposure error as a camera operating with an automatic exposure system. The difference is that while

the automatic camera is locked into its chosen exposure, a camera which lets you set both aperture and shutter speed manually will also let you ignore its recommendations, should they be unreliable, and take your picture even if its viewfinder signals aren't giving you the go-ahead. This ability to second-guess the camera's light meter is very important in photographing artwork.

THE LENS

A camera's lens projects the image of your artwork (or any other subject) onto the film surface, where it causes a chemical reaction in the light-sensitive emulsion of the film. Some cameras are designed so that the lens can be removed and interchanged with other lenses having compatible mounting hardware; in others, the lens is permanently attached to the camera body.

THE NORMAL LENS

The 50mm interchangeable lens often supplied with 35mm SLRs is well suited to photographing works of art. "50mm" refers to the distance between the back of the lens and the film surface — called the lens' focal length — and should not be confused with the "35mm" camera, which refers to the metric width of the film the camera is made to shoot. A 50mm lens is sometimes called a *normal* lens because when you look through a 35mm SLR's viewfinder, it produces an image that appears to be the same size as the subject when the subject is seen with the unassisted eye.

THE FIXED LENS

For several reasons, the fixed lens on 35mm point-and-shoot cameras is less effective in photographing artwork. First of all, it's generally not as sharp as a good SLR lens. And on non-zoom models, it's usually of shorter focal length — 35 to 40mm — which means that it covers

LESS IS MORE: BUYING A CAMERA

The best camera for photographing works of art is usually the simplest. Simple not in the sense of requiring the least thought to operate — such cameras are actually more complex — but rather in the sense of having the fewest automatic features. More often than not, these features will trip you up when you try to use the camera to photograph your work, and they should be avoided when shopping for a camera that you intend to use for this purpose. Automation is one of the reasons the currently popular 35mm point-and-shoot cameras are not well suited to photographing artwork. Choose a single-lens reflex (SLR) instead.

Although they will drive up the cost of an SLR substantially, automatic features are OK as long as the camera still has manual options. Make sure, for example, that autofocus cameras permit easy manual focusing, especially important in maximizing the depth of the zone of sharpness in your photograph when shooting three-dimensional work. Even more important, choose a model that allows you to control both the lens aperture and shutter speed independently, and make sure that these controls are coupled to a viewfinder display that clearly indicates which settings will produce "correct" film exposure. Avoid cameras in which the only available exposure system sets one control automatically when you set the other, or sets both according to an exposure "program."

In most other respects, almost any 35mm SLR will work well in photographing artwork. Virtually all of them offer a system of interchangeable lenses, which opens up the possibility of substituting other lenses for the factory-issue 50mm, and of purchasing wide-angle, telephoto, or zoom lenses for special purposes, such as shooting installation views or controlling the way a three-dimensional piece is reproduced on film. The optical quality of most name-brand lenses is consistently good, and the mechanical and electronic components of most cameras stand up to all but the most heavy use. Some cameras, however, offer a limited range of slow shutter speeds, which may force you to use wider apertures than are advisable in photographing three-dimensional work. Be sure shutter speeds go down to at least one second.

THE LENS

The engraved numbers on the front or side of your lens's barrel tell you its brand name, focal length (or on a zoom, focal length range), and maximum (widest) aperture. (Some lenses also indicate diameter of the front thread, usually with a Ø symbol, so that you know what size filter accessories to buy.) The maximum aperture is expressed by a ratio—on the lens shown here, 1:1.8, for a maximum aperture of f1.8. Other 50mm lenses have smaller or larger maximum apertures, such as f2 or f1.4. These apertures would be indicated by the ratios 1:2 and 1:1.4, respectively.

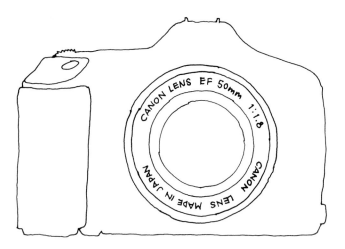

a wider angle of view, from the same camera position, than does the 50mm lens. As a result you have to get closer to your artwork to make it fill the viewfinder, which may cause it to appear somewhat distorted in the final slide or print.

Point-and-shoot cameras present another risk. Since you must usually view the artwork through a separate window offset from the lens, you won't see quite the same picture as the lens does. When you're within five or six feet of your artwork, this can cause it to be off-center in the finished slide or print. Smaller work that fits the viewfinder snugly may even end up cropped. Although some of these non-SLR cameras have marks in the viewfinder to help you adjust for this effect, in others you may have to adjust for it by eye after you've gotten your first results back. To do this, simply compare the slide to the way you originally composed the picture. If the artwork is shifted to one side, always frame it up shifted to the other side a like amount. But keep in mind that the closer you get to the artwork, the more extreme the difference will be.

As mentioned before, many point-and-shoot models now feature fixed zoom lenses of varying range, usually starting at 35mm or 38mm and extending to moderate "telephoto" focal lengths such as 70mm, 90mm or 105mm. (A few models even offer a wide-angle to normal range, for example, 28-50mm.) Other point-and-shoots offer a choice of two focal lengths—35mm and 70mm, for example—that are selected with a switch. If you must use one of these cameras to photograph your work, set it to a focal length of 50mm or longer. But keep in mind that while this may minimize viewfinder discrepancies and subject distortion, it does nothing to solve the exposure problems such cameras present.

INTERCHANGEABLE LENSES

If you have an SLR with an interchangeable lens system, other lenses may be helpful in photographing certain kinds of artwork. While *wide-angle* lenses—generally those with focal lengths of 35mm or shorter—are useful for shooting views of exhibitions, the most useful lenses feature focal lengths longer than 50mm. And while the 50mm lens is perfect for flat artwork, it can sometimes misrepresent three-dimensional work, particularly if it's small. It may make the parts of the work closest to the camera—the curved side of a ce-

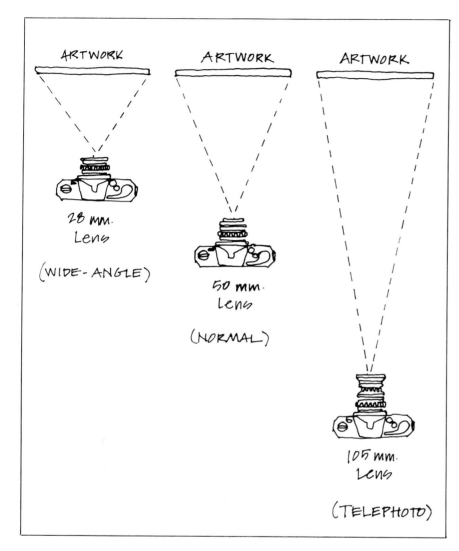

ARTWORK ARTWORK ARTWORK

28 mm. Lens

(WIDE-ANGLE)

50 mm. Lens

(NORMAL)

105 mm. Lens

(TELEPHOTO)

LENS FOCAL LENGTH

The focal length of a lens, which determines its angle of view, affects how close you must be to the artwork to make it fill the frame. This distance in turn affects the perspective with which the work is rendered. (The photographs on page 64 show the effect of lens focal length on the proportions of a three-dimensional work.)

For most artwork, the 50mm lens that usually comes with your camera is fine. For some sculptural work, though, a lens of longer focal length may keep the parts of the work in a more natural proportion to one another. A wide-angle lens, by contrast, is completely unsuited to photographing individual works of art. But the amount of space you have to work in may dictate your choice of lens—if you have the choice—rather than these aesthetic considerations.

ramic bowl, or the corner of a welded-metal construction—seem disproportionately large.

Telephoto Lenses. While changes in angle or composition can sometimes minimize this effect, a better way is to replace the 50mm lens with a lens of longer focal length, commonly called a *telephoto,* or "long" lens. In effect, this lens compresses the artwork, keeping its components more in proportion to each other—and closer to the way we see them with our much more sophisticated visual system. However, the lens' narrower angle of view requires that the camera be at a greater distance from the artwork, and this may not be possible in smaller spaces, particularly if the work is large. The "longer" the lens, the more room you'll need to work with. Lenses of 85mm to 105mm focal length should be adequate to prevent distortion in the artwork. If you have enough space, these lenses can also be used to photograph flat artwork, and they may even make squaring up the artwork easier.

Zoom Lenses. The increasingly popular *zoom* lens may also be used to photograph artwork. It offers a continuous spectrum of focal lengths within a certain range. By rotating a ring or sliding a collar on the lens the user can pick and choose a focal length, tailoring it to the subject. Although zoom lenses are available in many different ranges, the most useful for photographing artwork range from wide-angle to moderate telephoto, such as 35-105mm or 28-85mm. In terms of focal length, zooms in this range are almost all-purpose lenses for photographing artwork because you can use their wide-angle settings for installation views and their normal and telephoto settings for individual works.

One drawback of zoom lenses is

that they usually produce a dimmer viewfinder image than do lenses of fixed focal length, making framing and focusing in low light more difficult. And if not well made, they may not produce as sharp an image as a fixed focal-length lens. Whether using a zoom lens or a lens of conventional design, avoid focal lengths of 135mm and above. This range can cause a loss of a sense of volume in photographing three-dimensional artworks, and may require impractically large workspaces.

Macro Lenses. If your artwork is small, you may find that some of the lenses discussed above won't focus close enough to the work to make it fill the viewfinder frame. The longer the lens, the more likely it is that this will be a problem. While there are ways to adapt these lenses for use at closer distances (these will be discussed in the section on photographing small works in Chapter Seven), such measures can cause other compromises. Most manufacturers make lenses that are specially designed to focus at close distances—distances so close that the image of the subject projected on the film is as large as the subject itself. These are called *macro* lenses, and are available in a variety of focal lengths. The most common ones (and the most useful for shooting flat artwork) are 50mm, 55mm and 60mm, focal lengths that provide about the same angle of view as the normal lens that you probably have on your camera. In fact, a macro lens will focus from its closest distance to as far as the eye can see, like any lens of conventional design, and for this reason it can be used for general picture taking as well.

If you're in the market for a camera to photograph a lot of artwork, you may want to consider substituting a 50, 55, or 60mm macro lens for the lens usually supplied with the

HOW TO CLEAN YOUR LENS

A frequent but frequently ignored reason for lack of sharpness in photographs is a dirty lens or filter. It's important to keep both clean to ensure that your artwork's finest details are recorded on the film.

To keep a lens dust-free, you may want to buy a photographic blower brush, or use a clean, soft camel's hair brush. For removing smudges and grease, you'll need to use photographic lens-cleaning tissue (the silicon-treated tissue for cleaning eyeglasses may leave a deposit on your lens surface) and a detergent cleaning solution intended for photographic lenses, such as that sold in small squeeze bottles by Kodak. Both are inexpensive and available in any photography store.

If your lens is removable, take it off and check the surface of the back element to see if it's clean, by holding it at an angle to a strong light source. Because it's protected, chances are it's OK, but give it a dusting at the least.

To clean either the back or front surface of the lens, blow on it lightly to remove any grit or dust that might scratch it, fold a sheet or two of lens cleaning tissue over on itself, moisten it with several drops of lens cleaning fluid, then apply it gently to the lens surface in a spiral motion, starting at the center of the lens and working your way out to the edges. Then take a dry tissue and polish the lens surface even more gently in the same way. Inspect the surface by holding it at an angle to the light, and repeat the cleaning if need be. Don't rub too hard, or you may abrade the thin anti-reflection coatings of optical plastic on the lens. If you have trouble removing streaks left after cleaning, try polishing them out with a cotton swab.

A glass filter can be cleaned the same way. Be sure to check the inside surface of the filter as well. NEVER try to clean an optical gelatin filter, should you use one. It can be scratched by the slightest pressure, and moisture can actually dissolve it or distort its flatness. Keep a gelatin filter in its protective packaging whenever you're not using it. (Filters will be covered in Chapter Seven, page 98.)

camera, particularly if your work is flat or very small. This will elevate the cost of the package by $100 or much more, because a macro lens is considerably more expensive than a standard lens. Macros are designed to focus on a flat plane, which is why they're so appropriate for two-dimensional work. Regular lenses, by contrast, focus on all points equidistant from the lens—in other words, a curved, hemispheric plane.

Macro Zooms. Many newer zoom lenses have similar close-focusing capabilities. Some of them shift into "macro" mode with a switch or a ring around the lens barrel that must be unlocked by pressing a button; in other "macro" zooms, the focusing ring's close-focusing range is increased at certain focal lengths. It's important to choose small lens apertures when using a zoom lens this way, particularly if you are setting it to the longer focal lengths of its range.

THE LENS APERTURE

All lenses contain a diaphragm of metal blades that forms an aperture that can be made smaller or larger either by turning a ring on the lens barrel or by spinning a dial on the

camera body. The numbers on the ring represent openings of different size and are called "f-stops." In addition to their effect on film exposure, these openings also determine how much of your artwork will be sharp (on either side of the specific point at which you've focused) in your finished picture. This zone of sharpness is known as the "depth of field," and its size can have a strong effect on the way your artwork is rendered, particularly if it is three-dimensional. The proper lens aperture can vary considerably with the nature of your work, so it will be discussed further as it pertains to specific kinds of artwork.

THE TRIPOD

The most fabulous camera in the world can't guarantee good photographs of your artwork. A *tripod* is the tool that assures a successful photograph. In fact, most of the problems that artists experience in photographing their work stem from having hand-held the camera. You *must* use a tripod because:

1. Even if you have nerves of steel, the strength of your light source ordinarily won't be sufficient to permit shutter speeds fast enough to prevent camera movement, or "shake" as it's known in the lingo. And although camera shake may not cause a visibly blurred image, it can reduce the sharpness of your slide or print considerably. A tripod allows you to use slower shutter speeds without ill effect.
2. The fixed camera position that the tripod affords is the only way you can be sure your artwork is perfectly centered in the viewfinder at the moment of exposure, and in the case of traditional two-dimensional work, that it appears "square"—i.e., that its corners form right

angles and that its sides are of equal length. The tripod is the only means by which you can apply a system to the task of "squaring up" two-dimensional work.
3. Many techniques in photographing both two- and three-dimensional work require a rigid camera position to build light-baffling or reflecting materials around.
4. Existing-light views of an exhibition or of work *in situ* indoors can only be made with a tripod, because of the slower shutter speeds low light levels require.

You can dispense with the tripod on some occasions, such as in photographing work outdoors. Don't try to get around using a tripod, however, by dragging your artwork outside to photograph it. Natural light is difficult if not impossible to control, and may pose color problems such as those described in Chapter Two. Even in bright light, though, it's a good idea to use a tripod; it's an effective compositional aid, and a way to keep a set of slides consistent.

WHAT TO LOOK FOR

Good lightweight tripods are available for as little as fifty to sixty dollars from discount suppliers. They can also be rented for as little as ten or fifteen dollars a day, or borrowed from more well-equipped friends. But before you buy a tripod, you should put it through its paces.

First of all, the model you select should be stable when its telescoping legs are fully extended. To test it, press down on the top to see how much it gives or wobbles. Its feet will grip some surfaces more securely than others.

Control Levers. The tripod should also have complete, accessible and easily manipulated controls at its *head,* where you mount the camera. These include two levers at right

THE TRIPOD
The tripod before extension of legs.

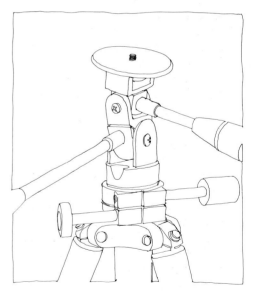

The tripod head.

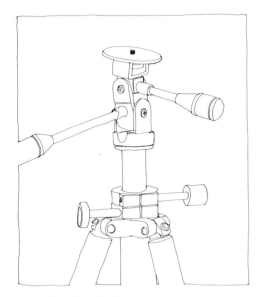

The tripod with center post extended.

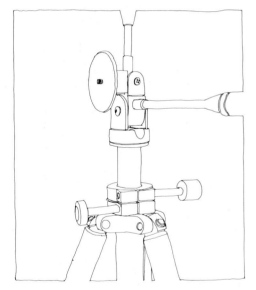

The tripod head with platform fully tilted.

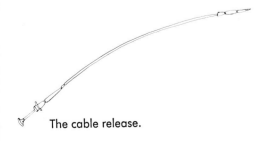

The cable release.

angles, one to tilt the camera forward and backward, the other to tilt it from side to side. Most such levers will lock into position when twisted; some may require tightening a separate nut, a more awkward design. Such lever-controlled designs are sometimes called *three-way* or *pan-tilt* heads. Do NOT buy or use tripods with leverless ball-heads to photograph your artwork, especially if it's two-dimensional.

The tripod head should also rotate independently of the sliding post it is mounted on, and you should be able to lock in its position with an adjacent nut. Make sure the tripod *has* a sliding post, because it is the only means by which you can raise or lower the camera without adjusting the legs, and it is also an important control in squaring up two-dimensional artwork. It locks into position with a knurled ring just below where the tripod's legs connect to its head, or with a nut on the side of the head.

Vertical Tilt. Finally, be certain you can tilt the tripod's camera platform to a fully vertical position. This is usually done with the lever that controls the head's side-to-side motion. Some tripods won't tilt all the way; you'll end up compensating for this fault by overextending the tripod's opposing leg, and all height adjustments will shift the image laterally because the sliding post will no longer be vertical. This capability is less of an issue if your work is flat, because it's easier to shoot a vertical piece on its side with the camera horizontal. But if you have to shoot a two-dimensional vertical piece as it hangs on a gallery wall, or if you're photographing freestanding vertical objects, obviously the camera must be vertical too.

You need to keep a few other things in mind when shopping for a tripod. One is to be sure it has enough extension so you can raise

the camera to a height that is level with the midpoint of your artwork, whether it's a standing sculpture or a painting. For example, even if you photograph them resting on the floor against a wall, very large paintings may require that the camera be elevated considerably above eye level, which some tripods won't permit. You can obtain some of this extension with the sliding post, but if you overextend the column you may sacrifice some camera steadiness, and limit the kinds of adjustments you can make when you square the work up.

Larger, pricier tripods may have geared center posts which you can raise and lower with a crank. This design is overkill for a 35mm camera, and invites damage to your tripod should you drop it. The fewer knobs and other protrusions the tripod has, the more likely it will last. Tripods also have a variety of leg-extension and locking gimmicks, but the most practical choice is probably a conventional telescoping tubular design with knurled locking collars.

THE CABLE RELEASE

At the slow shutter speeds a tripod permits, a *cable release* is an indispensible accessory. It allows you to trip the shutter without the risk of camera movement that pressing the shutter button with your finger creates. The cable release is a flexible cord with a sliding cable running through it. Its tapered end is usually screwed into the threaded opening in the camera's shutter button; the plunger on the other end is held between the index and middle finger. Depressing the plunger with the thumb fires the shutter.

Practice with the cable release before you load and shoot your film. Always push the cable release's plunger down gradually, holding the plunger end so that the cable itself

is gently flexed. If you keep the cable too taut, you may yank the camera during the exposure. Longer cable releases minimize this risk, but tend to get their internal spring fouled up more easily. A good compromise is a cable release around a foot long.

The cable releases for newer electronic cameras may not feature the mechanical design described above, depending instead on an electrical signal to trip the shutter. They plug into a separate socket on the camera body, and are more expensive than mechanical releases. That doesn't make them any less important in photographing artwork!

If you'd prefer not to buy a cable release, you can use your camera's self-timer (if it has one) to trip the shutter. Set it for as long an interval as possible, to let any vibrations created by setting it subside. However, this method of firing the shutter makes the business of taking repeated shots of an artwork far more time-consuming. A mechanical cable release costs as little as five or ten dollars, depending on its length and quality, and it's worth every penny.

A tripod and cable release are indispensible in photographing works of art. But we might add one item to the list of reasons to purchase them: it gives you a tax-deductible excuse to buy something you may have fancied for your own dalliance in photography.

SUMMARY/**CAMERA AND TRIPOD**

- An SLR (single-lens reflex) is the best 35mm camera for photographing artwork because it lets you view the subject through the lens, rather than a separate window.
- Because the light-metering system in your camera is prone to error, it's best to use an SLR that offers manual exposure control when photographing artwork.
- Automatic exposure systems can be used in photographing artwork only if they offer provisions for overriding the camera-selected exposure.
- Both manual and automatic exposure systems make use of viewfinder displays, either to help you determine and set the proper exposure, or to tell you what settings the camera has chosen.
- Most SLRs are supplied with a 50mm "normal" lens, but offer a system of interchangeable lenses.
- The fixed, relatively wide-angle lens on many 35mm point-and-shoot cameras can distort an artwork.
- Telephoto lenses may be used to minimize distortion in three-dimensional work.
- Zoom lenses can take the place of a number of fixed focal-length lenses because they offer a continuous range of focal lengths.
- Macro lenses are useful in photographing artwork because they focus much closer than conventional lenses, and focus on the flat plane formed by two-dimensional work rather than a curve.
- A dirty lens or filter can cause a dramatic reduction in the sharpness of your photograph.
- The variable diaphragm inside your lens controls both exposure and the depth of the zone of sharpness in your photographs.
- The tripod is as essential in photographing artwork successfully as the camera itself.
- The tripod you use should feature a "three-way" design with two locking levers, one for tilting the camera forward and backward and the other for tilting it from side to side.
- The tripod head should allow you to tilt the camera to a fully vertical position.
- The tripod head should be attached to a sliding post, and rotate independently of the post.
- The tripod should have adequate height when extended.
- The tripod should always be used with a cable release.

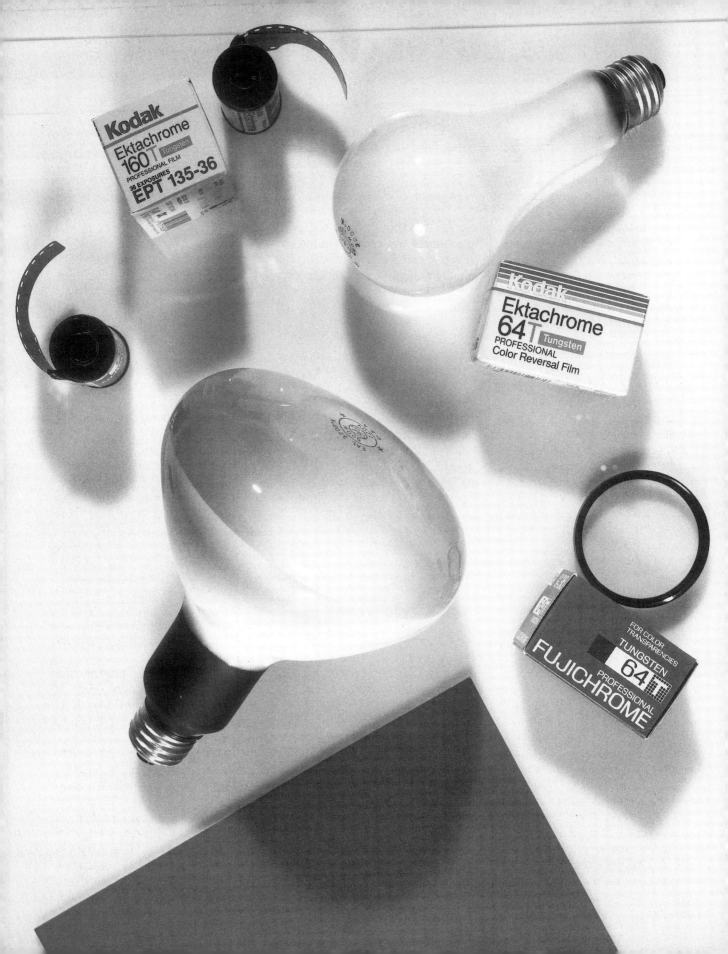

The time-honored notion that natural light is best to paint by and truest to color has led many artists to photograph their work by daylight, usually near a window or in open shade outdoors. But while daylight may seem the most pleasing light source to artist and layman alike, photographic film doesn't see things the way we do. The brain constantly tunes the human visual system to different sources of light; color films, on the other hand, are made to record accurate color only in a certain kind of light, and are said to be *balanced* for that light.

THE COLOR OF LIGHT

The film that people ordinarily use, whether for snapshots or for an attempt at photographing their artwork, is balanced for daylight. But for photographic purposes, daylight is rather strictly defined as light having the characteristics of direct sunlight. This includes the light from electronic flash units, which professional photographers often use to photograph works of art. Such professional units are specifically designed for studio use, and are much more powerful than the kind of compact device you would mount on your camera for snapshots. *Never* use a camera-mounted flash unit to photograph a work of art; even if the work doesn't dissolve in a sea of glare, it will have a flat, dull appearance. Never use undiffused sunlight as a light source, either, because of its strong directionality and unevenness.

To avoid these problems, many artists choose to photograph their work by indirect daylight, such as that in open shade or by a window — both more even sources of natural light. But because the light from a window or in open shade has clear sky as its primary source, *daylight* film — designed for the warm, direct rays of the sun itself — will often render it with a strong blue cast in the finished slide, a frequent complaint of do-it-yourself artwork photographers. If you must shoot slides by daylight, do so on an overcast day, and use corrective filtration on the camera, as described in the section on filters in Chapter Seven. For photographing works of art, though, far better results can be obtained with controlled *tungsten* light, and film balanced for this light.

COLOR TEMPERATURE

In photography, light is described by its *color temperature* on the Kelvin scale, or degrees Celsius above absolute zero. This has nothing to do with the actual heat of a particular light source, but rather with the color emitted by a hot object, which gets bluer as the object gets hotter. At 5500 degrees, the color it emits corresponds to that of sunlight; this is the color temperature of the light that daylight film is "balanced" for. It's understandable, then, why daylight film records the light in open shade or from a window on a sunny day as bluish: blue skylight has a color temperature of nearly 12000 degrees Kelvin. At the other extreme, daylight film renders subjects illuminated by artificial incandescent light with a strong brownish-yellow cast, because the color temperature of the light that a tungsten filament emits — about 3200 degrees on the Kelvin scale — is considerably lower than the 5500-degree light that daylight film is designed for. If you've ever taken pictures on daylight film by studio floodlights, this cast is probably all too familiar to you.

TUNGSTEN-BALANCED FILMS

Many people aren't aware that certain slide films are made specifically for use in tungsten light — the kind of light we illuminate our homes with. In tungsten light, tungsten-balanced color film will render blues blue and reds red, and will reproduce whites and grays without an unnatural color cast. For this reason, we'll be using tungsten-balanced films to make slides of your artwork.

Like natural light, tungsten light varies somewhat in its color temperature, although to a much lesser degree. Lower wattage bulbs such as those we use in lamps have an even lower color temperature than the 3200 degrees that tungsten films are balanced for — as low as 2600 degrees Kelvin. Even tungsten-balanced films may give this kind of light a slightly yellowish rendition, which is rarely objectionable for general-purpose photography but may misrepresent the colors of an artwork. The brighter the lightbulb, generally the closer its color temperature will be to 3200 degrees. But even the 500-watt floodlamps artists sometimes use to paint by are a bit lower in color temperature than the light for which tungsten film is balanced. For this reason, we'll be buying special bulbs that are manufactured to produce light of a very specific color temperature.

Type A and Type B. Tungsten film balanced for 3200-degree light is sometimes called *Type B* film. This designation is really only used to distinguish it from one other film, a tungsten-balanced version of Kodak's Kodachrome slide film identified by the code letters KPA. Tungsten Kodachrome is balanced for light with a color temperature of 3400 degrees Kelvin, a slightly bluer light than any other tungsten film is designed for. It is sometimes called *Type A* film. Tungsten Kodachrome is a sharp, fine-grained film, well suited to photographing indi-

vidual works of art.

You have more of a choice with tungsten-balanced films made for use in 3200-degree light. Kodak offers a couple of tungsten Ektachromes, Ektachrome 64T and Ektachrome 160T, while Fuji makes Fujichrome 64T. Interestingly, the Fuji film is actually balanced for a slightly lower color temperature than the Ektachrome films—3100 degrees Kelvin rather than 3200 degrees. That makes the finished slide a tiny bit cooler in its overall color than a slide from one of the tungsten Ektachromes, although you wouldn't notice the difference unless you viewed the two side-by-side. The difference may make the film a better choice for shooting individual artworks by the existing floodlighting of galleries and studios, because its color balance is a little closer to the color temperature of ordinary tungsten light. But all of these films yield excellent results in 3200-degree tungsten light.

There are differences between these films that go beyond their color balances. For example, in addition to its slightly lower balance, Fujichrome 64T has somewhat higher *saturation*—a photographer's term for the brightness or richness of a film's color—than Ektachrome 64T. Again, it's something you probably won't notice except in a side-by-side comparison. And once again, each film can be depended on to yield a slide that is a good facsimile of your artwork. But you may find that the characteristics of one film are better suited to the qualities of your artwork than another. If you plan to make a career out of your art—and of marketing it—it's a good idea to try each film and compare it to the others. Then stick with the one that works best for you and your work.

FILM SPEED

A film's ISO rating—often called its *speed*—is an index or measurement of its sensitivity to the kind of light it is balanced for. When a camera's ISO control is set to the correct number for the film in use, its meter knows how much light that particular film must receive to produce a properly exposed slide or negative. The higher a film's ISO number, the more sensitive it is to light. That means it needs less light than a film with a lower ISO number to produce a correctly exposed picture.

Many new 35mm cameras set the film's ISO automatically according to a bar code on the film cartridge, but others require that you set it manually, often with a dial on or near the camera's rewind crank. Cameras that set the ISO automatically also usually have a provision for adjusting the ISO manually. However it's done, the ability to override the camera and set a different speed than the one the manufacturer recommends can be useful for special processing techniques, and also if your camera allows no manual exposure control, as we'll learn. But initially, you should be sure that the film's ISO is set correctly, so that the light meter in your camera knows how much exposure to recommend.

Slow Films. The films we will be using have lower ISOs than the films you're probably accustomed to using for general-purpose photography. Tungsten Kodachrome has an ISO of 40, which is why we'll call it Kodachrome 40 from here on in. Ektachrome 64T (code letters EPY) and Fujichrome 64T (code letters RTP) have speed ratings of ISO 64, as their names suggest. Likewise Ektachrome 160T (code letters EPT and ET), which at ISO 160 is quite a bit more sensitive to light than the other tungsten films.

Films with low ISO numbers, whether color or black and white, slide or negative, are best for photographing individual works of art in controlled light because they produce sharper, more fine-grained images than the higher-speed films. Stick with Ektachrome 64T, Fujichrome 64T, and Kodachrome 40 for that purpose. Ektachrome 160T's ISO of 160 does make it useful for shooting installation views and individual works in existing gallery light, and for photographing three-dimensional work when you need good depth of field and your lighting is limited. Its appearance is somewhat "grainier" than that of the other tungsten slide films—especially noticeable when the slide is projected or enlarged. Ektachrome 160T's extra sensitivity to light is usually unnecessary when you photograph your individual works of art, because you will be flooding them with artificial light, and using a tripod, which permits longer exposures.

(There is yet another tungsten balanced Ektachrome now available, Ektachrome 320T, often used for shooting production stills on TV or movie sets. At ISO 320, it is faster than necessary for most of the applications described herein, especially if you're using a tripod. But it may prove useful when you must shoot by very low existing tungsten light—especially if you've forgotten your tripod! See Chapters Four, Five and Seven for details.)

One advantage to the Ektachrome and Fujichrome films—either tungsten- or daylight-balanced—is that they may be easily "push"-processed by the color lab or photo finisher. This special treatment allows you to set a higher ISO than the manufacturer recommends for a film, which may be useful when relatively low light limits your shooting options, or when you want a more "contrasty" slide, as

explained later. Refer to Chapter Seven, page 104, for more information about pushing film.

AMATEUR AND PROFESSIONAL FILMS

Most film manufacturers make their emulsions in both "amateur" and "professional" types. Amateur films are designed to sit on a camera store shelf at room temperature for prolonged periods; professional films, on the other hand, are "aged" by the manufacturer until tests indicate their color balance and other characteristics are optimum, at which time they are refrigerated until sold. Ektachrome 64T, Fujichrome 64T, and Ektachrome 160T (code EPT) are professional films, and professional photo suppliers should have them stored in a refrigerator. (Ektachrome 160T is also available in an amateur version, code ET.) Kodachrome 40, although described as a professional film by Kodak, is sometimes not refrigerated.

Unless you plan to use a professional film immediately, you should keep it in your refrigerator, too. Allow at least an hour for the film to warm up before you use it, so that no condensation forms on the film surface in the camera. If you buy a large quantity of film (either for the sake of consistency or economy) you may want to freeze it, in which case you should allow several hours for thawing. And if you don't intend to take your exposed film to the lab or photo finisher the next morning, put it back in the refrigerator, *in its plastic canister,* after you shoot it. Professional films are more sensitive to the ill effects of heat and age than are amateur films, so be especially careful with them. Improper storage and handling may cause changes in color, contrast and speed.

Effective Speed. While all manufacturers test the speed of their films

before releasing them for sale, Kodak actually admits it when a specific batch of its professional tungsten Ektachrome varies from its official ISO. Kodak calls the tested ISO of a given batch of film its *effective speed,* and prints it in color on the poop sheet supplied with the film. Variations are pretty rare (the most common seems to be Ektachrome 160T coming in at ISO 200 instead of ISO 160) and are not great enough to cause big differences in your slides. But if you're using the professional Ektachrome films, remember to check the poop sheet for the film's effective speed, and set your camera's ISO control accordingly.

FILM PROCESSING

The tungsten Ektachrome films require the same kind of processing as their daylight cousins, a method

described by the Kodak proprietary name of *E-6.* Fujichrome 64T can also be processed in E-6 chemistry. E-6 processing is available at professional photography labs and commercial photofinishers. Photography shops without on-premises processing will simply send your film to one of these operations, then mark up the price, so it's better to patronize the lab itself, if it does reliable work. Labs and commercial photofinishers can often turn E-6 films around in several hours, so that if you live near one you can shoot a test roll and have it processed while your setup is still intact. If your film has to be sent off, it may be a couple of days before you get it back.

Kodachrome 40 is processed in an entirely different way—a method that is far more complex

THE 81A FILTER

It's conventional wisdom that most people prefer warm colors to cool ones—whether in their living rooms or their slides. For this reason, you may want to consider using a warming filter over the camera lens when shooting your artwork, particularly if it has light or pastel tones. The filter gives a warm edge—an added richness—to the film's usually neutral rendition, and provides some insurance against the blue cast that can sometimes crop up in E-6-processed slides. If you keep the filter on the lens when you take your light reading, the meter should compensate for the very slight degree to which it cuts back the light reaching the film.

Filters that produce a slight warming effect are usually described by their Kodak proprietary designation—the Wratten #81 series. Of these, an 81A filter is perhaps the most useful. If it proves too strong, you can substitute an 81, or if too mild, an 81B. See the color plates on pages 112 and 113 for an illustration of these filters' effects.

Try to buy glass-mounted, screw-in type filters, so that you can clean them should they become smudged or dirty. They usually cost ten to fifteen dollars, depending on their type and diameter. Make sure you buy them in a size that fits the front thread of your lens barrel, the diameter of which is sometimes indicated in millimeters on the front of the lens. (Don't confuse this number with the focal length of the lens.) You can also buy warming filters in square gelatin, polyester or resin sheets. Read the section on filters in Chapter Seven for more details.

and strictly proprietary. Whether you take the film to a lab or a photography store, it will have to be sent to a special processing facility, and usually takes a couple of days to get back, depending on where you live.

LIGHTS

Although tungsten-balanced films will produce far more accurate color in any level of tungsten light than daylight film, it's best not to use the ordinary bulbs you may have on hand to light your work. As mentioned, these don't provide the precise color temperature of light that tungsten films are calibrated for, so you should purchase color-balanced bulbs such as those described below. (If you must use ordinary bulbs, Fujichrome 64T may produce a slightly less yellowish result than tungsten Ektachrome.) You may already have *clip-on light fixtures,* however, and you'll need at least two of these, particularly if you're shooting flat work. Be sure that they're designed to accept a 500-watt lamp. *Don't* use fixtures with paper-lined sockets, or those with questionable wiring—and expect to pay ten or twelve dollars for a decent one.

PHOTOFLOODS

There are two basic styles, or profiles, of *photoflood* lamp, the bulbs specifically made for color photographic work. One, which we'll call a *standard* photoflood lamp, is shaped like a conventional light-bulb. Because this kind of bulb gives off light in all directions, you need a metal *reflector* (two or more for flat work) to concentrate and aim the light. Whether you buy or use your own light fixtures, be sure they have an outside thread onto which you can screw the reflector. The alternative is to buy a *reflector photoflood,* which is a conical bulb with a fairly long stem and a built-in reflector. The reflector-style photoflood lamp eliminates the need for a separate metal reflector, and its illumination tends to be a little more even than that of a standard photoflood in a reflector—which can make it a help in lighting flat work.

Unfortunately, reflector photofloods are considerably more expensive than standard-profile photoflood bulbs, although you do save the price of separate reflectors. They will cost you from ten to fifteen dollars, while a standard photoflood lamp will cost only three to four dollars. Reflectors cost five to ten dollars apiece, depending on their size, and they're often sold as a unit with clip-on light fixtures. Packages combining reflector, fixture, and a lightweight collapsible stand can be had for as little as forty dollars. Bigger reflectors—those ten to twelve inches in diameter—will provide broader, more even light. The light produced by a standard photoflood lamp in a reflector is somewhat brighter than that produced by a reflector photoflood of similar wattage.

Wattage and Color Temperature. Both standard-profile and reflector photofloods are available in various wattages. Unless your work is small and you can place your lights close to it, the 500-watt bulbs are the most practical choice. (You can always back them away from the work if they create too much heat.) The 500-watt reflector photoflood lamp that produces 3200-degree light is known by the code letters EAL; this bulb has a frosted front face that further diffuses the light. The standard-profile 500-watt 3200-degree bulb goes by the code ECT. The EAL and the ECT bulbs are the ones you should use with the tungsten Ektachromes and with Fujichrome 64T.

Similar bulbs are available with a

BASIC LIGHTING HARDWARE
A clip-on light fixture. If you feel extravagant, you can buy collapsible light stands that accept the metal sleeve on certain fixtures, or to which you can simply clip the fixtures.

color temperature of 3400 degrees Kelvin, specifically for use with Kodachrome 40. Be sure you don't mix them up, though; while using 3200-degree bulbs with Kodachrome 40 may produce a slight, unobjectionable warmth, using 3400-degree bulbs with the tungsten Ektachrome films will result in a bluish cast in your slides. The 500-watt reflector photoflood for use with tungsten Kodachrome goes by the code letters DXC. The standard-profile 3400-degree bulbs go by EBV for the 500-watt version. All bulb types have the same code numbers whether or not they're manufactured by Westinghouse, GE, or Sylvania.

Burn Time. Any of these color rated lamps has a more limited useful life than the kinds of bulbs we light our living spaces with, but even this varies considerably from bulb to bulb. The EAL bulb has a "rated

life" of fifteen hours; the DXC and EBV, only six hours. The ECT bulb has a rated life of sixty hours. A bulb's rated life is the amount of burn time for which the bulb's color temperature is guaranteed; the bulb may actually last much longer. The bulb's useful life may be further limited by the buildup of carbon on the inside, which gradually reduces its brightness, and by turning the lamp on and off excessively. Keep careful track of the amount of time you actually have the bulb on; write it down on the bulb's packaging, to avoid confusion. Don't leave the bulbs on needlessly, and don't use them for general illumination, particularly the reflector photofloods (they're too expensive). Also, don't mix old and new bulbs, particularly in a flat copy setup. In spite of the limited lifespans of these bulbs, if you're judicious in their use they should last for many photo sessions.

Because these bulbs are extremely hot when they're on, they can set flammable materials on fire if within a couple of feet of them for a long enough period. Again, the bulbs should be used only in fixtures designed for high wattage. The type of fixture sold in photography stores is usually meant for this kind of use, and has a wooden handle so that you can aim the lamp when it's on without burning yourself.

WHERE TO BUY EQUIPMENT

The films described above, as well as the photographic lamps made specifically for use with them, are generally only available in a well-supplied photographic store that caters to a professional clientele. If you're not in any hurry, you may be able to special-order them through a less well-stocked outfit. Mail-order suppliers are often a more dependable source; see the list on page 125. In a pinch, regular tungsten bulbs of as high wattage as pos-

BULB PROFILES

The reflector photoflood lamp, A, requires no separate reflector, but is considerably more expensive than a standard lightbulb-style photoflood, B. But if you opt for the latter, you will need to buy metal reflectors, C, which screw into the thread on the clip-on fixture.

sible, and the "amateur" version of Ektachrome 160T (ET), will suffice, and can be obtained from hardware stores and suburban camera shops. Clip-on light fixtures and metal reflectors can be purchased either at camera stores or hardware and lighting outlets.

Advanced Lighting Options. If you find yourself photographing your work extensively, you may want to consider purchasing professional quartz lights. Quartz lights

come in a variety of styles and are priced anywhere from one hundred to hundreds of dollars apiece, depending on features. A good part of the cost is the quartz halogen bulb itself, which burns as long as 150 hours, and never varies from its rated color temperature. These lights are available only through a professional photography dealer. Be sure to ask the dealer about their proper treatment and use. Among other things, you should

never touch the bulb itself; any oil or grease on its surface could cause it to fail or even shatter. The most commonly used bulbs produce from 600 to 1000 watts of light, and thus burn even hotter than 500-watt floodlamps.

Quartz halogen lamps are also available in small, cylindrical screw-in bulbs that your clip-on fixture will accept. Like standard-profile photofloods, you'll need a reflector with these bulbs (they're not very long, so choose a reflector with a short stem), but their lifespan is much, much greater. Made by Osram, they're also much more expensive — thirty to forty dollars apiece — and they don't come in strengths greater than 250 watts.

Another advanced lighting option is electronic flash. Preferred by many professional photographers, "strobe" light is more or less the same color temperature as daylight, so daylight-balanced film is used with it rather than tungsten film. Because the illumination electronic flash provides is instantaneous, it doesn't subject delicate artworks to the strong light and heat that tungsten bulbs produce. And because relatively fast shutter speeds may be used with it, you don't have to worry as much about competing ambient light. While a few 35mm flash systems may permit the kinds of lighting arrangements described in this manual, you will still need an expensive, specialized meter to measure the evenness of the light. Professional-level strobe hardware is extremely costly, something best left to the professional you've decided not to hire.

COMPETING LIGHT SOURCES
Because you'll be using continuous tungsten light and relatively long exposures (slow shutter speeds) to photograph your work, you'll have to eliminate any other ambient light sources that might affect the even-

ness or color of your result. Windows open to the outdoors must be covered with opaque cloth or plastic; if you're shooting in a window-filled loft, it may be easier to shoot at night. Former industrial spaces often have fluorescent lighting, and because it's not particularly bright, it's easy to forget to turn it off before shooting. Depending on your exposures, if left on it can contribute a noticeable greenish cast to your pictures. If you're using regular tungsten bulbs to throw extra light on the piece for framing and focusing, be sure to turn them off as well. (Don't worry — you'll be reminded of all this later, when you're actually ready to expose your film.)

THE EXPOSURE EQUATION: SHUTTER SPEED, LENS APERTURE, AND YOUR CAMERA'S METER

As you've learned, different films have different sensitivities to light, indicated by their ISO numbers. You must always adjust your camera's film speed control to the proper ISO, or double-check that your camera's automatic film-speed setting is correct. (Consult your manual to find out how to confirm it.) Setting the correct speed is the only way the camera's metering system will know how much light the film needs for proper exposure — that is, to produce a slide that is neither too dark nor too light.

SHUTTER SPEED
The amount of light that reaches the film is controlled by two mechanisms. One is the *shutter,* which is a cloth or metal curtain in front of the film (or sometimes a diaphragm of metal leaves in the lens) that uncovers the film for a precisely timed period — anywhere from $1/8000$ of a second to one, two, four, eight or more seconds, depending on the model. The slower the shutter

speed, the more light reaches the film through the lens opening. Each change in shutter speed represents a doubling or halving of this interval, and, consequently, of the light that is allowed to pass to the film. You set the shutter speed with a dial or other control usually on the top deck of the camera.

LENS APERTURE
The other mechanism that controls the amount of light reaching the film is the *lens aperture.* The aperture is a variable opening formed by metal blades inside the lens itself. You change its size by adjusting a ring on the lens barrel (usually close to where the lens connects to the camera body) or by spinning a dial or sliding a switch on the camera body. Each number on the ring — 2, 2.8, 11, 16 — represents a different-sized opening, often called an *f-stop.* (If your camera has no aperture ring, those numbers are displayed in the viewfinder and sometimes on an external LCD panel as well.) The larger the f-stop, the more light can reach the film in a given amount of time — that time being the shutter speed, of course.

The confusing thing is that the smaller the f-stop number, the larger the opening. The aperture f2, as it's designated, is twice as large as f2.8; f11 is twice as large an opening as f16. Study the lens barrel or the aperture display to see the sequence. (If you take a lens with an aperture ring off the camera, you can see the aperture open and close as you turn the ring.) Each of these changes in aperture will produce the same change in exposure that a similar adjustment in shutter speed produces. For example, if you want to increase your exposure, you can use either a slower shutter speed — e.g., change from $1/8$ second to $1/4$ second — or a wider aperture, f5.6 instead of f8.

WHAT THE LIGHT METER TELLS YOU

When measuring light, your camera's meter arrives at various combinations of aperture and shutter speed that it thinks will produce a good exposure on film with the ISO number you've set. With a camera in "program" mode, this combination is set automatically. With a camera set to its aperture-priority or shutter-priority mode, you set one and the camera sets the other. In a manual camera, you set both according to the signals the camera provides.

It's important to understand that you can obtain the same exposure — in other words, make the same quantity of light strike the film — with various combinations of shutter speed and aperture. You'll observe this as you change one or the other on your camera. Imagine that you're photographing a meadow, and you've set a shutter speed of $\frac{1}{125}$ second. With an ISO 100 film, the camera selects (in the case of shutter-priority) or advises (in a manual mode) an f-stop of f11. Suddenly you see a horse galloping across the meadow, and you decide to increase the shutter speed to $\frac{1}{250}$ second to better freeze the movement of the horse. But this cuts in half the amount of time the light has to strike the film, so the camera will in turn select or advise an f-stop of f8 — a larger opening that admits twice as much light as f11 in a given period — in order to give the film the same amount of exposure to light. You could even choose a shutter speed of $\frac{1}{500}$ second, which would necessitate an even wider aperture of f5.6. Other combinations of f-stop and shutter speed that would produce this same exposure (though they'd be too slow to stop the horse's motion) are $\frac{1}{60}$ second at f16 or $\frac{1}{30}$ second at f22.

A film of a given ISO always

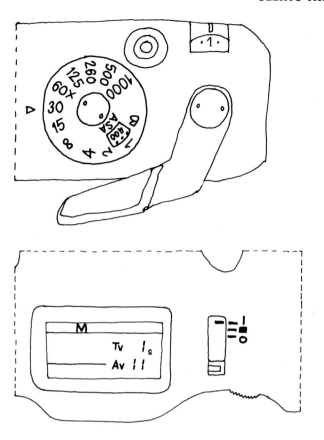

THE SHUTTER SPEED

This control is often found on the top of the camera, but on some models it is a ring around the lens mount, or a dial or toggle switch on the camera body. (Check your manual if you're unsure.) Shutter speed — the length of time the curtain covering the film is open — is one of the two ways in which the amount of light reaching the film is controlled. The traditional shutter speed dial at top is set to $\frac{1}{30}$ second; the top-deck LCD panel at bottom indicates that the camera is set for a one-second exposure (note the "s" symbol) at an aperture of f11.

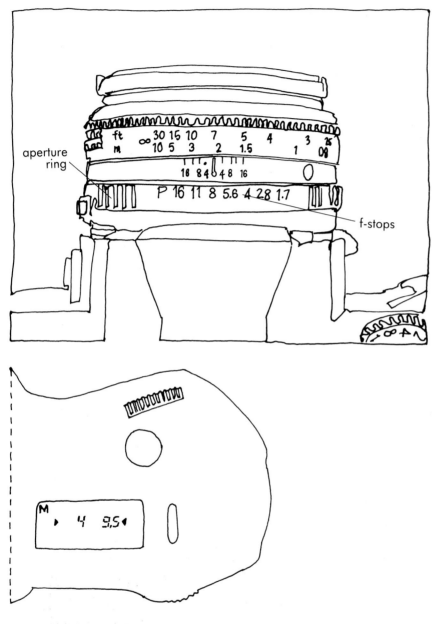

aperture ring

f-stops

THE LENS APERTURE

One way to control the amount of light reaching the film is by changing the size of the opening formed by the diaphragm of metal blades inside the lens. (See illustration on facing page.) On traditional cameras, a ring on the lens barrel is used to make the adjustment; numbers on the ring represent the size of the openings, called f-stops. (The aperture ring at top is set to f8.) In many newer model cameras and their lens systems, the lens has no aperture ring; the f-stop is set instead with dials and switches on the camera body, and the numbers displayed in the viewfinder and/or on an external LCD panel. (The camera at bottom is set for a shutter speed of 1/4 second and an aperture of f9.5, which is halfway between f8 and f11.) If your camera fits this description, check the manual to learn how to adjust the aperture.

needs about the same amount of light to produce a well-exposed negative or slide. Yet in general-purpose photography, light levels differ dramatically from subject to subject, depending on whether you're indoors or out, or whether it's bright or overcast. This is why you need the kind of wide-ranging exposure control that the lens aperture and shutter speed provide. A certain film may require an exposure of 1/250 second at f16 in bright outdoor light, but need a much slower shutter speed of 1/60 second and a very wide aperture of f2 to produce the same film exposure in dim indoor light.

FILM SPEED AND THE LIGHT READING

A film of a given ISO, however, needs more or less light than another film with a different ISO to produce a properly exposed slide or print of a subject in a given light level. This directly affects the combination of aperture and shutter speed that your camera's meter recommends or sets. Because a film with an ISO of 50 has only half the sensitivity to light of one with an ISO of 100, your camera's meter will set or recommend either a one-stop wider aperture or a one-stop slower shutter speed to double the amount of light reaching the film. In a situation requiring an exposure of 1/250 second at f8 with an ISO 100 film, an ISO 50 film would require an exposure either of 1/125 second at f8, or 1/250 second at f5.6. (Your camera will tell you this if you change the ISO setting while pointing it at the same subject.) If, on the other hand, you were to use a film with an ISO of 200—with twice the sensitivity of the ISO 100 film—the camera would indicate proper exposures (i.e., combinations of f-stop and shutter speed) of either 1/500 second at f8 or 1/250 second at f11.

You're less likely to encounter

the variety of shooting situations and light levels that the 35mm camera is designed for in photographing artwork. With the exception of work that must be photographed *in situ,* our conditions will be more consistent: we will be setting up our own lights, using the relatively slow shutter speeds that a tripod permits, and avoiding very wide lens apertures.

The most common mistake of artists who photograph their own work is in allowing their camera's light metering system, whether manual or automatic, to have the final word on what exposure the film will receive. The problem with this is that the light meter in your camera assumes that the tones or brightnesses in your subject — whether it's your artwork or your Uncle Fred — will average out to a medium gray value. This is often true of a real world scene with a variety of surfaces and objects, and evenly distributed highlights and shadows, which is why the system works fairly reliably in general-purpose photography. But these assumptions are far less often true of an artwork.

The camera's exposure system will set or recommend a combination of f-stop and shutter speed that will render any given value as a medium gray in your slide or print. If you fill the camera's viewfinder with a white wall, for example, it will choose an exposure that will represent that wall as a medium gray instead. Even if a person is standing in front of the wall, enough of it may occupy the frame to throw off the exposure substantially, causing the figure to be underexposed. The camera will make the same mistake in determining exposure for artworks that are primarily light in tone, such as a watercolor of pastel hues, or a pale marble sculpture. It will underexpose these sub-

jects — that is, make them too dark — if you let it.

Conversely, if you allow the camera to set the exposure (or, if you're using the camera in a manual mode, you use the exposure it recommends) for a very dark subject — perhaps a minimalist painting of deep, subtly different values and colors of near-black — it will make those dark tones medium gray in the final photograph by overexposing them.

THE GRAY CARD

If the tones in your artwork happen to average out to the medium gray the camera's meter is calibrated for, then you might well obtain a good exposure by letting the camera set itself, or by manually setting the exposure it recommends. More than likely, though, your work won't conform to this tonal model. The solution to this problem is to show the camera's meter what it wants to see. You can do this with something called, rather simply, a "gray card" — an 8 × 10-inch sheet of smooth, even gray cardboard manufactured by Kodak and other companies specifically for taking light readings. You can buy a package of two or three (they get smudged) for under ten dollars in many photography stores. The card reflects 18 percent of the light that strikes it, which is exactly the amount your camera assumes its subject reflects. The procedures described in later sections on lighting and determining exposure assume that you are using a gray card, so buy one when you pick up your film and lights.

The use of the card will be explained in more detail in later sections. Basically, once you've set up your lights, you simply place the card in the same light that falls on your artwork — against a piece of sculpture, or in the same plane as a painting or work on paper — and fill

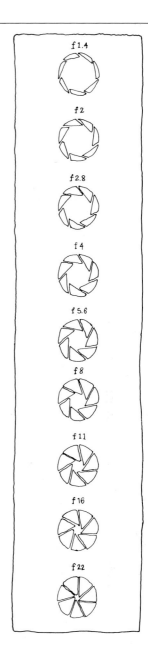

THE APERTURE DIAPHRAGM

The numbers on the aperture control ring of your lens (or shown in the viewfinder and on external displays) represent different-size openings formed by the diaphragm of metal leaves inside the lens. The size of this opening is one of the two ways in which the amount of light reaching the film is controlled, the shutter speed being the other. A larger opening — indicated by a smaller number — lets in more light; a smaller opening, indicated by a larger number, lets in less light. The smallest number represents the largest aperture you can get with your particular lens.

the camera's viewfinder with it. There's no need to focus the camera on the card, but you may want to secure the card in some way so that you have both hands free to operate the camera. Be sure not to cast a shadow on the card, nor to angle it in such a way that you pick up glare from your lights.

When you point it at the gray card, your camera will indicate a combination of aperture and shutter speed that will produce a correct exposure on the film. Remember that you can obtain correct exposure with various combinations; the most suitable combinations for each type of work and situation will be discussed later in this chapter and in the chapters on specific kinds of work. You will also learn how to override an automatic exposure system, if manual exposure control is unavailable, so that it will "remember" the correct exposure indicated by the gray card.

FILM EXPOSURE AND EXPOSURE BRACKETING

If your camera is set to the correct ISO for the film you're using, its meter's "reading" of the light reflected by the gray card should tell you the correct exposure for your artwork. If, however, the artwork is especially light or dark, or high in contrast, it may make a better slide if slightly under- or overexposed. We'll see how to do this in a minute. But first, you should give a little thought to the best combination of shutter speed and aperture for your particular artwork. Again, many such combinations will expose the film correctly, giving you the same lightness or darkness in the finished slide. A gray-card reading of ¼ second at f8 will give you the same film exposure as an exposure of ⅛ second at f5.6. This is because a one-stop decrease in the size of

the lens opening—from f5.6 to f8— is exactly offset by a one-step slower shutter speed.

CHOOSING A SHUTTER SPEED

Because you're using a tripod, you can select (within limits) as slow a shutter speed as you need without risking blur. Ordinarily, the strength of the lights you will be using, along with the smaller lens apertures (f-stops) that should be set when photographing artwork, will require that you use shutter speeds in the ⅟₁₅ to one-second range. (This will vary according to the number and wattage of the lights you are using, how far from the work they are, and whether or not you are diffusing or "bouncing" them.)

If you're using Kodachrome 40 or Ektachrome 160T, keep one thing in mind. All films undergo a loss of sensitivity when exposures exceed a certain length (shutter speed)—an effect that goes by the intimidating-sounding name *reciprocity failure*. If you shoot the film with such long exposures, the slide will end up slightly *darker* than if you'd combined a shorter exposure time (shutter speed) and a wider aperture to get the same amount of light to the film. It's a confusing idea, but don't worry about it if you're using Ektachrome 64T or Fujichrome 64T; with those films it doesn't start to happen until exposure times reach the ten- to twenty-second range, far longer than you'll ever need. With Kodachrome 40, however, you may see some darkening at speeds slower than ⅛ second, and as you near one second, the same thing can happen to Ektachrome 160T. The solution is simple: increase the exposure by setting a slightly wider aperture. If your calculated exposure with these films is one second, for example, use an aperture ½ stop wider. And be sure to "bracket" your ex-

posures, a technique that will be explained later in this chapter. Reciprocity failure is usually more of an issue in photographing three-dimensional work, and you will be reminded about it in that section.

CHOOSING AN APERTURE

The option to choose slower shutter speeds is important because you should use a relatively small aperture (higher-numbered f-stop) when photographing artwork. The size of the lens aperture affects something called *depth of field*, which, simply put, is the zone of sharpness in your subject in front of and behind your focused distance. The use of smaller apertures increases the size of this zone, and becomes especially important in photographing three-dimensional work, or any other three-dimensional subject in which you want maximum clarity. And because a standard lens (unlike a macro lens) focuses on a curve, and not the flat plane formed by two-dimensional work, it's important in shooting flat artwork to have enough depth of field to compensate for the difference between the two.

The most useful tool in calculating depth of field at a given f-stop is the scale on the lens barrel. Its use is explained fully in the box on pages 34 and 35. If your lens has no depth-of-field scale, or a skimpy one, refer to the depth-of-field charts for 50mm and 105mm lenses on page 37. Later sections will also refer you to this information.

The amount of depth of field you get at a *given* f-stop also varies considerably with the distance you've focused on. The closer you are to your subject—that is, the closer you've focused—the shallower your depth of field will be at that aperture. For this reason, the smaller your artwork, the smaller the aperture you will need to set. Try to use an f-stop of f11, for exam-

ple, if your flat work is less than two feet across. Flat work larger than two feet across can be photographed at an aperture of f8, provided you focus carefully.

Three-dimensional work, on the other hand, requires the use of even smaller f-stops than flat work — f-stops small enough to create a zone of sharpness adequate to encompass the entire depth of the work. That's why it's more important to determine the depth of field with three-dimensional work than it is with two-dimensional work. Very small three-dimensional works may even require f-stops as small as f22. However, the smallest aperture some lenses offer is f16. By contrast, macro lenses, because they are designed to focus at very close distances, usually stop down to an aperture of f32, but this is rarely necessary.

Whether two- or three-dimensional, the larger the artwork, the wider the aperture you can get away with. That's because larger works must be photographed from greater distances to keep them within the frame, and this increased distance improves depth of field. Avoid apertures wider than f5.6 if at all possible, or you may run a serious risk of having part of the work out of focus. And if you're using a lens or zoom focal length longer than 50- or 55mm, such as 85- or 105mm, use an aperture a stop smaller than those recommended above — for instance, f11 instead of f8. These recommendations are only general guidelines, and should be checked against the lens' depth-of-field scale, if it has one. They may be particularly useful, though, if you have to use a lens with a skimpy depth-of-field scale, or none at all.

Remember that you can set the lens aperture ring to in-between positions, too — for example, a half or a third of the way between f8 or f11.

If your aperture control is on the camera body, your viewfinder and/or top-deck LCD display panel will show in-between numbers, with the increments sometimes in thirds of stops and sometimes in halves, depending on your particular model. The third-stop sequence between f5.6 and f8, for example, is f6.3, f7.1; the half-stop value is f6.7. Between f8 and f11, third-stop increments are f9.0 and f10, while the half-stop value is f9.5. Don't ask what the funny numbers actually mean. Just know that depth of field at these settings can be determined by reading the distances "between the lines" on the depth-of-field scale or accompanying charts. Again, the gray-card reading should indicate the correct shutter speed at any chosen aperture — and you may in fact need to set an in-between aperture to get just the right exposure. And, of course, if you're in a shutter-priority autoexposure mode, you can make the camera select a smaller aperture by setting a slower shutter speed.

DEPTH OF FIELD AND THE VIEWFINDER IMAGE

It's important to point out that the appearance of any subject in your SLR camera's viewfinder is misleading in terms of depth of field. This is because even though you may have set a small aperture like f11 on your lens, the camera keeps the aperture diaphragm open to its widest setting until just before you trip the shutter, when it automatically closes it down to the f-stop you've set. It does this to allow as much light as possible into the viewfinder, to provide a bright image for framing and focusing. But this also means that the depth of field of any given subject as observed through the lens is that available at its widest aperture, and therefore much shallower than

what you'll get when the lens is stopped down to your selected aperture before the shutter is tripped.

Many SLRs offer a control called the "depth-of-field preview," a switch or button that allows you to view your subject through the lens at the f-stop you've set. Unless you've set your lens to its widest aperture (lowest f-number), this will cause the viewfinder image of your subject to darken — in fact, the smaller the aperture you set, the darker it will be. This darkening makes visual judgment of depth of field very unreliable. It's better to make use of the lens' depth-of-field scale, and focus the lens to maximize depth of field, as explained in the box on page 34. What's more, the viewfinder image produced by your lens' maximum aperture may be disconcerting if you're shooting three-dimensional work, because parts of the artwork will appear to be unsharp. Just remember, though, that the photograph will be taken through the smaller aperture you have set, and thus show considerably better depth of field.

Once you've set a camera in a manual mode to the appropriate combination of aperture and shutter speed, using the gray card to guide you, it will remain at those settings until you change them yourself. When you remount your camera on the tripod so that the artwork fills the frame, the camera may recommend a different exposure based on its averaged reading of the artwork's tones. Ignore these readings and take your pictures.

FILM EXPOSURE WITH AN AUTOEXPOSURE SYSTEM

If your camera offers automatic exposure only, the exposure it will choose when you put your camera back on the tripod and make the artwork fill the frame probably won't agree with the gray-card reading. If it does agree, you can let the cam-

era do its automatic thing; if it doesn't, you will need to override the camera's settings in some way. (If the automatic reading off the artwork itself is only slightly different than the gray-card reading, and your camera has an autoexposure compensation dial, you can simply *bracket* the automatic exposure enough to include the exposure indicated by the gray-card reading, a technique explained later.)

Autoexposure Compensation. If you're not sure what, if any, autoexposure override controls your camera offers, check the manual. The most common is an *autoexposure compensation* control, often a dial found around the rewind crank. In newer models, it's usually a push-button affair. The dial, or in newer models, the associated display, is marked in stops — +1, –1, +2, –2 — each of which is the equivalent of a one-step change in aperture or shutter speed. The in-between positions are usually marked in thirds. Setting the autoexposure compensation dial to +⅔, for example, will give the film an additional ⅔ stop of exposure, making your slide lighter than it would have been had you let the camera use the exposure it had indicated. Setting the dial to –2, on the other hand, will give the film two stops less exposure, making the slide considerably darker than it would have been.

To get the correct exposure with an automatic-only camera, you have to adjust the exposure compensation control until the autoexposure indicated in the viewfinder or the LCD display matches the gray-card reading you took in the center of the artwork. For example, say you got a gray-card reading of ¼ second at halfway between f8 and f11 in a shutter-priority autoexposure mode. When you remount your camera so that the artwork fills the frame, the camera indicates f16 — a

READING THE DEPTH-OF-FIELD SCALE ON YOUR LENS

Calculating *depth of field*—the depth of the zone of sharpness in your photograph—needn't be a seat-of-the-pants affair. The lens barrel is frequently marked in such a way as to show you how much of your subject will be clear in your final slide or print.

- *Aperture Ring.* The lens aperture is usually set with the ring on the lens barrel closest to the camera body. Most standard lenses such as the 50mm you are probably using have apertures ranging from f1.7, f1.8 or f2 down to f16 or f22; other lenses, particularly zooms, telephotos and macro lenses, may have smaller maximum apertures such as f2.8, f3.5 or even f4. Macro lenses and long zooms or telephotos may stop down to an aperture as small as f32 or f45. On occasions when even apertures as small as f11 or f16 may not provide adequate depth of field, such as in shooting extreme close-ups, these smaller apertures may be useful. To select a particular aperture, you usually click it into place below a centered dot. (On some systems, apertures are set with a control on the camera body rather than a ring on the lens.)

- *Focusing Ring.* The next moving ring on your lens barrel is the focusing ring, which is marked with scales in both meters and feet. (Be sure you don't confuse them.) When you focus on a subject, the number that represents its distance from the camera lines up with the line or dot centered on the lens barrel below it. (This mark also usually indicates the aperture being used.) On either side of this line or dot are more lines, each with a number beneath or beside it. Notice that these lines refer to lens apertures, and that each numbered line appears on both sides of the focusing mark. *These lines are the depth-of-field scale.*

- *Zone of Sharpness.* After you focus a subject, find the lines that correspond to your chosen aperture. These lines will indicate two distances on the focusing ring, one to either side of your focused distance. This is the range within which your subject will be sharp.

 For example, say your subject is seven feet away; you focus on it, and the number 7 on the foot scale lines up with the central line or dot. The lines marked 8 on the depth-of-field scale fall at six feet on the right and around nine feet on the left. This means that at an aperture of f8, your zone of sharpness will run from six to nine feet when you're focused at seven feet. Note how depth of field improves if you choose to set your aperture at f16; the zone of sharpness extends from about five feet to twelve feet.

 On certain camera lenses, most notably Nikon's manual-focus lenses, the manufacturer has simply color-coded the lines on the depth-of-field scale to match the colors of the numbers on the aperture ring, thus eliminating the need for additional numbers. For example, f11 on the aperture ring is yellow, and the lines on the depth-of-field scale that show you the zone of sharpness at f11 are also yellow.

 You may notice that your focused distance also has an effect on depth of field. In the example above, with the aperture set at

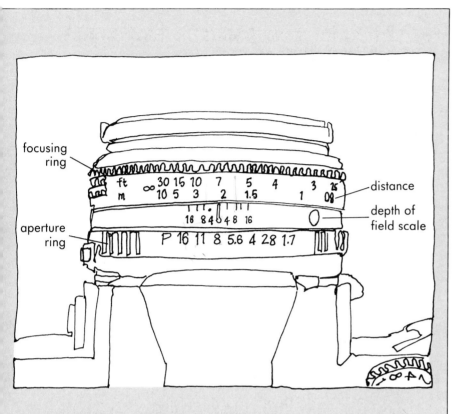

focusing ring

aperture ring

distance

depth of field scale

f8, focusing on fifteen feet instead of seven would give you a zone of sharpenss from ten feet to about twenty-five feet, much deeper than the three-foot zone you'd get when focused at seven feet. In fact, the closer you focus, the shallower your depth of field will be at a given aperture, which is why smaller artworks require the use of smaller apertures, especially if three-dimensional.

- *In Focus.* Depth of field at any given aperture can and should be maximized by careful focusing. With two-dimensional artwork, it's safest simply to focus on the middle of the piece, then select a moderately small aperture to deepen the zone of sharpness in compensation for the fact that most lenses focus on a curve, not the flat plane formed by two-dimensional artwork. Specific apertures will be discussed in Chapter Three. With three-dimensional work and installation views, however, focusing on the closest part of your subject wastes the available depth of field in front of your focused distance. Depth of field at any aperture extends about twice as far behind the point at which you've focused as it does in front of it. That means if you focus a third of the way between the nearest thing that must be sharp and the farthest thing, then choose an aperture that provides a deep enough zone of sharpness to include them both, you'll be getting the most out of any given aperture's depth of field. This strategy will be reiterated in the sections on three-dimensional work and installation views.

smaller aperture that will produce less exposure than the artwork really needs. Leaving the shutter speed set the same, adjust the auto-exposure compensation control toward the plus side, until the aperture indicated in the viewfinder display is between f8 and f11, as it was with the card reading. If you look at the dial or display, it will be halfway between +1 and +2. This kind of correction is more likely with an artwork that is, on average, lighter in tone than the gray card.

If a work is darker in tone than the card, you will probably have to make a correction in the opposite direction, because automatic exposure systems tend to overexpose very dark subjects. If the gray-card reading was ½ second at f8, but the work itself causes the camera to choose ½ second at f5.6, turn the autoexposure compensation dial toward the minus side, until the aperture display reads f8. The autoexposure compensation dial or display will then read –1.

If your automatic-only camera offers aperture-priority autoexposure, you will have to use the shutter speed the gray-card reading indicated at your selected aperture as the "target" for your autoexposure-compensation adjustments. If, for example, with the aperture set at f11 the gray-card reading caused the camera to choose ¼ second, but the camera's reading off the work itself indicates ⅛ second, set the exposure compensation to +1, to obtain the additional stop of exposure. The viewfinder's shutter-speed display should then indicate ¼ second. If the reading off the work itself indicates that the camera will choose a shutter speed of one second, which would result in severe overexposure of the work, set the exposure compensation at –2, which should cause the viewfinder to display ¼ second.

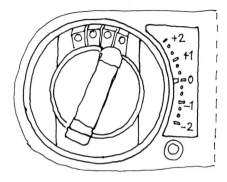

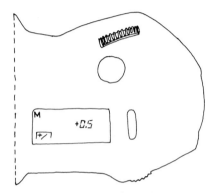

AUTOEXPOSURE COMPENSATION

This control lets you override an automatic exposure system's settings; adjusting it increases or reduces the exposure, and thus lightens or darkens the slide. The traditional dial shown at top is calibrated in third stops, and set for no compensation. The LCD panel at bottom indicates that compensation is adjustable in half stops, and is set for +0.5, or an extra half stop of exposure. Either way, each +1 or -1 change is equivalent to a one-stop change in aperture or shutter speed.

If your camera has no autoexposure override option, you can resort to changing the ISO setting to obtain the correct exposure. Adjust it as described above, until the viewfinder display you get when the camera is reading off the artwork itself matches your gray card settings. Adjust it toward the higher numbers to reduce exposure; this makes the meter think the film is more sensitive than it really is, so it gives it less exposure. This is the usual correction for an artwork that is dark. Adjust the ISO control toward the lower numbers to increase exposure; this makes the meter think the film is less sensitive than it really is, so it gives it more exposure. If your camera sets the ISO automatically and you can't set it yourself, you can't use this technique.

Autoexposure Lock. Another automatic exposure override system that is common on more sophisticated cameras is the *autoexposure lock*. This is usually a button that you hold in after taking your local reading—in our case, off the gray card—to lock in your autoexposure settings. It prevents the camera from recalculating the exposure (incorrectly) when you show it the whole subject—in our case, the artwork. The problem with this device is that you usually have to keep depressing the button until you make the exposure, which is awkward if you must then remount the camera on the tripod. Furthermore, it's not a good idea to have any hand contact with the camera when you're using the longer shutter speeds that are necessary in tungsten light. But if the design of the autoexposure lock on your camera doesn't present any of these problems, simply take your reading off the gray card, lock the exposure in, remount the camera, and then take your picture. Be sure that the exposure remains locked in

if you need to shoot additional frames.

MAKING AND BRACKETING YOUR EXPOSURES

Once you've established the correct exposure for your combination of film speed and lighting, and you've chosen and set a suitable combination of aperture and shutter speed (and if necessary, figured out how to trick your camera into using this combination), you're finally ready to take your long-awaited photographs. Make sure that you've focused properly (if you have an autofocus camera, set it for manual focusing); that the artwork is square and/or centered in the viewfinder (the fine points of which are treated in the next two chapters); and that all extraneous light sources have been eliminated. Don't forget to use a cable release to trip the shutter, to eliminate camera movement during long exposures.

After you've exposed your first frame, advance the film slowly and gently. Don't force the film advance lever any further than it needs to go to move to the next frame. Too much pressure may cause the camera to shift on the mounting screw. Keep double-checking the viewfinder as you expose more frames to be sure that this hasn't happened. Most cameras will allow you to advance the film in several short strokes rather than a single long one, which can be useful in preventing this problem. Before making the next exposure, allow ten seconds or more for any vibrations caused by advancing the film to stop. If you live over a subway or a factory, make your exposures when the train has passed or the machines are quiet. Vibrations can be transmitted right through the tripod.

Shoot as many slides at your chosen exposure as you think you will

need. You can always use the extras, and a good original slide is better in quality than a commercial duplicate. It's cheaper, too.

In spite of everything you've done to assure proper exposure of your film, you should still *bracket* your exposures—that is, shoot additional "insurance" frames with both more and less exposure than that indicated by the final gray card reading. The photographic process involves many variables that can affect the final result, making the slide lighter or darker than it should have been. (Your camera's meter or shutter could be off, for example.) What's more, a light artwork may look better in a slide if it is slightly underexposed; a very dark artwork may look better if somewhat overexposed. And you may choose to make your slides a little lighter or darker depending on the circumstances in which they will be viewed: a darker slide for projection, a lighter one for viewing in frosted slide pages. Nonetheless, the gray card reading provides an excellent standard.

BRACKETING EXPOSURES IN A MANUAL EXPOSURE MODE

Bracketing your exposures is easy in a manual exposure mode. If your indicated exposure is ¼ second at f11, for example, shoot a frame at ¼ second with the aperture set halfway between f8 and f11, then another with it set halfway between f11 and f16. The first will give you a slide that is slightly lighter than the one your calculated exposure will yield; the second, a slide that is slightly darker. This is called bracketing by a half-stop. If your calculated exposure called for the aperture to be set between f8 and f11, you would bracket a half-stop in either direction by taking a second picture with the aperture set at f8 and a third with it set at f11. You can extrapolate a half-stop bracket

DEPTH-OF-FIELD CHARTS

Refer to the charts below to find out the depth of field—the depth of the zone of sharpness in your photographs—available at different lens apertures and focused distances. One chart shows depth of field for a standard 50mm lens, the lens you'll probably be using; the other for a 105mm lens, an excellent choice for three-dimensional work. These charts are an important resource if your lens has no depth-of-field scale on its barrel, especially when you're shooting three-dimensional work. (If your lens does have a depth-of-field scale, the charts can be used to double-check your reading of the scale.)

If you've focused your 50mm lens to three feet, for example, the chart tells you that at an aperture of f8, depth of field is just five inches. With the lens focused to seven feet and stopped down to f11, depth of field is almost four feet.

Indeed, as the charts show, depth of field increases both with smaller apertures and greater distances. To increase depth of field at a given distance by about 50 percent, use an aperture one stop smaller—for example, f11 rather than f8. To double depth of field at a given distance, use an aperture two stops smaller—f16 rather than f8. With a 50mm lens, to get about the same depth of field at three feet that an aperture of f5.6 would give you at five feet, you'd have to use a much smaller aperture of f16.

Keep in mind that depth of field extends about twice as far *behind* your point of focus as it does in front of it. That's why focusing about a third of the way between the closest and farthest parts of the subject you want sharp makes the most efficient use of the available depth of field. Once you've focused, refer to the charts, or to the lens' depth-of-field scale, to see what aperture will give you enough depth of field to include both parts. When in doubt, use a smaller aperture!

DEPTH OF FIELD WITH A 50mm LENS

FOCUSED DISTANCE (in feet)	f5.6 (feet)	f5.6 (inches)	f8 (feet)	f8 (inches)	f11 (feet)	f11 (inches)	f16 (feet)	f16 (inches)
1.5		5/8"		7/8"		1¼"		1¾"
2		1 5/16"		1 7/8"		2 5/8"		3 13/16"
3		3½"		5"		6 15/16"		10 3/16"
4		6 11/16"		9 5/8"	1'	1 7/16"	1'	8"
5		11"	1'	3 3/8"	1'	10 3/16"	2'	9 11/16"
7	1'	10 7/8"	3'	1 3/16"	3'	11 9/16"	6'	4 1/8"
10	4'	11/16"	6'	1 13/16"	9'	2¼"	18'	¾"

DEPTH OF FIELD WITH A 105mm LENS

FOCUSED DISTANCE (in feet)	f5.6 (ft.)	f5.6 (in.)	f8 (ft.)	f8 (in.)	f11 (ft.)	f11 (in.)	f16 (ft.)	f16 (in.)	f22 (ft.)	f22 (in.)
2		¼"		3/16"		5/16"		7/16"		11/16"
3		9/16"		7/8"		1 3/16"		1¾"		2 7/16"
5		2¼"		3 1/8"		4½"		6 5/16"		8 15/16"
10		8 1/16"	1'	3"	1'	8 11/16"	2'	6¼"	3'	7 7/8"

from any in-between setting, for that matter. As you get more confident, you may prefer to bracket by thirds of stops, setting the aperture (in the first example) a third of the way from f11 to f8, then a third of the way from f11 to f16. Even this small change will produce noticeably different slides, but often the calculated exposure and one or more brackets will produce slides that are acceptable.

You can bracket even further on either side of your indicated exposure if you think your work may not be typical. In the half-stop example described above, you might shoot additional brackets a full stop over—at f8—and a full stop under, at f16. If you're bracketing in thirds of stops, shoot extra frames at ⅔ over—i.e., at ⅔ of the way from f11 to f8—and ⅔ under, at ⅔ of the way from f11 to f16. If you want to save film by eliminating one of these broader brackets, go with ⅔ or one stop over for dark work, ⅔ or one stop under for light work, eliminating the bracket at the other extreme.

Shutter Speed. You can also use variations in shutter speed to bracket exposures. You may opt to do this when you're afraid that using a wider aperture to bracket your exposure might compromise your depth of field. (There's little harm in using a smaller f-stop to bracket on the "underexposure" side, because it can only improve your depth of field.) In the example above, for instance, if you were reluctant to open the lens aperture all the way to f8 to obtain a stop of extra exposure, you could use a one-stop slower shutter speed—½ second instead of ¼—to obtain the same result. If you wanted to bracket a half-stop over without opening the lens aperture to a setting halfway between f8 and f11, you could also change the shutter speed

to ½ second. This in effect increases exposure by a whole stop, so if you close the lens aperture down a half-stop, to between f11 and f16, you reduce the whole stop increase to a half. Newer models that let you set in-between speeds make bracketing with shutter speed changes much easier. You'll just have to get used to the funny numbers—for example, ⅕ and ⅙ second between ¼ and ⅛.

As a rule, shoot as many frames on each bracket as you think you will need final slides. When you become more experienced, and get a sense of what the acceptable exposure range for your work is, you'll make more efficient use of film.

BRACKETING EXPOSURES WITH AN AUTOEXPOSURE-ONLY CAMERA

If you're working in an automatic exposure mode, use the autoexposure compensation control to bracket your exposures. If it's set at 0, bracket in halves or thirds in either direction, by setting the control at +½ or +⅓, +1 or +⅔, –½ or –⅓, and –1 or –⅔. If you've already adjusted the autoexposure compensation control to make the camera's settings match your gray-card reading, use its adjusted position as a starting point. For example, if your autoexposure compensation control is already set at +1, make exposures at +1½ or +1⅓, +2 or +1⅔, then +½ or +⅔, 0 or +⅓.

ISO. If your camera offers no autoexposure compensation control, you can use the film-speed (ISO) control to bracket your exposures. One-third stop brackets can be obtained by increasing the ISO by one notch or number, which will cause the camera to give the film a third-stop less exposure (the equivalent of –⅓ on an autoexposure compensation control), or reducing it by a notch or number, which will cause

the camera to give the film a third-stop more exposure. If you've already adjusted the ISO setting to make the camera's settings match the gray-card reading, use that adjusted ISO as a starting point.

Again, as you become more familiar with the way photographic film records your artwork, you can be more parsimonious in your bracketing. If you find, for instance, that the best slide always seems to be either the one indicated by the gray-card reading, or the one receiving a half-stop less exposure, then you can limit yourself to those two exposures, shooting as many frames on each as you will need slides. This presumes, however, that your work is fairly consistent in tonality.

In the abstract, all this information may seem a bit overwhelming. But it will make much more sense when you're shooting your work, and when you see your first results. You will, however, have to make some initial decisions about film and lights; if you can afford to experiment, do so.

Techniques that relate specifically to different kinds of work are presented in the following two chapters. If your work is two-dimensional, read Chapter Three; if it's three-dimensional, read Chapter Four. You might want to skim the chapter that doesn't pertain to your work, just for the extra insight it may provide. Good luck!

SUMMARY/**SEEING THE LIGHT: THE BASICS**

- In photography, light is described by its color temperature. Daylight has a different color temperature than most artificial light.
- Films are designed (balanced) to be used with a specific color temperature of light. They produce accurate color only in the kind of light they are balanced for.
- Tungsten light and tungsten-balanced slide films are better than natural light for photographing works of art because they offer greater control.
- Tungsten bulbs are available in color temperatures of 3400 degrees Kelvin for Kodachrome and 3200 degrees Kelvin for other tungsten-balanced films like Ektachrome 64T.
- The higher the film's ISO number, the greater its sensitivity to light, or speed.
- Films with low ISO numbers are good for photographing art because they produce a sharp, fine-grained image of the work.
- "Professional" films are designed for critical use, such as photographing artwork, and must be stored in a refrigerator. Allow them to warm up before using them, and return them to the refrigerator if you don't plan to have them processed immediately.
- Ektachrome films can be processed by a professional lab or photofinisher; Kodachrome must be sent to a special processing facility.
- Tungsten photofloods are available in two profiles: a standard, lightbulb-shaped lamp, which must be used with a metal reflector, and a cone-shaped reflector photoflood lamp.
- 500-watt bulbs should be used for all but the smallest artwork. They must be burned conservatively, and a cumulative record kept of how long they're on.
- In a pinch, you can use regular, high-wattage lightbulbs and the "amateur" version of Ektachrome 160T (ET) to photograph your artwork.
- The 81A filter is useful in eliminating the risk of a blue cast in the finished slide.
- All other sources of light must be eliminated when using tungsten light to photograph your artwork.
- A film of a given ISO speed must receive a specific amount of light to produce an acceptable exposure. The shutter speed (length of exposure) and lens aperture (size of the opening) allow you to regulate the light to obtain this quantity.
- The relationship between shutter speed and lens aperture is proportional: a one-stop smaller aperture can be compensated for by using a one-stop slower shutter speed (i.e., an increase in exposure time) to produce the same exposure—and thus the same lightness or darkness in the slide.
- Since a camera's meter assumes that all the tones in an artwork (or any subject) will average out to a specific medium gray, the meter may miscalculate the needed f-stop and shutter speed when the artwork is filling the frame.
- Take the light reading off an 18 percent gray card to give the meter the tone it is calibrated for. This will result in a consistently correct exposure.
- Because it keeps the camera steady, a tripod permits the longer shutter speeds needed to photograph artwork by tungsten light—usually $\frac{1}{15}$ to one second.
- Depth of field—the depth of the zone of sharpness in your photograph—can be increased by using smaller f-stops. (from 8 to 11)
- Because of its greater depth, three-dimensional artwork requires the use of smaller lens apertures than two-dimensional work. The smaller the artwork, the smaller the f-stop you must use to photograph it.
- If an automatic exposure system's averaged light reading of artwork disagrees with the gray-card reading, adjust the camera's autoexposure compensation control, if it has one, to make the settings match.
- The camera's ISO control may also be used as an autoexposure override mechanism. Setting lower numbers than the ISO recommended for the film will increase film exposure; setting higher numbers will reduce exposure.
- When you make your exposures, keep checking the camera's viewfinder to make sure the camera hasn't shifted on its mounting screw.
- Advance the film gently, and allow time for vibrations to subside before exposing the next frame.
- Shoot as many slides at your chosen exposure as you think you will need final slides. Shoot the same number on each exposure bracket.
- Bracket your exposure generously in your first attempts at photographing your work; as you begin to see a pattern in the exposures that are best for your work, you can limit the bracketing range.

If you're a painter who goes to great pains to make your stretchers square, you've probably been disappointed when the slides you've shot of your work represent it as a trapezoid or a rhombus, rather than the rectangle you created. The problem occurs when you don't take care to make the sides of the artwork parallel to the edges of the camera's viewfinder before you take the photograph—and it not only distorts the shape of the work, but distracts from its content, especially if it's strongly graphic. The camera adjustments that correct this condition aren't instinctive, and without them, squaring up the work becomes a trial-and-error chore. If the few simple procedures outlined here are followed, you'll save yourself a lot of aggravation.

SETTING UP

Place your work on a secure surface. If you can't hang a painting on the wall, place it on an easel or a shelf if it's small enough, or rest it on the floor against a wall if it's large. If it's a vertical piece, put it on its side. Works on paper, such as prints and drawings, can be attached to the wall with safe tape on the back of the work, or with pushpins if you can accept their encroachments as part of the presentation of the piece. Just be sure to position the work so that you can operate the camera at a comfortable height. If you're resting the work on the floor or a shelf, angle it up slightly to accomplish this (which you will have to do anyway to make it stand). Make sure there's enough room in front of the piece for the tripod and you—scope it out with the camera if you're uncertain—and to the sides of it for the lights. The larger the work, the more room you'll need both ways.

Positioning the Tripod. Once the artwork is in place, follow these steps to position your camera and tripod. By looking through the camera and fitting the artwork snugly in the viewfinder, determine about how far from the work the tripod should be placed. Set up the tripod there, making sure to extend the legs evenly so that its sliding post is plumb. For greater stability, extend the upper, thicker leg sections of the tripod first, to their fullest position. If you need to extend a portion of the lower sections (rather than the full section), it's easier to do so before spreading the tripod legs, because you can measure each leg against the others for evenness. Lock in each section securely with the locking nut or clamp.

At the same time, extend the sliding post several inches to allow for future lowering adjustments, and lock it in securely. The combined height of the legs and post should place the camera on an imaginary line running out from the center of the artwork and perpendicular to it.

Camera Angle. Mount the camera on the tripod head, so that it is parallel to the side lever and at a right angle to the forward-backward tilt of the head. Be sure that the camera is secure enough so that it won't twist on the mounting screw when you advance the film.

If the artwork is leaning back against a wall, use the tripod's rear adjusting arm to incline the camera forward at approximately the same angle. If the work is on a vertical wall, adjust the camera to a vertical position. A carpenter's angle finder or a bubble level is useful for these adjustments. The level should have a bubble tube running at a right angle to the length of the level itself. (If the tilt of the artwork is

steep, however, a level may not be reliable.) Place the level or angle finder against the surface of the artwork, and note the position of the bubble or needle. Then place it flat against the camera back, or if protrusions interfere, against the end of the lens barrel. Then adjust the camera's tilt until the bubble or needle matches its position when against the artwork.

Viewfinder Fit. Finally, adjust your distance from the work by moving the whole tripod forward or backward. Refocus the lens as you do, because focus can have a small effect on the size of the viewfinder image of the artwork. If your camera offers autofocus, don't use it; set it to manual focus instead.

The artwork should fill the viewfinder frame, but because a slide mount (and usually a commercial color or black-and-white print) will crop out a small amount of the image area on all sides, leave a small margin, perhaps 5 percent of each dimension. (See box on page 43.) Remember to adjust for any discrepancies between your viewfinder and what ends up on film, as discussed earlier. This will vary from camera to camera. If your camera shifts the image to the right, frame up your work off-center a like amount to the left, and maintain it in this position as you square the work up. If your viewfinder shows you a lot less than you will get on film, allow less space between the edges of the artwork and the sides of the viewfinder.

SQUARING UP

The procedure of squaring up your artwork is in essence a way of making sure that the film is parallel to the surface of the artwork when you photograph it. That parallelism is the best insurance against distor-

CAMERA ANGLE

If the artwork is leaning back against a wall, use the tripod's rear adjusting arm to incline the camera forward at the same angle. Use a bubble level or carpenter's angle finder, if necessary, to adjust the camera so that the film is exactly parallel to the artwork.

tion. Although you haven't set up your lights yet, you may want to turn them on your artwork so you'll have a bright viewfinder image to work with.

As you look through the camera, you'll probably see that the image of the artwork is skewed. Examine it carefully, using the edges of the viewfinder as a reference. *If the artwork is narrower at the top than the bottom* — that is, if the sides taper toward the top — unlock the rear tripod arm and tilt the camera forward until the right and left sides seem parallel to the sides of the viewfinder, then lock the tilt in place with the arm or its separate locking nut. This adjustment, which in effect enlarges the top edge of the work, will begin to crop into the top edge and bring the bottom edge

well into the frame. In order to correct this, loosen the center column and raise it, keeping the work centered, until you've brought the top edge back into the viewfinder. Raise it until the artwork is centered again, then lock it in place.

If the artwork is narrower at the bottom than at the top, tilt the camera backward until the sides are parallel. (Basic geometry: in a rectangle, if the left and right sides are parallel, the length of the top and bottom will be the same.) This will cause the work to drop in the viewfinder, so loosen the column and lower it to re-center the work. This is why you need to extend the column initially, because if you try to lower the camera by shortening the tripod legs, you will probably undo your hard-won parallelism.

Apply the same technique if the top and bottom of the work converge to either side. If they converge to the right — that is, the right side of the work appears shorter than the left — loosen the head-locking nut and rotate the camera to the left until they are parallel. (Do not loosen the column to rotate the tripod head.) The image of the artwork will then shift to the right in the viewfinder frame, and you will have to move the whole tripod very carefully to the right so as not to disrupt the parallelism of the top and bottom of the work.

If the top and bottom of the artwork converge to the left — that is, if the left side appears shorter than the right — rotate the camera to the right until they are parallel, then shift the tripod to the left to center

FRAMING UP YOUR WORK: THE FINER POINTS

Unless you're a photorealist whose work conforms to the 2:3 proportions of a 35mm camera's image, your painting, print, or other work will rarely fit precisely into the viewfinder. In fact, the more square the piece is, the more studio clutter or spackled wallboard will end up in the frame. There are two solutions to this problem. One is to cover the wall behind the piece with black paper or cloth; black velvet, velour, or similar materials are best for this purpose because they are so nonreflective. (See "Useful Accessories," page 122.) But a better solution is to block out the offending areas on the finished slide itself with a special slide-masking tape, which will be described in Chapter Seven. Likewise, a photographic print can be cropped by a lab or trimmed at a later stage.

- *Edge Details.* In photographing a work on paper, it may be important to you to show the edge of the sheet, especially if it's a watercolor or print with a deckle. In this case, you should back the work with a contrasting material, dark if the work is light in tone, light if it's dark. If the proportions of your work are such that this leaves large areas of the material to either side of the piece, you can mask the slide with tape to match the margin at the long edges of the opening in the slide, where the edge of the work comes closest.

 Any time you want the edges of a work to be visible, or if you want a white border in a slide of a matted work to show that it's matted, leave a little extra room around it when you size it up in the viewfinder. In any and all cases, be sure the artwork is centered in the viewfinder, with equal amounts of space on either side. (If your camera shifts the image to the side, however, you will need to compensate for this by framing the work off-center.) Inconsistently off-center slides can be disconcerting when projected, because the image jumps back and forth on the screen.

- *Dark Work.* The squaring-up procedure described here assumes that your artwork is reasonably square, and depends on your being able to discern clearly the edges of the work. Even if you've thrown a lot of light on the work, if its tones are predominantly dark and you've backed it with black paper or cloth, you may have trouble seeing the edges. To make it easier to spot them, put sheets of white paper behind or abutting the work, and remove them when you're ready to shoot. Or simply wait until you're about to shoot and slip your black cloth or paper behind the piece. In either case, be very careful not to disturb the position of the piece.

- *Light Work.* If a work is very light in tone and you're photographing it against a light wall (and intend to mask the slide), you may find it easier to discern the edges if you slip a few sheets of black paper behind the piece. Don't forget to remove them when you're ready to shoot!

the work in the frame again.

If shifting the tripod laterally disrupts the parallelism of the top and bottom of the work, repeat the squaring procedure in the new position. Alternate this technique for the sides and then the top and bottom, and repeat it until the work is square and centered.

If the sides or the top and bottom of your artwork appear parallel but "lean" one way or the other, loosen the side arm of the tripod head and tilt the camera sideways to correct it. This may reveal that the edges of the work aren't really parallel to the sides of the viewfinder, so repeat the squaring procedure again. Manipulate the side tilt frequently as you square up, using the edge of the viewfinder frame as a reference. You can also match your side tilt to the artwork with a bubble level placed on the top of the work and camera, if the camera has a flat portion to rest it on.

If your camera is tilted, rather than level—that is, if the artwork is leaning back against the wall—it's better to make any small rotational adjustments by loosening the tripod's mounting screw and twisting the camera on it. Rotating the tripod head itself will not maintain the proper orientation of film plane to subject plane. However, rotating the camera on the platform changes its relationship to the side tilt and forward-backward tilt levers, which could complicate further squaring-up procedures. So make an effort to center the camera laterally early in the process.

Squaring up takes practice, and even an experienced person can get bogged down and frustrated. If the procedure is going nowhere, kick the tripod out of whack (not out of frustration) and start fresh.

If Your Work Isn't Square. If your artwork isn't square nor meant to be—if it's a circle or a triangle or an

Right.

Wrong.

amoeba shape—the technique described above obviously can't be used. In this event, you should square up on a rectangular work of the same size and simply replace it with the odd-shaped work, making sure that the latter is in the same plane and position as its proxy. If a rectangular work isn't available, cut a rectangular piece of cardboard or paper with the same approximate dimensions (circumference, in the case of a circular work) and square up on it. This is the only way to be sure that the shape of the work in the photograph will exactly match the original.

LENSES AND TWO-DIMENSIONAL WORK

Squaring up can be somewhat easier with a "longer" focal length lens, such as a 90mm or 105mm telephoto. But even if you have access to such a lens, you may be constrained from using it by the size of the space you're working in. Like a telescope, a long lens has a relatively narrow angle of view, which requires that you be farther from the work to fit it into the camera's viewfinder. If your space is small, if your work is large, or both, you may not be able to use it. What's more, the closest focusing distance of a long lens may place you too far away from a small artwork to fill the frame with it.

Some newer zoom lenses offer a "macro" mode that allows you to focus quite closely. Such lenses are a viable alternative to macro lenses and close-up attachments, and you may find them indispensible if your work is small. It's especially important, though, to select smaller lens apertures if you are using a long lens or a zoom set to macro mode to shoot small work. Refer to the section on "Photographing Small Artwork," page 96, for further information.

WIDE-ANGLE LENSES

On the other extreme, if your work is very large relative to your working space, you may find that the standard 50mm or 55mm lens doesn't encompass its entire surface even when your tripod's against the far wall. In this case, you either have to relocate to a larger space, or use a slightly wide-angle lens such as a 35mm, which will allow you to include more of the work from the same distance. ("35mm" here is a reference to the lens' focal length, not to the 35mm film format of the camera itself.)

The price of this approach is that any lack of squareness is much more pronounced. With even wider-angle lenses such as 28 or 24mm, the center of the work may appear to bulge. Wide-angle lenses make squaring up the work much more difficult; avoid using them if at all possible. The fixed focal-length lenses on many point-and-shoot cameras are moderately wide-angle, usually from 35 to 40mm in focal length. They will therefore distort the work to some extent, although not as badly as the image in the viewfinder might suggest.

You can minimize the distortion caused by a wide-angle lens, if that's all you have to work with, by moving farther away from the work. But this will, of course, reduce the size of the work on the film. If you're shooting slides, this is probably unacceptable; if you're shooting film for the sole purpose of making prints, you can have a custom lab enlarge and crop the image to size, or have a commercial photofinisher make a print a size larger than you need, then trim it.

A zoom lens of moderately wide-angle to medium-telephoto range—for example, 28-85mm or 35-70mm—may bail you out in the kind of tight shooting situation that a 50mm lens is too "long" for. Set-

SQUARING UP: A VISUAL GUIDE

If the artwork converges toward the top,

tilt the camera forward until the sides are parallel.

Then raise the column to center the work.

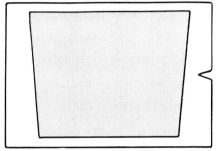

If the artwork converges toward the bottom,

tilt the camera backward until the sides are parallel.

Then lower the column to center the work.

If the artwork converges toward the right,

rotate the camera to the left until the top and bottom are parallel.

Then move the tripod to the right to center the work.

If the artwork converges toward the left,

rotate the camera to the right until the top and bottom are parallel.

Then move the tripod to the left to center the work.

ting it in the 40-odd-mm range will allow you to include more of the work without the distortion likely from a 35mm lens, which is the nearest wide-angle alternative in a lens of fixed focal length. Always use the lens at its longest possible setting to minimize distortion; in other words, get as far away from the artwork as possible, then adjust the zoom setting to make the artwork fill the frame. If space allows, use such a lens at its 50mm setting.

SHOOTING MORE THAN ONE WORK

If you're shooting more than one artwork in a session, and if the pieces are of similar size, you can expedite the framing and squaring-up procedure by using pieces of masking tape on the floor or walls as register marks. If you're leaning a painting against a wall, for example, put an "L" of masking tape at the lower corners; if you've hung or taped the work on the wall, put tape marks at all corners. Even if the succeeding pieces aren't the same width, these marks will help you center them, and if they're about the same height as the first, placing each artwork's bottom edge the same distance from the wall will maintain the same angle, eliminating the need to square up again.

SHOOTING DETAILS

An overall view of an artwork can fail to convey its full richness, especially if the image is never projected or enlarged. If your work is large and/or complex, or if it has distinctive surface characteristics, consider shooting details of it to supplement the overall view. If you're not using a macro lens, or a zoom lens with a "macro" mode, shooting details often requires the use of close-up attachments. Read about "Photographing Small Artwork," page 96, for more information.

Because depth of field is reduced at the close distances involved in shooting details, you should use smaller lens f-stops. This will in turn require the use of slower shutter speeds to obtain equivalent exposure. If you boost the light levels, however, you may be able to use smaller apertures without any changing shutter speeds. (Lights can be moved closer to the work for details.) Anytime you change the light, whether to brighten the artwork or alter the light's character and direction to suit a specific detail, you will have to take a new meter reading and change your camera's settings accordingly.

LIGHTING TWO-DIMENSIONAL WORK

In photographing three-dimensional artwork, light has a descriptive function, defining surfaces and contours by causing the work to cast shadows on itself. By contrast, the primary function of lighting in photographing two-dimensional work is simply to ensure that the entire surface of the work receives the same amount of light, so that its tones and colors are reproduced in their true relationships.

If your work is heavily textured or impastoed, or includes areas of relief, you may want to light it as if it were sculptural—that is, by using a single diffused source of light and reflectors to fill in shadows. Unfortunately, it is much harder to obtain even light across a broad surface using this technique, and you run the risk of glare if you try to compensate for unevenness by moving the light so that it strikes the work at a more direct angle. You'll have to assess the trade-off in terms of the character of your specific work. If you opt for the standard treatment described here, using direct light on either side of the work, be on the lookout for distracting double shadows. These can, if necessary, be softened by diffusing or bouncing

both light sources, as described in the section on lighting three-dimensional work in Chapter Four.

SETTING UP THE LIGHTS

For work of moderate to small size, two bulbs of the 500-watt varieties described in Chapter Two are usually adequate. For large work, you may want to consider the use of four lamps, two on either side of the work in low and high positions. If your work is large and you only have two bulbs, place them far enough away so that the light will fall evenly across the surface of the work. The disadvantage to this is that the intensity of the light drops off geometrically as you back the lamps away, requiring longer exposures (slower shutter speeds) and in some circumstances even the use of unacceptably wide lens apertures. A faster film, such as Kodak's Ektachrome 160T, will make more efficient use of such lowered light levels.

Placing the Lights. Once you've set up your tripod, camera and artwork, it's easy to establish proper position for your lights. In essence, you want to light flat work at an angle from both sides. If you're using a single light on either side, each should be placed at a height corresponding to a point midway up the artwork. If the work is leaning back, then keep the lights at the level of the plane formed by the horizontal midline of the artwork and the camera position, angling them down slightly. If you're using two lamps on either side of the work, place the high ones at a level corresponding to a quarter of the way down from the top of the work, or higher, the low ones at a level corresponding to a quarter of the way up from the bottom of the work, or lower. The risk in using two lamps on either side is that you'll get a "hot" area in the horizontal center of the work, so you may find your-

self raising or angling the upper bulbs up and lowering or angling the lower bulbs down a bit to avoid this.

Unless you've purchased photographic light stands, described in the "Useful Accessories" appendix on page 122, you'll have to improvise when it comes to securing your clip-on light fixtures. A painter's ladder can be used, as long as it's high enough; the back of a tall chair will suffice if the work is placed fairly low. Don't try to make up for placing a lamp at an incorrect height by angling it up or down. You'll risk uneven light.

Preventing Flare. As a general rule, keep the lights in about the same plane as the camera—in other words, as far from the plane of the work (i.e., the wall you're working against) as the camera and tripod. If you place them too far forward of the camera, direct light may strike the camera lens, causing *flare,* a fogging or veiling of the image. If you look back into the lens as you position your lights, you will be able to see any light falling directly across the lens surface.

If you feel you must place the lights forward of the camera, perhaps to maximize their effect on a larger work that has forced you to place the camera far away from it, you can prevent flare by *baffling* the lens. This may be done by taping small black cards to either side of the lens barrel, so that they extend far enough out from the front of the lens to block the light falling across its front element, or by setting up larger cards to either side of the camera, between it and the lights.

A *lens hood,* a rubber or metal shade made for your specific lens, will also give you more flexibility in placing your lights. Independent manufacturers make clip-on or screw-in lens attachments for holding square gelatin filters, which usually have "barn door" flaps on

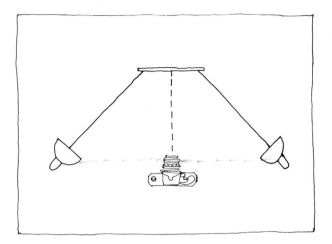

LIGHTING SETUP

The angle and aim point of the lights can be varied to suit individual artworks, as described in the text. But be sure the lights aren't at such a steep angle that they cause glare on the sides of the work, or at such a shallow angle that the light is uneven. In general, lights should not be placed at an angle greater than 45 degrees from the plane of the work.

either side to cut out stray light. However you deal with this problem, be sure that your baffle doesn't intrude into the picture area. Many macro lenses are designed with the front element considerably recessed, so that the lens barrel itself acts as a shade.

Preventing Glare. The other general rule to placing your lights is to make sure the angle formed by the lights and the plane of the work (i.e., the wall, if you're shooting the work against one) is no greater than 45 degrees. If you place the lights closer to the camera position, so that they strike the work more directly, you may cause glare on the sides of the work.

With these general principles in mind, position one of the lights. Then, using your foot as a ruler, measure the distance between the light and the camera. Place the other light at the same distance from the camera, and at the same distance from the wall or the plane of the work. If the angle of the lights is relatively steep—that is, close to

Lens hood.

Filter holder attachment with "barn doors."

45 degrees—aim the lamps at the near side or center of the work. If the lights are closer to the plane of the work, striking it at a more oblique angle, aim them at the far edge of the work, to reduce the likelihood of having too much light on its sides.

Turn the lights on, and look through the camera. If any sign of glare is apparent on the sides of the work, move the lights closer to the wall, or to the plane formed by the work, so that they strike the work more obliquely. Don't make the angle any more extreme than necessary to eliminate the glare, because you may run the risk of uneven light—specifically, of not enough light reaching the vertical center of the work. To get a better sense of the angle at which glare begins to occur, stand right behind the camera with your eyes at the film plane, then move slowly from side to side as you look at the side of the work opposite the direction you're moving.

Covering Up. If there are any reflective or brightly colored surfaces near the work, it's advisable to cover them with cloth or paper of neutral tone, preferably gray or black. Depending on their angle relative to the lights and the artwork, they can contribute a color cast to parts of the work. If you are shooting a large work which is resting on a polyurethaned wooden floor, for example, light reflected off the floor may give the bottom of the painting an orangy or yellow cast. Using black cloth to cover the floor, on the other hand, may drink up some of the light available to the work, so do any such covering before you begin to light the work, so that you can compensate for its effects on the evenness of the light.

If you follow the suggestions described above, the light falling across your artwork should be quite even. If your work is on the small side, and your lights at a fair distance from it—you don't want them much closer than five feet anyway—the lighting probably won't even need further adjustment. But if your work is at least a couple of feet square, you'll probably have to fine tune the lighting to make it even, using your camera's built-in meter and the gray card described in Chapter Two.

METERING FOR EVENNESS

Be sure your camera is set to the proper ISO, or film speed. If you are following the recommendations for slide film made earlier, this will be 40, 64, or 160. (If you're shooting black-and-white or color print film, the ISO will probably be 125 or 100, and with some brands, 50 or 25—although these speeds may be altered slightly to achieve better negative quality, as explained in the section "Shooting Negative Film," page 102.)

With the lights on the work, and all other lights off or blocked out, place the gray card, gray side out, against the middle of the work. If you have three hands, hold the card; if not, try to secure it in some way. If you can recruit someone to hold it for you, be sure he or she doesn't cast a shadow on it. Make sure the card lies in the same plane as the work; if it's at an angle it can throw off your readings, especially if it picks up glare from your lights.

Carefully unscrew your camera from the tripod, so as not to disturb the tripod's position. (Because you have to remove the camera to take the readings, then replace it when you're done, you may want to put off fine tuning the squareness of the artwork until after you've metered the light for evenness.) Fill the camera viewfinder with the gray card, but don't get so close that you

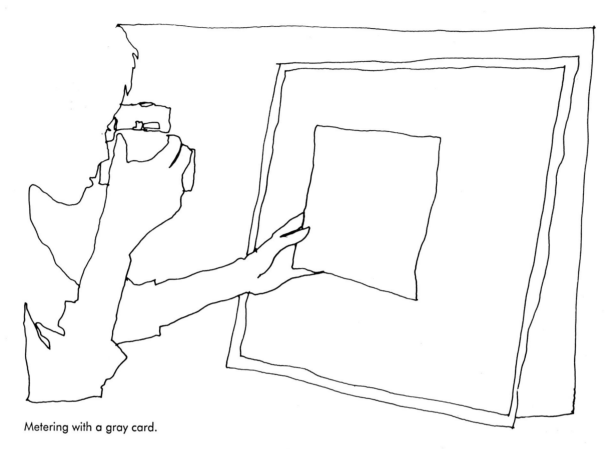

Metering with a gray card.

cast a shadow on it. There's no need to focus the camera on the card; in fact, it's best to have the focus set roughly to where it will be when you take the picture.

The combination of shutter speed and aperture that you use as the basis for evening the light needn't be the same as the combination you use in actually exposing the film. In this operation, you're simply using the camera's light meter as a measuring tool to aid in adjusting the lights. But just to avoid confusion, refer to Chapter Two, page 33, to refresh your memory about the best combinations of aperture and shutter speed for your work, and use these values as the basis for making your lighting even.

METERING IN MANUAL EXPOSURE MODE

If you're using your camera in a manual exposure mode (as you should be if you have that option),

set the lens aperture to the f-stop that seems most appropriate for your particular artwork. Then adjust the shutter speed until the camera's viewfinder or LCD panel symbols indicate the correct exposure. If an in-between shutter speed seems to be required, and your camera only offers whole speeds, set the longer speed and then stop the lens aperture down (that is, set a higher number) to obtain the proper signals. Be sure the gray card completely fills the viewfinder as you make these adjustments.

The object at this point is to take individual readings with the card placed in different areas of the work, and compare them to the reading you get at the center of the work. If you're shooting a medium-sized work — say, in the two- or three-foot square range — take readings at the four corners of the

work as well as the center. If your work is larger, you should probably take additional readings in the middle of the right and left sides and in the middle of the top and bottom. When in doubt, take more readings rather than fewer.

Let's say your work is large. Leaving the camera set to the aperture and shutter speed indicated by your central reading, take your gray card and place it against the work in the middle of the left side. Fill the camera viewfinder with it again, and check your viewfinder or LCD panel symbols. If they indicate overexposure (usually symbolized by a plus sign), your light is brighter on that side than in the middle of the work, and needs to be reduced there.

To accomplish this, first try pointing the light toward the opposite edge of the work. Take another reading. If the meter still indicates

overexposure, move the light farther away from the work until a "correct exposure" signal is obtained. Then double-check the center reading to see if it has fallen into the "underexposure" range. If it has, you may need to move the light out slightly so that it strikes the work more directly, and thus gets more light into the middle of the work. (Be watchful for glare if you do this.) As a last resort, try aiming the light *beyond* the far edge of the work, to take advantage of its natural fall-off in intensity.

Repeat the process each time you take a new reading in a different area of the work. If the readings you get at the corners or center top and bottom are off, you may need to point the lights up or down to direct more or less light at those portions of the work. For example, if the reading at the upper-right corner of the work indicates underexposure (usually represented by a minus sign), aim the right-hand light higher. If readings along the entire top edge of the work indicate underexposure, aim both lights higher; if they indicate overexposure, aim both lights lower. You may also need to change the height of the lights — raise or lower them — to make their coverage more even.

Any such changes may also affect the overall light level and the gray card reading you get in the center of the work, so keep taking new readings there, resetting your aperture if need be. Your ultimate objective is to get the gray-card readings off all parts of the work as close as possible. To sum up, move the lights closer to add light when underexposure is indicated; move them farther away to subtract light when overexposure is indicated. Re-aim the lights or adjust their height when the readings at the top or bottom of the work disagree with the central reading. If all the fiddling

in the world doesn't seem to produce even light, the lights may be too close, so back them both off and start again.

If you're using two lights on either side of the work, you'll probably have to adjust them individually. Increase the vertical separation of each pair, or aim them at more of an angle away from each other, if the illumination in the horizontal center of the work is too bright.

METERING WITH AN AUTOEXPOSURE SYSTEM

If your camera offers no manual exposure control, to obtain even lighting you'll have to interpret the settings it selects and displays in the viewfinder. Shutter-priority is the easiest autoexposure system to work with. Once you've set the shutter speed, the camera will select an aperture when you present the gray card to it.

Say the camera indicates an aperture of f11 when you take your first reading in the center of the work. If, when you take a reading on the side or in a corner, it indicates a setting between f11 and f16, a smaller aperture, this means that there's more light there than in the center. (That's why the camera has decided that a smaller aperture is needed for proper film exposure.) You therefore need to reduce the light falling on that part of the artwork to make it match the central reading, by re-aiming and/or moving the lights away or out until the two readings agree.

If a reading indicates a larger aperture than f11 — f8, for example — this tells you that less light is falling on that portion of the work than on its center (something the camera is trying to compensate for by selecting a wider aperture), and that you need to boost it. To put it simply, *a smaller aperture than that indicated by your central reading is an indication of too much light, a larger aperture an indication of too little light.*

Aperture-Priority. An aperture-priority automatic exposure system is often harder to use in metering light in this way. Even cameras that offer stepless shutter speeds — that is, continuously variable in-between speeds, in addition to the usual $\frac{1}{125}$, $\frac{1}{60}$, etc. — don't indicate these exact speeds in the viewfinder or external LCD display. Rather, the display jumps back and forth between the official, whole-step geometric speeds, making the measurement of light levels across the surface of your work a much more approximate business. But the same technique can be applied.

Preset your aperture to f8 or f11 (for example), look to see what shutter speed the central gray-card reading indicates, then try to match that shutter speed at the other points at which you take your readings. If a slower shutter speed is indicated at those other points — $\frac{1}{4}$ instead of $\frac{1}{8}$ second, for example — it means that less light is present, so you must increase it by adjusting your lights. If a faster shutter speed is indicated — $\frac{1}{15}$ instead of $\frac{1}{8}$ second — it means that more light is present, and you should decrease its level.

Exposing the Film. Once you've made the light even, you're ready to shoot. Review the section at the end of Chapter Two if you're uncertain about the details of exposing film. This section also explains how to override automatic exposure systems to obtain correct exposure, and how to bracket your exposure so that you have several slides of varying lightness or darkness to choose from.

You should, of course, use your gray-card reading as a starting point. Make sure you hold the card flat against the center of the artwork to take the final reading. Make as many exposures on each bracket

THE COPY STAND

If your work is small, and you expect to be making slides of it regularly, you should think about purchasing a *copy stand*. A copy stand is a stable platform with a vertical rail attached at the back; you mount your camera, lens down, on the end of a horizontal bar that's connected to the rail. The bar can be moved up or down the rail to adjust for different-sized artwork, which you place on the copy stand's *baseboard*. (Most copy stands won't accommodate work much larger than about 18" × 24" if you're using a 50mm lens.) The copy stand simplifies the squaring-up procedure greatly, because if it is well made, the camera and artwork will always be parallel to each other in the front-to-back plane. Use a bubble level to make sure they are parallel in the side-to-side plane.

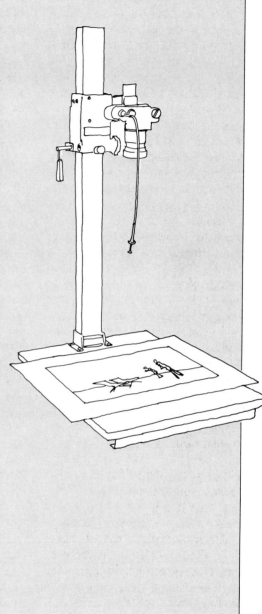

- *Leveling the Camera.* Place the level on the baseboard of the copy stand, so that it runs from side to side. Note the position of the bubble. Then place the level on the back of the camera, making sure no protrusions prevent it from being parallel to the film plane. (If this isn't possible, then hold the level against the front rim of the lens instead.) Loosen the camera-mounting screw a little, and twist the camera on it until the bubble's position matches its location when on the baseboard. Make sure you don't cause the camera to shift as you tighten the screw.

 Once you've leveled the camera, all you need to do is adjust its height and focus. Move the artwork itself to center it in the viewfinder. Masking tape can be used to make register marks on the baseboard of the copy stand if you're shooting a number of like-sized works. If for some reason (more than likely, poor construction) the baseboard and camera aren't parallel in the front-to-back axis, you can always put the artwork on a rigid board, and place shims between that board and the copy stand's baseboard at bottom or top to match the camera's orientation.

- *Lighting.* Lighting artwork on a copy stand is much the same as lighting vertical flat artwork, except that the lights will be pointed down at the baseboard from either side. Many copy stands may even have lights attached to stalks that extend from the sides of the baseboard, but these tend to put the lights rather close to the work, and limit the size of work you can photograph to the width of the baseboard itself. All the information in this chapter about lighting angles, distances, making the light even, and exposing film is applicable to shooting work on a copy stand. If your work is quite small, the information in Chapter Seven is also applicable.

as you will need final slides, and be sure to let the camera "settle" between exposures.

Finally, you can always reshoot, for minimal cost, if your first results are unsatisfactory. Before doing so, however, refer to Chapter Six, "Evaluating Your Results," for help in diagnosing the problem.

VARIATIONS ON TWO-DIMENSIONAL WORK

Although you should know enough by now to photograph most two-dimensional work, the muse—or more ordinary forces—may create a need for the special techniques presented here. These techniques are essential if your work is either reflective or translucent, or if you must photograph it under glass.

WORK UNDER GLASS

On occasion, you may have to shoot a print or a work on paper in a glassed frame. Any reflections on the glass will be far more noticeable in the slide or print than on a gallery wall, where a viewer can pay selective attention to the artwork underneath the reflections. While a very light piece may play down reflections on the glass, dark artwork is a particular problem because it turns the glass into a virtual mirror, reflecting you, your tripod, and anything else in the room.

One way to minimize this effect is to reduce the light falling on you and your tripod. You can do this by setting up dark cards or curtains between you and the lights, or using a long lens so that your camera position will be well behind the plane of the lights. Use of the second technique may require baffling between your lights and you anyway, because of the increased risk of light entering the camera lens and causing flare.

THE BAFFLING SOLUTION

The only really safe way of eliminating reflections on a glassed artwork is to baffle the tripod, the camera, and anything else that happens to fall within the angle of reflection of the work, including yourself. You can do this with a large piece or pieces of black poster board or matboard, or black cloth that can be hung from the ceiling.

If you use a black card, you'll have to cut a hole in the middle of it to poke the lens through. Use the rim of the lens as a template for the hole by placing it against the middle of the board and outlining it. Don't make the hole any larger than it needs to be, or else some of the metal parts of the camera may show through and be reflected by the glass on the artwork. If the hole is cut fairly precisely, so that it fits the lens snugly, and the board is reasonably stiff and not too large, the lens will actually support it, sparing you the need to hold it or otherwise support it with tape or rods. You can even attach it to the lens with tape (black photographic tape if on the front), but be sure to focus the lens before doing so, and be careful not to move the focusing ring when you do attach it.

If you use black cloth, cut a slit in it to slip the lens through. Because of its lack of rigidity, a cloth baffle will have to be suspended, either from the ceiling or a rod or bar above the camera. A wooden dowel running between two ladders, one on either side of the camera, is an inexpensive option. You may have to support a large or flimsy piece of cardboard or posterboard in a similar way.

More Is Less. The size of the card or piece of cloth needed for the task depends on the size of the artwork. The larger the area of a glassed work, the more of its surroundings it will reflect—and the larger the card or cloth must be. The baffle almost always needs to be larger than you think it does, so be generous with whatever material you are using.

The best way to determine the size you need is to look through the camera, or stand directly behind it with your eyes just above it, and extend your arms to either side, waving your hands. (Use a stick if your arms aren't long enough.) Observe their reflection, and note where it passes out of the image area of the work. If all but your hand is reflected in the glass, the card has to be at least as wide as your armspan, wrist to wrist. Very large works may require cards or cloth larger than what's available, so you may have to set up additional cards or curtains to either side of your main baffle.

Once you've set up the baffling cards, look through the viewfinder to see if they block out the entire reflection. Even a small fragment of the original reflection—a tripod leg or an errant piece of masking tape—can be very distracting if it's in the wrong place. Cover any such offending areas with black tape, cloth or paper. With some setups, your baffling materials may absorb a small amount of the light illuminating the work, so be sure to bracket your exposures on the "over" side.

As you shoot your pictures, be sure the reflection-baffling rig doesn't jar the camera during the exposure—a particular risk if you must hold the baffle. It's better to secure the baffle to eliminate this as a possible cause of lack of sharpness in your photographs.

Filters Aren't the Answer. Artists having a little familiarity with photographic technique may be under the impression that a polarizing filter can be used to eliminate reflections on glass. This filter, described more fully in Chapter Nine, will eliminate or minimize reflections when they are at a fairly steep angle

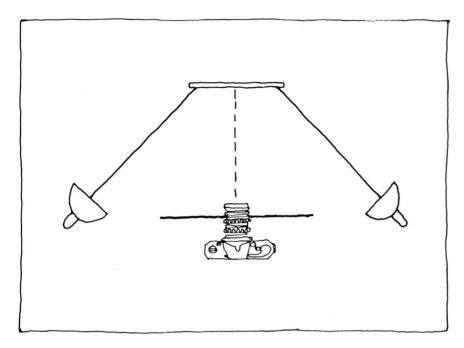

WORK UNDER GLASS

A large black card with a hole cut to size in the middle to poke the lens through will eliminate reflections on a glassed work. To *create* reflections off shiny materials in an artwork, substitute a white card.

to the camera and reflective surface. But it won't eliminate the sort of direct reflection that occurs when you photograph a glassed artwork.

REFLECTIVE MATERIALS IN FLAT ARTWORK

If your artwork contains reflective materials such as foil, gold leaf, pieces of mirror or metal, glitter or sequins, you may find that lighting it from the sides doesn't produce the kind of shininess you'd like. Oddly enough, the solution to this problem is quite similar to that for eliminating reflections in glass. Simply substitute a white card or sheet for the black one, cutting a hole in it for the lens, as described previously. The white surface (which is, in effect, bounce-lighted by the light reflected off the work itself) will give the shiny materials something to reflect.

LARGE WORK

If your work is large, you may be so far away from it that a white card or sheet used in this way doesn't reflect enough light back to the piece. If this is the case, you may

need to throw some extra light on the white surface with a third or fourth bulb (fifth or sixth, if you're lighting the work with two lamps on either side). A regular non-photoflood lightbulb is OK to use for this purpose, as long as it doesn't contribute a significant part of the light falling on the work. Just be very sure that none of the added light enters the camera lens, and that it doesn't create unwanted glare on the surface of the work.

Using bounce light such as this is a relatively safe way of creating reflections in the work, but sometimes even turning on an ordinary household bulb close to your camera position will produce enough reflection on the shiny portions of the work. A 100-watt bulb is usually too dim to cause glare problems.

STAINED GLASS

Stained glass is perhaps the trickiest kind of two-dimensional artwork to photograph, because it must be *transilluminated* — lighted from behind. Never shine a light di-

rectly through a stained glass window to photograph it. Even if the window is opaque enough to diffuse the light, doing so will not produce an even result.

To shoot stained glass that's not installed, you will need to find a way to support it that allows for a clear, unobstructed area behind the work. If the piece is mounted in a wooden frame, you may be able to stand it on the far edge of a table. Alternatively, you can support it with guy wires to the ceiling or walls, or a sturdy length of dowel, lattice, or strapping across the top. (This support system can be masked out in the finished slide.) You must leave enough room around the work not only to shoot it from the front, but to light it evenly from the back, as described below.

BACKLIGHTING WITH A DIFFUSION SCRIM

The easiest way to light stained glass is by placing a sheet of diffusion material behind it, then illuminating the material from the back. White plastic garbage bags, translu-

VIDEO

A still photograph can only represent a moment in a videotape. But it may be useful to support other materials, and to serve as a "reminder" to anyone considering your work. It also may be necessary to provide slides of a videotape for use in a catalogue.

As simple as it may seem, you must keep a number of things in mind when photographing a television screen or video monitor—most of them relating to its characteristics as a light source for its own imagery. First of all, use daylight, not tungsten film. It will produce more accurate color, although your result may still appear somewhat blue-green, a color combination called cyan in photography. Use of a relatively strong (CC 30 or 40) red filter over the camera lens will eliminate this cast, but knowledgeable videographers may be able to adjust the monitor's color balance to accomplish this. Black-and-white televisions tend to photograph very blue/cyan, and may require heavy yellow filtration to record as a neutral gray on film.

Also, eliminate any strong ambient light sources, to prevent reflections on the surface of the screen. (For the same reason, don't ever use flash to photograph a TV screen.) And if the "frame" you've chosen to photograph has bright highlights and deep low values, it may reproduce better if you reduce the monitor's contrast. Video images appear higher in contrast in a photograph than when actually viewed. Because of this, you should also adjust the brightness control so that detail is visible in both light and dark areas.

You will need a tripod to photograph off a TV monitor, both to maintain squareness and to permit the use of slower shutter speeds. Because the shape of the screen is a rectangle with bowed sides, you can "square" it up reasonably well with the method described in the "Squaring Up" section, page 40. Essentially, you want the camera to be lined up with the center of the screen, to avoid distortion of its shape. Keep the room lights on when you set up your camera so that you can use the frame of the TV itself as a reference. Make the screen fill the viewfinder, but leave enough room around it so that its curved sides won't be cropped by the slide mount. When a video image is reduced to 35mm size, the shape of the screen is important in indicating that the image is from a videotape. Smaller TV/monitor screens may require the use of close-up attachments if the closest focusing distance of your lens won't let you fill the viewfinder with the screen. Don't get too far away from the monitor; not only will the slide be less dramatic, but the camera's meter may be thrown off by the large dark area surrounding the screen.

Take your meter reading directly off the screen to determine your starting exposure. (If you're using a color-correcting filter in front of the lens, the camera's meter should put you in the ballpark, provided the video image has a variety of colors.) When you take the reading, try to crop out as much of the surrounding dark area as possible, and include as much of the screen as you can. An automatic exposure system will change its reading when you frame up the monitor with the dark areas surrounding it, so you will have to override it with the autoexposure compensation control or ISO dial, or lock in the previous settings if the camera has a provision for doing so. To make the camera accept the previous settings with the autoexposure compensation control or ISO dial, use the technique described in Chapters Two and Three for making an automatic exposure system's averaged reading match the settings indicated by the gray-card reading.

Use of shutter speeds much faster than ⅛ second can result in the appearance of dark bands in a photograph of a videotape image. Such slow speeds may be insufficient, however, to freeze movement in the tape, either in the subject or from one shot to the next. Freeze-framing can solve this problem, but it may cause other kinds of distortion. Experiment to determine how fast a shutter speed you can use while still maintaining acceptable image quality. If there's no time for this, make a number of exposures at different shutter speeds from ⅛ to ⅓₀ second, bracketing your exposures with lens aperture changes at each speed. Even if you've established a good shutter speed, because of the variable nature of video imagery, it's important to bracket your exposures heavily.

cent shower curtains, and the like can be used, provided they have no visible texture or color. White bed sheets aren't as good because they transmit light less readily and may show their texture through transparent glass if close enough to the back of the piece. They will also require much longer exposures.

Commercial diffusion films that are ideally suited to this purpose are sold by professional photography stores in sheets and rolls. Tracing vellum can even be used if you are careful not to get the lights too close to it. Be sure any material you purchase or use is wide enough to fill the entire glass area from your camera position. Scope out the piece with your camera, if you haven't already set it up, to determine this.

Use as many bulbs as necessary to produce even light across the diffusion surface, remembering that the loss of brightness and requirements of evenness will probably demand at least two bulbs. You can, however, light the diffusion surface at a somewhat more direct angle than you would a painting, as shown in the diagram at right. Use your camera's meter to make the light across the diffusion surface even, adjusting the lights in the same ways described earlier in this chapter. Take the readings directly off the white surface of the diffusion material, keeping in mind that the indicated combination of aperture and shutter speed has no direct bearing on your final exposure. You can meter off the front surface of the material or the back, but be sure no light from the bulbs enters the lens directly as you take your readings.

BOUNCE LIGHT
An alternative method to the backlighted scrim is to bounce light off white paper, a white sheet, or a white card behind the piece. One

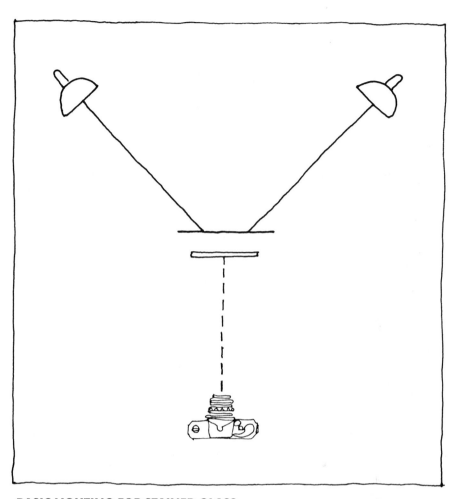

BASIC LIGHTING FOR STAINED GLASS
A sheet of diffusion material is placed behind the work, then backlighted evenly from the sides. Baffling cards, not indicated here, should be carefully placed so that no direct light enters the lens.

drawback to this is that the bounce surface must be placed farther from the work than a backlighted diffusion surface, to make room for the lights and allow even illumination of the surface. This in turn requires the use of a larger surface area of material. It also tends to make less efficient use of the bulbs' output than the diffusion technique, depending on the thickness of the diffusion material.

In shooting stained glass, it's also not a bad idea to throw some light on the front surface of the glass, just as if you were lighting a regular flat artwork. This will give a sense of substance and detail to the leading, and is absolutely necessary if your piece contains nearly opaque glass, which reflects as much light off its front surface as it transmits, depending on lighting conditions. The light on the front surface of the glass, however, should be two or three stops dimmer than that passing through it, depending on the degree of transparency in the glass itself. This can be accomplished by placing the lights farther away from the front surface, using lamps of lower wattage, or bouncing or diffusing the lights to reduce their intensity. Unless your frontlighting is considerably brighter than this (which may be necessary for very dense glass), it shouldn't affect the exposure, which is based on the backlighting, as we'll see.

EXPOSING FOR STAINED GLASS

Determining the correct exposure for stained glass is almost as tricky as the setup required to shoot it, because it comes in such a variety of translucencies. If by chance your piece transmits, on average, the same amount of light that a camera's meter is calibrated for—the 18 percent reflection of the gray card—you can probably get a reliable exposure simply by using the settings that an automatic exposure system chooses or that a camera in manual exposure mode recommends when you fill the viewfinder with the artwork.

It's likely, though, that your piece transmits more or less light than this. So it's better to use the known brightness of the backlighted or bounce-lighted surface illuminating the piece to determine the correct exposure. This is as simple as taking a reading off the surface itself (again, making sure that no direct light strays into the lens if the surface is backlighted), then increasing your exposure by four stops. This adjustment gives you an exposure equivalent to that produced by a gray-card reading in a front-lighted setup.

For example, if your meter reading off the illuminated surface (the side facing the work) is 1/60 second at f11, use 1/4 second at f11 as your starting exposure. If it is 1/8 second at f22, use 1/8 second at f5.6 as your starting exposure. As always, you can combine aperture and shutter speed changes to achieve the increase in exposure, too. If your indicated reading is 1/30 second at f11, and you're reluctant to reduce your shutter speed to 1/4 second, you can reduce it to 1/8 second to gain three stops of exposure, then open the aperture a stop to f5.6 for the fourth.

Whatever starting exposure you use to photograph stained glass, it is even more important to bracket your exposures broadly than with other kinds of work. Bracket them at least a stop in either direction, remembering not to set overly wide apertures, and to keep the shutter speed within the limits required by the film. If observing these constraints becomes a problem, either boost the light levels or use a higher-speed film.

Glass Values. Stained glass works which contain areas of extremely different translucence may produce a slide with far too much contrast, in which either the very transparent parts are washed out or the more opaque ones are too dark. The only practical solution to this problem is to mask the more transparent sections of the piece with tracing vellum or translucent diffusion film. The film must be cut to the exact shape of the areas to be masked, and carefully and invisibly applied to the back of the work. (You can use small, strategically placed pieces of transparent tape.) This may, however, make an absolutely clear piece of glass appear frosted. You can use your meter to measure the change in transmission that masking causes, but the only sure way of testing the balance between light and dark glass is to shoot a test. If the light areas still seem washed out, use another (or a thicker) layer of diffusion film.

A quick, if less certain, way of shooting stained glass is to prop it up in a window during the day. Be sure the window has no direct sunlight coming through it. Place a smooth sheet of tracing vellum or diffusing film behind the artwork to further diffuse the light and eliminate the background. Make sure none of the frame or lattice of the window intrudes into the glass of the piece. Use daylight film with a warming filter (81B or 81C). You can take meter readings directly off the diffusion sheet and adjust your exposure as explained, or take an averaged reading off the glass of the piece itself and bracket your exposures heavily.

INSTALLED STAINED GLASS

You have fewer options, and less control, if you're shooting stained glass that's installed. An installed work is probably backlighted with daylight, in which case you must shoot daylight-balanced film. A modest amount of tungsten light

falling on the inside of the window shouldn't create a serious color temperature problem; in fact, you may want to boost the level of front light, to give detail to the leading and surfaces of the glass. (Just be sure it's from enough of an angle to prevent glare.)

Because you can't meter the light source as described above, take your reading off the window itself, making sure to crop out any dark surrounding areas which might cause overexposure. If you're using an automatic exposure system, lock in those settings, or adjust the autoexposure compensation control or ISO dial when you recompose to show the full piece, so that the settings match those indicated by the closer reading off the window. Be sure to bracket your exposures heavily in both directions.

SUMMARY/**TWO-DIMENSIONAL WORK**

- Position your artwork securely in a place with good clearance to the front and sides of the work.
- Set the tripod up at a distance from which the artwork roughly fills the camera's viewfinder. Raise the camera to a height that falls along an imaginary line extending directly from the middle of the work.
- Attach the camera securely to the tripod's mounting platform, and adjust its angle to match that of the work.
- Fine tune the camera's distance from the work, and square the artwork up by manipulating the controls of the tripod, moving it if necessary. Use the sides of the viewfinder frame as a reference for squareness.
- Position your lights to either side of the camera. Don't make their angle on the work any steeper than 45 degrees; if you see glare when you look through the viewfinder, make the angle more oblique (i.e., move the lights closer to the plane of the work, so that they strike it at more of an angle). If you're using a single light on either side, raise them to a height corresponding to the middle of the work.
- Take meter readings off the gray card at the center, corner and sides of the work to measure the evenness of the light. By adjusting the lamps' angle, height and/or distance from the work, increase the light level in areas that are less bright than the center, and decrease the light level in areas that are brighter. The end result should be that the readings are consistent across the entire surface of the work.
- Choose your final combination of aperture and shutter speed, checking to make sure the gray-card reading indicates that this combination will produce proper exposure at the ISO you have set.
- If your camera only offers automatic exposure control, make the necessary adjustments to the autoexposure compensation control or ISO dial to obtain this combination.
- Focus the lens carefully and take your pictures, making sure to bracket the exposure fully.
- To photograph work under glass, baffle the camera and anything else the glass reflects with black paper, board or cloth.
- To photograph work containing shiny materials, place white paper, cards, or cloth around the camera to provide something bright for those materials to reflect.
- To photograph stained glass, place a sheet of translucent film or vellum behind the work, then light it evenly from the back. Bracket your exposures heavily.

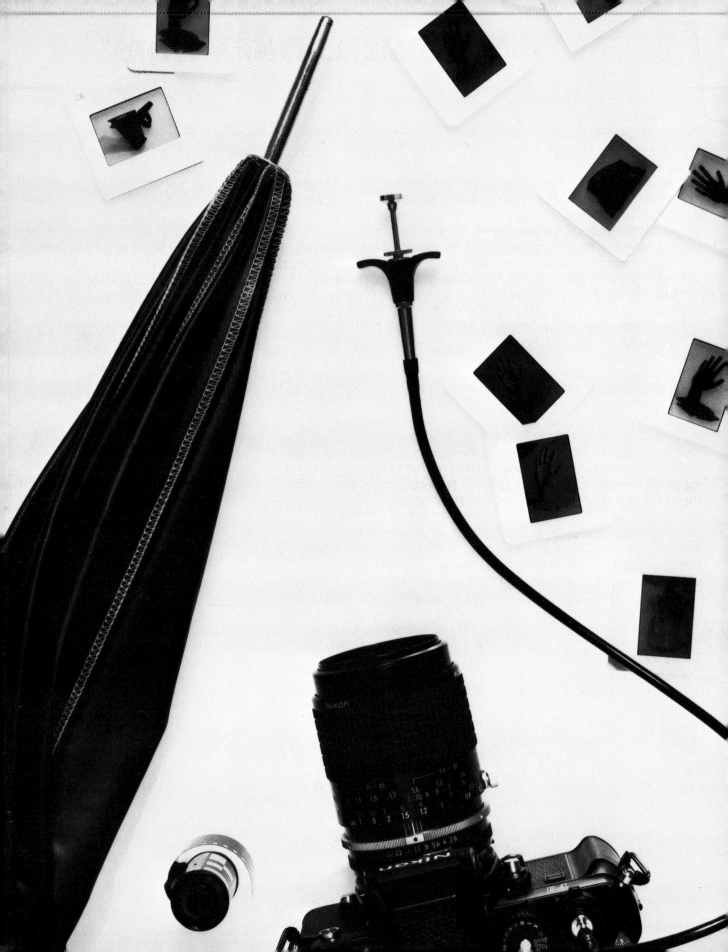

FOUR THREE-DIMENSIONAL WORK

In technique, what distinguishes the photography of three-dimensional work from that of flat work is the nature of the light itself. While the even, direct light appropriate for two-dimensional artwork simply insures that the film will record the work's tones and colors in their true relationships, the kind of light needed in photographing sculptural work has a modeling function: it describes contours, textures and shapes. For this reason, it generally must be softer and more unidirectional than the light used for flat work. Use of direct light from more than one source can create confusing shadows on a three-dimensional work, and multiple shadows across the background against which it's photographed.

The other difference in photographing three-dimensional work is that, with the exception of times you want to show a work *in situ*, you will probably want to shoot it on a background of plain, uninterrupted paper, known in the trade as a "seamless." While cloth can be used in some circumstances, paper is better because its stiffness makes it easier to control.

3-D EQUIPMENT

The information you've gotten thus far on films, photolamps and general technique applies to sculptural as well as flat work. But the differences may warrant the purchase of another few items of photographic "software." One of these is a photographic *umbrella*, a less-than-waterproof version of the real thing. Its white or silver lining acts as a reflector, bouncing the light from your bulbs back at a sculptural work in a much softer and more flattering way. White boards, sheets, or even strategically located white walls and ceilings may be used in a similar

fashion, but they reflect light in a less efficient and even more diffuse way than does the parabolic shape of an umbrella. Some photographic umbrellas are made of translucent material so that they may be used as diffusers, too.

Photographic umbrellas can be purchased in a good professional photography store. They cost anywhere from twenty-five to seventy-five dollars, depending on their size and style, and must be secured in some way at the appropriate position. Fixtures for this purpose, designed to mount on lightstands, are also available, although clamps and duct tape will also do the job. Umbrellas with a silver lining are even more reflective than those with white linings, but the light from them will have a more focused quality, producing a slightly more contrasty image.

A SUITABLE BACKGROUND

Another expense in shooting sculptural work is for the background material. Although this can be as little as the cost of a large sheet of drawing paper, something you may even have on hand, it might be as much as the price of a roll of seamless background paper, or a piece of Formica or Plexiglas.

Seamless background paper is available in various colors from professional photography stores. You may have to special-order it, particularly if you want an offbeat color, so plan ahead. It comes in rolls of four-, nine-, and twelve-foot widths, each twelve yards long. The four-foot roll (which actually measures 52 or 53 inches) will cost over fifteen dollars, the nine-foot, twenty-five plus. Store the unused portions of the roll tightly coiled and upright. When the portion you've been using becomes dirty, scuffed or torn, roll out another length.

PHOTOGRAPHIC UMBRELLA
The white or silver lining of an umbrella acts as a reflector to bounce the light from the bulbs back at a sculpture in a soft and flattering way.

Ralph Helmick

EFFECT OF BACKGROUND ON SCULPTURAL WORK

The color or tone of your seamless background paper can have a strong effect on the appearance of the artwork in the photograph. In the photograph at top left, a white seamless makes the background virtually disappear, emphasizing the shape of the work. However, because the white ground bounces light into the shadows of the piece, it appears to be somewhat flatly lighted. The artwork was lighted in exactly the same way for the photograph at bottom left, but placed on a medium gray seamless instead. This change makes the light seem much more dramatic. Notice that the highlights on the fingers and palm stand out more strongly, but that the shadows tend to merge with the background tone, emphasizing the work's shape less effectively than the treatment at left. If you're shooting your work against a white ground, you may choose not to soften your light source as much, to create more contrast between highlights and shadows. In some cases, direct light may even be appropriate, although you might have to create additional fill light with reflectors.

For smaller objects, other kinds of paper and flexible boards can be used, and may even be preferable if they have a less visible texture than seamless background paper. (The smaller the object, the closer you must place the camera to it, and the more visible the texture of the background paper will be.) Good-quality poster board and matboard are useful, although if you plan to shoot a free-standing object on them, be sure they are flexible enough to be bent into a smooth 90-degree curve. (This is necessary to produce a continuous background.) If you want to photograph against a white background, bristol board is an excellent choice, although many drawing papers will suffice.

Color and Contrast. Seamless background papers are manufactured in several dozen colors, as are poster boards and matboards. If all colors aren't in stock, ask your professional photo dealer to show you a sample book. But be forewarned; like paint swatches, a small sample can be misleading. Make a conservative choice, particularly if you are special-ordering a roll sight unseen. In most instances, a white or light-to-medium gray will do the most justice to your artwork, and be the least distracting. There are exceptions—gold jewelry looks beautiful on a royal blue velvet, for example. But in general, avoid bright colors; depending on your lighting arrangement, they can even affect the artwork's color. Your objective should be to show the work as clearly and simply as possible. Curators will thank you.

Think about the *contrast* between background and artwork, as well as the color. (If you're using black-and-white film, this should be the main consideration.) A light object—of silver, marble, clear plastic—will "read" better on a background deeper in tone, such as a medium gray. A black background can be very dramatic, but use it with caution. A darker object—of oxidized metal, clay or some kinds of wood—will probably look better on a white or medium gray. If photographing a very dark object, you may choose to shoot against a medium gray rather than white, because the additional exposure a dark object sometimes needs can cause the background to be rendered lighter than it appears. A light gray ground will retain some tone in such a case, whereas a white ground might go blank. Also available are single-size seamless backgrounds with graduated tone and color; these simulate the effect of light "falloff" on the background that's a favorite trick of professional studio photographers.

OTHER BACKGROUND MATERIALS

There are several alternatives to paper backgrounds. Cloth is a possibility, but because it is hard to shape into a smooth curve without a support, it works best when it can be hung behind the artwork, rather than running underneath it. (Artworks that can be suspended or cropped at their pedestals are well suited to this treatment.) As a background, black cloth will usually appear blacker than black paper, but its texture may still be visible in the slide. The smaller the artwork, the more pronounced any texture will be. Black velvet, velour or velveteen don't have a visible warp and woof, and their napped texture absorbs more light than regular woven cloth, which makes them look blacker in a photograph. These materials are available in rolls specifically for photographic applications; see the list of mail-order suppliers on page 125. Unless you're using a small piece, you'll probably pay a premium at a fabric store! Any cloth background must be supported underneath by a rigid, curved surface if the object is to sit on it.

Canvas. There are also commercial background materials made of heavy canvas and muslin, hand-painted with abstract muted brushed patterns. These can also be bought from mail-order sources like the ones listed in the "Useful Accessories" appendix, although a professional dealer can also special-order them for you. They aren't cheap, and you can probably duplicate them yourself. There's no harm in experimenting; paint-splattered dropcloths, old, low-pile monochrome rugs, and the like, may produce useful effects in some circumstances. A very smooth-surfaced, minimal piece of sculpture, for example, might benefit from the contrast of a rough, stippled background. But again, be conservative!

Formica. Formica—available from building supply outfits, good lumberyards, and even well-supplied hardware stores—makes an excellent background surface, as strange as it may sound. It's flexible enough to bend into a nice, smooth curve, although because it wants to spring back flat, you will have to attach it securely to the table and wall you'll be working with. Because it's quite scratch-resistant, Formica lasts indefinitely, unlike seamless paper. Its durability offsets its higher price—about two dollars a square foot. Buy it in a matte finish to minimize reflections. A medium gray is a good all-purpose choice.

Plexiglas. Even Plexiglas has its applications, although because it's shiny you must be careful in positioning your lights. You usually have to buy it at a plastics specialty shop. Jewelry, glossy ceramic work, or any piece with a high-tech appearance looks particularly snappy against black Plexiglas. And one way to prevent a shiny object—whether glazed or metallic—from

SIDE VIEW, BASIC THREE-DIMENSIONAL SETUP.

Don't place the artwork too close to the curve of the seamless, or else the shadow it casts may curve up the background. Keep in mind that the higher the light source, the shorter the shadow will be.

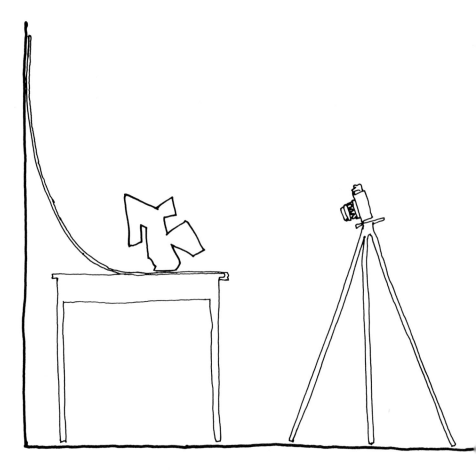

reflecting the color of the ground it's sitting on is to "float" it on a clear Plexiglas surface, with the colored background behind or several feet beneath it. Although this technique is somewhat advanced, it will be described briefly later in this chapter. Translucent (milky) Plexiglas can be used when you want to eliminate shadows on the background, or make it disappear into a blank white. You do this by illuminating the background from behind, a technique which will also be described later.

Plexiglas comes in different weights. Unless you are "shooting down" on an object, and only need a flat, rigid background, buy a sheet that's thin enough to bend into the smooth curve that free-standing artworks will require. The larger your artwork, the thicker it can be, because the curve in a larger sheet of Plexiglas will be more gradual.

An eighth of an inch is a good thickness for medium-sized works.

FILL THE SPACE

Whether you use Formica, Plexiglas, cloth or paper, be sure your material is both wide and long enough to fill the entire viewfinder when your camera is at the proper distance from the artwork. Keep in mind that as the background material recedes from the artwork and the camera, its lateral coverage is reduced, and its edges may appear in the upper corners of the viewfinder. That's a particular problem if you're forced to use a wider-than-normal lens; the change in perspective will reduce the coverage of the background material. Also, because of the long, gradual curve required in a seamless background, you will need a surprisingly *long* piece. You won't know the exact needs of your artwork until you've set it up, so when in doubt, overestimate.

THE SETUP

If your artwork is small, it may be easier to photograph it on a sturdy table. If it's large, use the floor, but in either case, work against a wall that's free of windows, woodwork or hanging objects.

Unless you intend to shoot down against a flat background—a treatment that works well for jewelry or the interior of bowls—you will have to attach the leading edge of your background paper, board, or other material to the wall, well above the highest point of your artwork. Use strong tape or pushpins. (More forceful measures, such as nailing or screwing, may be required for rigid materials like Formica.) Then roll the paper out, allowing it to form a smooth curve on its way down to the table or floor. Roll it out generously on the surface your artwork will rest on; you don't want the artwork too close to the curve, or else any shadow it casts will be curved as well. And make sure the curve isn't too abrupt.

If your seamless is paper, handle it carefully to avoid crimping or tearing, and cut the proper length from the roll with a mat knife or scissors. Store the remainder tightly coiled and upright, to prevent the formation of bumps and dimples in its surface. Secure the cut edge of your background material to your working surface.

If you're handy and ambitious, you may be able to improvise a freestanding support for the roll of seamless. In professional studios, the entire roll of seamless is hung on a metal rod which is supported by two vertical posts running between ceiling and floor. Paper is then rolled out as needed.

POSITIONING THE ARTWORK

If you're photographing your work against a flat background, its proper placement should be self-evident. If you're using a curved seamless ground, be sure the work is far enough forward on it so that any shadow it may cast doesn't follow the curve of the ground. On the other hand, if the vertical portion of the seamless is too far away from the work, it may end up much darker in your photograph—resulting in a strong bluish cast if you're using a white or gray background. None of this will be fully apparent until you establish your lighting arrangement.

If the artwork is heavy or has sharp edges, be careful not to tear or scratch the background when you position it. If you're shooting a large object and must walk on the background paper to position it, put clean sheets of paper down to protect the ground from footprints. Be sure the side of the artwork that you want to photograph is facing directly toward your camera position. Once you establish the proper camera-to-artwork distance, look through your camera from that position to make sure the seamless fills the frame.

SETTING UP THE CAMERA

It's best to set up the camera and tripod before positioning the light or lights, because their placement will probably affect your lighting arrangement. You can throw some casual light on the artwork to make framing and focusing easier, though.

Make the artwork fill the frame, whether horizontal or vertical, but don't cramp it. If it doesn't conform to the image area of your 35mm camera, remember that a finished slide can be masked to eliminate empty areas, and that a print can be cropped. (This will be covered in Chapter Seven.) Consider the height of the camera carefully. A slightly elevated position will show the top of a piece as well as its sides, but may tend to make the upper portions of the piece loom, an effect that can be minimized by using a lens of longer focal length, as described below. A low camera position may make the artwork seem monumental, or simply emphasize its monumentality. If this treatment appeals to you, be sure the background material extends far enough above the top of the piece to fill the viewfinder frame. By and large, it's best not to make the photograph's perspective on the piece too distracting. Let the artwork speak for itself.

LENSES AND THREE-DIMENSIONAL WORK

In shooting three-dimensional work, many professional photographers opt to use lenses of longer focal length than the standard 50mm, usually in the moderate telephoto range, from 80- or 90mm to 135mm. (Zoom lenses can be set to their longer focal lengths for this purpose.) This is because lenses of longer focal length can have the effect of making the individual parts of a sculptural work appear to be in truer proportion to one another. The effect is due to the greater distance you must be from the work to fit it into the frame. (The longer the focal length, the narrower the lens' angle of view.)

The extra working distance a longer focal length requires may prevent you from using a long lens, even if you have access to one, because your space may be too small, your work too large, or both. Even if your artwork is small, the closest focusing distance of a longer lens may place you too far away from the work to fill the frame with it.

Many zoom lenses offer a "macro" mode that allows you to focus at very short distances. These lenses are a viable alternative to macro lenses and close-up attachments, if your work is small. It's especially important, though, to select

35mm lens

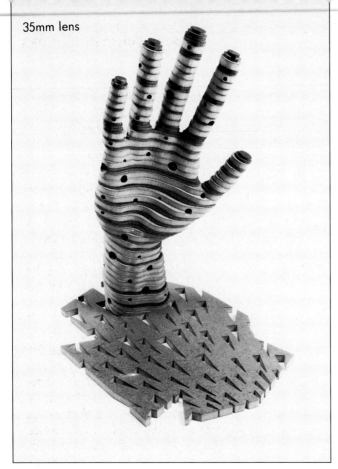

50mm lens

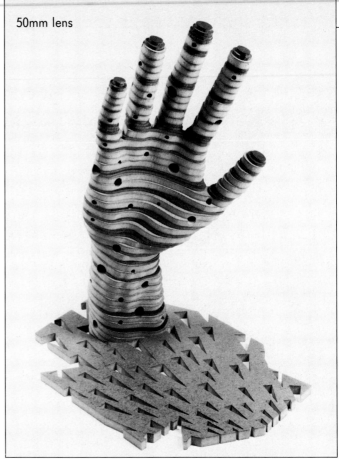

EFFECT OF DIFFERENT FOCAL LENGTHS ON SCULPTURAL WORK

The *focal length* of a lens (see Chapter One for a complete definition) has a dramatic effect on the way an artwork is represented in a photograph. It determines how far from the artwork your camera must be to make the work fill the frame, and this in turn affects the *perspective* with which the work will be represented.

In the pictures above, for example, the lenses with shorter focal lengths, and thus wider angles of view (35mm and 50mm), required that the camera be closer to the piece to make it fill the frame, resulting in an image in which more of the base is visible, and in which the fingers seem to loom forward. By contrast, the fingers in the 105mm shot, left, seem more in proportion to the rest of the hand, but less of the top surface of the artwork's base is visible—all because the longer focal length's narrower angle of view forces you to shoot the piece from farther away.

Choosing a focal length is really a matter of taste, and of what aspect of the work you want to emphasize. However, in the 35mm shot—included to show how a non-zoom point-and-shoot camera might render the piece—the relationship between the wrist and fingers is quite distorted. It's rarely appropriate to use anything wider than a 50mm lens in photographing artwork, either two- or three-dimensional.

105mm lens

smaller lens apertures if you are using a long focal length or a zoom set for macro mode to shoot small work. Refer to the section on shooting small artwork, page 96, for further information.

Large Works. On the other extreme, if your work is very large relative to your working space, you may find that the standard 50- or 55mm lens doesn't have a wide enough field of view to fit it into the frame. In such a case, you either have to relocate to a larger space or use a slightly wide-angle lens or focal length, for example 35mm. This will permit you to show more of the work from the same distance. ("35mm" here refers to the lens' focal length, not the 35mm film format of the camera itself.) The price of using a shorter focal length is considerable distortion, depending on the nature of the work; the parts of it closest to the camera will seem disproportionately large. The fixed focal length lenses on many point-and-shoot cameras are moderately wide-angle, usually from 35 to 40mm in focal length, so they will distort the artwork as well.

You can minimize the distortion caused by a wide-angle lens, if that's all you have to work with, by moving farther away from the work. This will, of course, reduce the size of the work on the film. If you're shooting slides, this is probably unacceptable; if you're shooting film for the sole purpose of making prints, you can have a custom lab enlarge and crop the image to size, or have a commercial photofinisher make a print a size larger than you need, then trim it down.

ZOOM TO THE RESCUE

A zoom lens of moderately wide-angle to medium-telephoto range — for example, 28-85mm or 35-70mm — may bail you out in the kind of tight shooting situation that a 50mm lens is too "long" for. Set-

ting it in the 40-odd-mm range will allow you to include more of the work without as much distortion as a 35mm lens, which is the nearest wide-angle alternative in a lens of fixed focal length. Always use the lens at its longest possible setting to minimize distortion; in other words, get as far away from the artwork as possible, then adjust the zoom setting to make the artwork fill the frame. If space allows, use such a lens at its 50mm setting or beyond.

LIGHTING THREE-DIMENSIONAL WORK

Because of its tremendous variety, three-dimensional work doesn't lend itself to hard-and-fast lighting rules. Keep in mind that the function of light is not simply to make the piece bright enough to shoot at reasonable camera settings, but also to describe its contours, surfaces, and shape. Sometimes this description is the result of shadows the artwork casts on itself, which create a sense of volume. But be sure that any shadows on the work don't obscure important features.

In shooting three-dimensional work, it's advisable to stick with a unidirectional light source. This prevents confusing multiple shadows on the work and background. With certain kinds of work or interpretations, this single source can be direct and undiffused, creating a dramatic, high-contrast effect which usually produces shadows that must be "filled in" with reflectors placed outside the camera's field of view. Most work, however, is better served by a softer kind of light. One way to soften the light is by *bouncing* it.

BOUNCE LIGHT

Bounce lighting is most easily accomplished with a photographic umbrella, described at the beginning of this chapter. You "aim" the

inside of the umbrella at the work, and point your lights back into it, away from the work. You can also bounce the light with a large white card or board or a white sheet. If convenient, you can use an adjacent wall or low ceiling as a bounce surface, but be sure it's a white of neutral tone. A warm white wall will color the work somewhat if light is bounced off it. Flat, white bounce surfaces such as these tend to be less efficient reflectors than photographic umbrellas.

Because of the loss of brightness involved in bounce lighting (often several "stops"), it's not a bad idea to use two 500-watt bulbs, both pointed at the same reflector. This will reduce the need for awkwardly long shutter speeds, and for wide apertures that might compromise your depth of field — an important consideration in shooting three-dimensional work.

DIFFUSED LIGHT

A somewhat more efficient alternative to bounce lighting is *diffusing* a light that's aimed directly at your artwork with a piece of translucent material. White plastic garbage bags — one side only, to reduce light loss — work well, as do old shower curtains, as long as they have no visible color. (Even if they don't, they often have a slight warming effect on the color of the slide.) You can also buy a commercial photographic diffusion film, available in sheets or rolls at professional photography stores. It comes in different degrees of translucency; get one that's neither so thick it cuts way down on your light levels, nor so thin that it doesn't adequately soften your light.

Whether you're bouncing your light or diffusing it, be sure your bounce surfaces or diffusing materials are at a reasonable distance from your lamps — several feet, if possible. This is both a safety consider-

BIRD'S-EYE VIEW, BASIC THREE-DIMENSIONAL SETUP.

Direct light (top, page 66) is rarely flattering to an artwork because it creates heavy, empty shadows. But if a white reflector card is placed off-camera to the side of the work opposite the light source (top, page 67), these shadows can be filled in. Although this treatment may be useful for artworks in which you want to enhance texture, a softer light is generally more suited to sculptural work. Soft light defines the contours of an artwork more effectively, and the shadows it creates are less harsh, although you may still choose to lighten them with a reflector card. You can soften the light by bouncing it into a white or silver-lined photographic umbrella (bottom, page 66) or by diffusing it with a sheet of translucent film (bottom, page 67) or even a white plastic bag.

ation—the bulbs burn hot enough to melt or set fire to materials that are too close—and a practical one. To create a broad, soft light, the bulb's beam must span a good portion of the bounce or diffusion surface. That's why you have to use a reflector or diffuser of reasonable size. A one-foot square, for example, won't do the job. The larger the work, the more surface area you'll need for equivalent softness. Because works of art may vary in terms of the quality of light that is most becoming to them, it's difficult to give exact figures; be generous. Experiment with and observe the effect of different combinations of light-to-diffuser distance and diffusion surface area. Both will affect the quality as well as the intensity of the light.

Diffusion Hangups. Supporting and securing the bounce or diffusion surface will also require a little improvisational skill—although there are the usual commercial alternatives, for example a metal rod that may be attached horizontally to a light stand with a special fixture. If you're using a stiff card for bounce lighting, it can be clipped or taped onto a ladder or an exposed pipe. A sheet can be suspended from the ceiling, but may need to be angled down toward the work by guying back its lower edge with tape or string. Diffusion materials can be similarly supported. Heavy wooden dowels are useful for these purposes, and can be purchased at lumberyards or good hardware stores. You can even use a prefab commercial painting stretcher to keep a piece of diffusion material taut; build one yourself if you prefer, but keep it light if you intend to clip or tape it onto its supports.

PLACING AND ADJUSTING YOUR LIGHT SOURCE

In photographing three-dimensional work, your light source

A

B

C

D

EFFECT OF VARIATIONS IN LIGHTING TECHNIQUE

In photograph A, the artwork was lighted from a fairly high angle in front of and to the right of it, using a single bulb diffused with a piece of translucent film. In the second photograph, B, the piece was lighted with an undiffused lamp in the same position, creating much deeper shadows than the diffused light. In the third shot, C, a neutral white card was placed to the side and in front of the piece, angled so that it would bounce as much of the direct light into the shadows as possible. Using reflector cards in this way can soften the harsh effect of direct light considerably, and allows you to take advantage of its surface-defining quality without creating distractingly deep shadows on the piece. Photograph D shows the effect of a badly placed light source. Not only does the light fail to describe the contours of the piece, but it causes it to cast a distracting shadow on the background. Although you should always position your light source so that it best defines the work's contours, be conscious of where the work's shadow is thrown. If a strong shadow is inevitable, it can be played down by filling it in with reflectors or auxiliary lights.

should generally be positioned above and to the side of the camera, unless your camera-to-artwork distance is very long, as in photographing a large piece or using a "long" lens. In these cases, you may want to place the light and softening paraphernalia closer to the work to maximize its brightness. Be sure that it still illuminates the work and background fully, and be careful not to let it intrude into the picture area. You must also be careful not to let direct light from the bulb enter the camera's lens, carefully placing baffling cards to block it out, if need be. Aim your reflector, umbrella, or, if diffusing the light, your bulbs at the center of the work or even below, so that the lower portions receive as much light as the top.

Top Light. Some three-dimensional artworks look better in light that comes from above. Usually such *top light* (for examples, see "Color Section," page 106) is more effective if it's softened by bouncing or diffusion, but with certain pieces, even the light from a single, undiffused bulb may be appropriate.

The simplest way to create soft top light is to aim the lamps—you should use at least two 500-watt bulbs because of the reduction in light intensity caused by bouncing—at a low, neutral-white ceiling. If your ceilings aren't low enough, you can substitute a large piece of white board or a sheet and suspend it horizontally over the work. If you're willing to go to this amount of trouble, however, you can make more efficient use of the light available from your lamps by suspending a piece of diffusion material instead, and then aiming the lamps through the diffusion material.

Whether you're bouncing or diffusing your lamps, keep them slightly in front of the front surface of the work. Because this technique will tend to make an artwork lighter

at the top than the bottom, it may not be a good idea with tall pieces. **Adjusting the Lights.** However you light your work, study the way the light strikes it critically. Adjust the angle of your light source—its height and position—so that it falls across the artwork in the most descriptive way. Determine how much shadow on the side opposite the light source is necessary to define the contour of the work. Think about where the shadow of the work itself falls on the background, because this will be a part of your final image, even if quite soft or light. If the shadow seems too long, raise the lights and angle them down more.

If you feel the light is too flat, try a thinner diffusion material, or if bounce lighting, move the lights closer to your reflecting surface. Moving the entire light source farther away from the work will also accomplish this, but do so only if you can afford the loss in brightness. If you're using an umbrella with a white surface, consider exchanging it for one with a silver lining, which will give you a more contrasty, directional (but still soft) light. A similar alternative, if you're using a white card as a bounce surface, is to wrap aluminum foil around it, although you should make sure that it doesn't give the light a blotchy pattern. The effect of any of these techniques may not be fully apparent until you get your photographs back, at which time you may have to make adjustments and reshoot the work. For this reason, it's wise to leave your setup intact until you see your results.

Filling in Shadows. Reflectors can be used to bounce the light from your main source, whether it's direct, bounced, or diffused itself, back into the shadowed portions of the work. A large, neutral white card or sheet, placed off-camera on

the side of the work opposite the light, will "fill in" shadows that might otherwise be objectionably dark. Adjust the amount of fill by moving the card in and out until the relationship between the directly lighted parts of the work and the shadows looks right, remembering that photographic film won't always see things the way you do. Because your eye adjusts its "aperture" constantly for differences in brightness, those differences will tend to look more extreme in the finished slide. But by the same token, avoid overfilling the shadows, because this will reduce the sense of volume in the artwork. This is a particular risk in very light-colored works, which often need no fill at all if your main light source is soft enough and properly positioned. Darker works usually require heavier fill. The efficiency of your reflector can be increased by foil-wrapping it, but watch for spotty light.

Commercial reflectors, including reversible models that are silver on one side and white on the other, can be purchased from the suppliers listed on page 125. They come in cardboard and fabric and in rectangular and circular styles; the larger ones can be used as a bounce surface for your primary light.

If you exercise discretion, you can even use another light to fill in shadows. It must be much farther away from the work than your main light source, much more heavily diffused, or otherwise reduced in brightness—for example, through use of a lower-wattage bulb—so that it doesn't create a second set of shadows. If kept at reduced strength, it can even be used on axis with the camera, with your main light coming strongly from the side. This is a traditional technique in photographic portraiture; our approach will be somewhat more seat-of-the-pants, but as we'll see, your camera's meter can be used to measure and establish this relationship.

FILM AND THREE-DIMENSIONAL WORK

Adding more light to any artwork will help you stick to reasonably fast shutter speeds and still set the smaller apertures required. But you may only have a bulb or two at your disposal, or want to light the work in such a way that using a second bulb will cause double shadows. If you are using bulbs with a color temperature of 3200 degrees Kelvin (which you will be unless you're using Kodachrome 40), you have the option of using Ektachrome 160T. Ektachrome 160T is almost one-and-a-half times more sensitive to light than Fujichrome 64T or Ektachrome 64T. That means you can use a faster shutter speed and/or a smaller lens aperture without increasing the light. A setup that would require an exposure of one second and an aperture between f8 and f11 with ISO 64 film, for example, could be taken at about ½ second at f11—a one-stop faster shutter speed plus a ½ stop smaller aperture—with Ektachrome 160T.

That speed is also helpful when you're forced to shoot your work by existing tungsten gallery light, whether individually or in installation views. The only tradeoff is that the film isn't quite as fine-grained as its slower cousins. But its texture is barely visible unless the slide is printed or projected.

Pushing Film. There are two other ways to obtain higher film "speed," but they both involve some compromise in quality and color fidelity. One is to "push" the film as explained in the section in Chapter Seven on page 104. This entails setting an ISO higher than the one recommended for the film, to trick your meter into thinking that the film doesn't need as much exposure. This reduced exposure is then compensated for by extending the development, something you have to tell the processor to do. A by-product of the technique is increased contrast and graininess in the slide. Ektachrome 160T is sometimes pushed to an ISO of 320, which allows you to use a one-stop faster shutter speed—¼ instead of ½ second, for example—or a one-stop smaller aperture, f16 instead of f11. Your camera's meter will indicate these changes when you reset the ISO. (You can push an ISO 64 film to ISO 125 in the same way, if you discover that you need more film speed but can't obtain a roll of Ektachrome 160T.)

The other option, when film speed is of the essence, is to use a high-speed tungsten film announced by Kodak as this book was going to press. Called Ektachrome 320T, the new film is twice as sensitive to light as Ektachrome 160T. Just as with Ektachrome 160T pushed to ISO 320, it lets you set a one-stop smaller aperture or a one-stop faster shutter speed than normally-processed Ektachrome 160T—but without the tradeoffs of pushing. What's more, Ektachrome 320T can in turn be pushed readily from its nominal ISO of 320 to ISO 640. In the example above, this would permit the use of yet a smaller aperture or a faster shutter speed—f22 instead of f16, or ⅛ second instead of ¼. But keep in mind that pushing a film that's "fast" to begin with can result in considerable graininess.

Kodachrome 40. If you're shooting Kodachrome 40 and need smaller apertures, there is no higher-speed film that's compatible with the 3400-degree light of your bulbs. A Kodachrome facility can push the film one stop to an ISO of 80 (or even higher if you're willing to accept the quality trade-off), allowing you to use a one-stop smaller aper-

IMPORTANCE OF SHOOTING SEVERAL VIEWS OF A SCULPTURAL WORK

Unlike two-dimensional artwork, most three-dimensional work is meant to be seen from many different angles. Because a photograph doesn't give a curator or gallery director the opportunity to walk around your artwork, be sure to provide more than a single view of a three-dimensional piece.

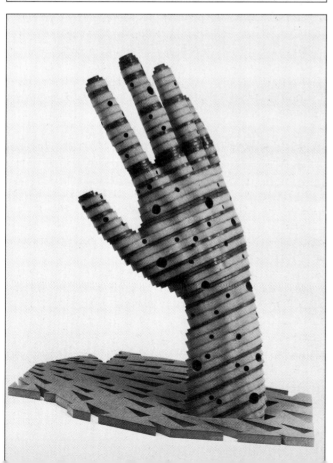

ture. The service costs extra, so if your work is three-dimensional, you're probably better off working with bulbs and film balanced for 3200-degree light.

METERING AND EXPOSING FILM

The use of diffusion and bounce techniques will reduce the strength of the light from tungsten bulbs. While you can cluster more bulbs as long as they don't create double shadows, try to minimize this loss of intensity by keeping the light source as close to the artwork as possible without creating unwanted falloff. Also, use as efficient a reflector or as thin a diffusion material as you can without compromising the quality of the light.

CHOOSING A SHUTTER SPEED

Even when you do your utmost to keep the light bright, three-dimensional work will generally require slower shutter speeds than flat work. Don't be afraid to use them; your tripod will keep the camera steady and your photo sharp. But read on to find out when you might encounter a problem.

If your camera only offers shutter speeds of up to 1/8 or 1/4 second, as some do, you may be forced to use wider apertures than are preferable for three-dimensional work. You can, however, set the camera to ''B,'' which keeps the shutter open for as long as the shutter button is depressed, and time the exposures with a watch. (You'll need a cable release, of course.) For accuracy, use exposure times of a second or longer, because the slower the speed, the less significant any timing error will be. (A 1/4 second error is only an eighth of a stop—12 percent—at a two-second shutter speed, but it's a half stop—50 percent—at a 1/2 second speed.) These manually timed speeds will allow you to use smaller lens aper-

tures, just as if your camera offered the actual shutter settings. Don't forget that using Ektachrome 160T rather than one of the slower tungsten films will let you set a faster shutter speed—and thus may help keep the required speed within the camera's range.

Fortunately, most 35mm SLRs offer manual shutter speeds of at least a second, and some go up to thirty seconds. The increments on this whole-second side of the shutter speed range are similar to the fractional speeds—four, eight, fifteen, and thirty seconds—so don't get the two mixed up. They're usually color-coded differently on a dial, and indicated with ''second'' marks on an LCD panel or in the viewfinder. Like the fractional speeds, any change in these slower shutter speeds represents a whole stop increase or decrease in exposure—a change that your camera's meter will compensate for by recommending (or telling the camera to set) a different lens aperture.

Shutter Speed and Reciprocity Failure. For example, the meter will tell you that an eight-second exposure at f11 is the same as a fifteen-second exposure at f16, or that a four-second exposure at f11 is the same as a two-second exposure at f8. The problem with this is that the meter doesn't adjust for the increasing loss of sensitivity that photographic films experience at very slow shutter speeds—the reciprocity failure described in Chapter Two. The effect of reciprocity failure is to make the slide a little darker—more underexposed—than it should have been. As you may remember, with Fujichrome 64T and Ektachrome 64T, reciprocity failure isn't a concern until the exposure exceeds ten or twenty seconds—and you shouldn't be needing exposures even close to that. Ektachrome 160T and Koda-

chrome 40, on the other hand, shouldn't be used with shutter speeds longer than about two seconds. If the required shutter speed is one or two seconds, add a half stop more exposure (wider aperture or slower shutter speed) than what the meter indicates. And as always, bracket your exposures.

CHOOSING AN APERTURE

All this dwelling on slower shutter speeds is to emphasize that you shouldn't let the light loss that is caused by diffusion and bounce techniques force you to set overly wide lens apertures to obtain proper film exposure. Wide lens apertures reduce your depth of field—the zone of sharpness in the picture. And good depth of field is even more important in shooting three-dimensional work than it is with flat work.

If any general rule can be applied, use an aperture of at least f8 with a 50mm lens, and if possible f11. With a 105mm lens, avoid anything wider than f11. But the best aperture is very much a function of the individual artwork. The deeper the artwork, the smaller the aperture you will need to include all of it in the zone of sharpness. And the smaller it is, the smaller the aperture you will need to make it all sharp, because depth of field is much shallower *at the same aperture* when you're closer to a subject. For the same reason, details of a larger piece will also require the use of smaller apertures than the photographs of the entire piece. For details of small or deep works, an aperture of f16 is sometimes appropriate, light levels and shutter speeds permitting. Use of an aperture that is too wide for the artwork will make parts of it appear unsharp in the photograph.

A more precise method of determining what aperture is appropriate for your artwork is to use the depth-

of-field scale on your lens barrel, or if the lens has a skimpy scale or none at all, to refer to the charts on page 37. The scale and/or charts will tell you how deep your zone of sharpness will be at various apertures; its use is described in detail in the box on pages 34 and 35 in Chapter Two. You can see from the scale or charts that your camera-to-artwork distance has as much effect on a photograph's depth of field as your choice of aperture—and that focusing properly can maximize your depth of field.

Your first inclination may be to focus on the closest part of the artwork. Don't do it. Because the zone of sharpness at a given aperture extends both in front of where you've focused and behind it, you will be throwing away the front portion of it if you do so. In fact, the zone of sharpness surrounding any point on which you focus extends about twice as far behind that point as it does in front of it. That's why you should focus about a third of the way between the closest and the farthest points you want to render sharply, then choose an aperture that will give you enough depth of field to include both points. This approach will help you make the most of that aperture's depth of field.

Don't Believe Your Eyes. The only thing that may make you nervous about doing this is that, as seen through the camera's viewfinder, the front of the artwork may appear to be out of focus. This is not, however, the way the art will look in the photograph. The camera keeps the lens open to its widest aperture until just before you trip the shutter—a device that allows as much light into the viewfinder as possible, giving you a bright image to frame and focus. When you press the shutter button, the lens is automatically stopped down to the lens aperture you have set just before the shutter

curtain opens. (If you are using a very old camera, you may have to open and close the lens aperture manually for viewing and shooting.)

One way to get a sense of the final appearance of the artwork is by depressing the camera's depth-of-field preview button, if it has one. This lets you view the subject at the aperture you have set the lens to, although it will darken the viewfinder considerably. While the subject will appear much sharper, this device should never be used as a substitute for the lens's depth-of-field scale or the charts on page 37. Although something may look sharp in the viewfinder (or even when it's viewed on a lightbox), it may not appear sharp in the projected slide or enlarged print.

As you get your results back, you'll begin to understand the effect of depth of field. You'll realize, for example, that wider apertures give better depth of field when you're farther away from your subject. If your piece is large and fairly shallow you may be far enough away from it to get away with an aperture of f5.6.

TAKING THE LIGHT READING

Once you've decided what aperture you need, use the gray card to determine the shutter speed required for proper film exposure in the light you have on the work. Take the camera carefully off the tripod. Place the gray card in the middle of the work so that the light falls on it unimpeded and aim its surface toward the camera position. Since you will probably need both hands to operate the camera, you may want to secure the card in some way, or have a friend hold it for you. Fill the camera viewfinder with the card, but make sure not to cast a shadow on it. (If a friend is holding it, be sure he or she doesn't cast a shadow either.) There's no need to

focus the camera on the card.

If you're forced to use aperture-priority autoexposure, the camera will set a shutter speed automatically when you set the aperture you want. With shutter-priority, you must adjust the shutter speed until your chosen aperture appears in the viewfinder display. In either case, you will probably have to override the camera's automatic exposure system when it comes time to make the actual exposures, to make it accept the settings indicated by the gray-card reading. (Refer to Chapter Two for details.) Simply adjust the shutter speed until you match up the needle, get the LED to glow, or see simultaneous plus and minus symbols in the viewfinder—that is, until the camera indicates correct exposure. If the symbols change when you remount the camera, simply ignore them and take your pictures. The proper exposure is locked in.

You can also take gray-card readings at other points on the work to confirm that the indicated exposure is the same as it was in the center. This isn't quite as critical as it is with flat work; softening the light by diffusing it or bouncing it tends to make it more broad and even to begin with. And of course, part of the modeling effect of light on three-dimensional work has to do with the way it changes in brightness across the artwork's surfaces. Pieces that are very tall, wide or long do run some risk of being unevenly lighted, however, and you should take readings to check this. A tall vertical piece, for example, should be metered top to bottom on its highlighted side.

Test Case. Let's say your first, central gray card reading of such a piece indicates an exposure of ½ second at f11. The reading you take at the top of the piece, however, indicates ½ second at f8 or one second at f11

equivalent exposures. That tells you the light there is a stop dimmer than that in the middle. You either need to raise your light source or aim it up—or, if these adjustments in turn reduce the light on the *bottom* of the work, back your light source away from the work to make its coverage more even. This adjustment will reduce the overall light level, so take your central gray-card reading again to determine the correct exposure.

Let's say your work is horizontal and you've lighted it from the left side. You get a gray-card reading at the middle of the work of one second at f16. But the reading you get on the right side of the work is one second at between f16 and f11, indicating the light there is a half stop dimmer than that in the middle. (An aperture-priority automatic exposure system may display two seconds at f16, because some such systems can only indicate whole shutter speeds, whether they are capable of actually using in-between speeds or not.) In order to correct this, you can do one or more of several things.

You can change the angle at which the light strikes the artwork, bringing it closer to the camera so that it hits the work more broadside. (This may reduce the sense of texture in the work, but there are always trade-offs.) You can back the light away from the work to make it more even, although this will mean using a wider aperture or slower shutter speed, as the camera will indicate when you take a new reading. Alternatively, you can try brightening the right side of the piece by using a reflector (a white sheet or board) to bounce some of the light back into the work.

SHOOTING DETAILS

Sometimes an overall view of an artwork fails to convey its full richness, especially if it is never projected or printed. If your work is large and/or complex, or if it has distinctive surface characteristics, consider shooting details to supplement the overall view. If you're not using a macro lens or a zoom lens with a "macro" mode, shooting details may require the use of close-

up attachments. Read the section on shooting small work in Chapter Seven for more details.

Because depth of field is reduced at the close distances involved in shooting details, you should set smaller lens f-stops. This will in turn require the use of slower shutter speeds to obtain equivalent exposure. If you boost the light levels, however, you may be able to use smaller f-stops without changing shutter speeds. (You can do this simply by moving your light source as close to the work as the need for evenness permits.) Anytime you change the light, of course—whether to brighten the artwork or alter the light's character and direction to suit a specific detail—you will have to take a new meter reading and change your camera's settings accordingly.

If you're still uncertain about how to determine the correct exposure, or how to override an automatic exposure system to obtain the correct exposure, review the section at the end of Chapter Two. Chapter Two also explains how to bracket your exposures in both an automatic and a manual exposure mode. Bracketing your exposures is even more important with three-dimensional work than two-dimensional work, because of the greater range of brightnesses that unidirectional light creates. Be sure to use your cable release, and let the camera "settle" between exposures.

Finally, remember that you don't have to accept your first results, as you might if you'd hired a professional photographer. If you're unhappy with the quality of the light or the presentation of the piece, you can reshoot it for no more than the cost of another roll of film and processing. If you've had a technical problem, however, refer to Chapter Six, "Evaluating Your Results," for help in diagnosing it.

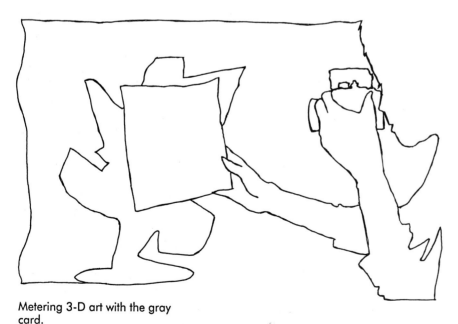

Metering 3-D art with the gray card.

VARIATIONS ON THREE-DIMENSIONAL WORK

The principles outlined so far will apply to most kinds of three-dimensional artwork. But because it's impossible to address every variation in the limited space of this book, you must experiment to arrive at a treatment suited to your specific work. If your work is environmental, or if it is difficult to photograph independent of its exhibition space, refer to Chapter Five, "Exhibition Photography."

METALLIC WORK

Other techniques, both in lighting and in presentation, may be useful in photographing three-dimensional work, particularly if it's reflective in nature. Metallic work, for example, must reflect something light in order to appear shiny. The kind of broad, soft illumination that is appropriate to other three-dimensional artwork is also good for metallic work, but usually only as a starting point. You will have to augment it with reflectors, such as neutral white sheets or cards (matboard works well) propped up off-camera around the artwork. (For very large work, you may have to rob the linen closet.) Arrange the reflectors by inspection; keep looking through the camera's viewfinder as you reposition and reorient them, until any distractingly dark areas in the piece are brightened. Keep the number of reflectors to a minimum, because a very shiny piece may reflect the seams or dark lines where they meet. By the time you're done, the artwork may be surrounded by a veritable wall of reflectors, with the camera's lens poking through it.

In general, the larger the piece, the bigger the reflectors will have to be, but their size and position will also depend on the contours and surface characteristics of the piece. A piece that curves away from the camera, or that has a hammered surface, may require more reflectors on the side than a flatter, smoother piece. When larger metallic works require that the reflectors be placed at a significant distance from the piece, their effectiveness is reduced, and you may have to throw light back into the reflectors with additional bulbs. In fact, some pieces may be better served by bouncing light directly into the reflectors, regardless of their size. If you do this, be sure that no light enters the lens directly; baffle the lens if need be.

Lighting reflective work effectively involves striking a delicate balance. Work that reflects too much light too uniformly loses a sense of surface and volume in the photograph. Should this happen, or if you suspect it may happen, you can even substitute light gray reflectors for white ones, to reduce their reflectivity. Metal surfaces that are worked—whether hammered, sandblasted, or etched—scatter the light they reflect, solving many of these problems.

TENT LIGHTING

Work that is highly polished and smooth, on the other hand, is much more difficult to photograph. It acts as a mirror that reflects camera, tripod, reflector cards, and the light source itself. Although a carefully placed light source and reflector cards sometimes work, as described before, more often than not you must construct a translucent tent around the work to completely eliminate the environment it would otherwise reflect. See the illustration on page 78.

Tent Materials. Various kinds of thin white fabric can be used for a light tent, provided they transmit light readily. (Because they don't, bedsheets are unsuitable.) Fabrics with some "give" can be pulled taut to produce a smooth inner surface. White sailcloth is an excellent and relatively inexpensive tenting material, when you can find it. Sailmakers may sell you the ends of rolls; buy it in a lighter weight for greater translucency.

Neutral white plastic bags can also be used, but make sure their seams or the places you tape them together aren't reflected in the piece. A more professional approach is to purchase a commercial diffusion film from a photography dealer, preferably in a wide roll. (Cloth-like materials are also available.) Ask which weight is a satisfactory compromise between good diffusing properties and efficient light transmission. The nature of the material you choose for your tent will depend in part on the tent's size.

Pitching the Tent. Don't construct your tent until you've established your camera position, because the latter affects the tent's shape and size. Whether you're shooting your artwork against a flat or curved background, you will need to make the tent extend all the way from the camera to the edges of your background material. Tack it or tape it to the edges of the table you're shooting on, or to the floor. You will probably have to extend the material above the piece as well, unless its surfaces are strictly vertical. Cut a small slit or hole in the material to poke the lens through.

You may also have to construct a framework of sorts to support the tenting material, using wooden dowels or other rigid rods. Remember, though, that anything inside the tent may be reflected by the piece. Commercial diffusion film may be rigid enough to support itself, in small enough expanses.

In spite of the tent, if you're shooting a very shiny, frontal artwork you may see the reflection of the lens when you look through the camera. It will appear as a dark spot

OTHER SETUPS FOR THREE-DIMENSIONAL WORK

To eliminate the shadow of your artwork, photograph it either on milky (translucent) Plexiglas or on clear Plexiglas with a sheet of diffusion film or tracing vellum over it, backlighting it from below (top). This technique will make the background a pure white, and if not carefully controlled can reduce the sharpness of the edges of the work. An alternative, and one which permits the use of colored backgrounds, is to photograph the work on clear Plexiglas and roll out a seamless background paper below it, (bottom). In such cases, the light on the work itself may be enough to illuminate the seamless, but in others you will have to aim an extra light at the seamless. Either of these techniques requires that you turn the table you are working with on its side, as described in the text.

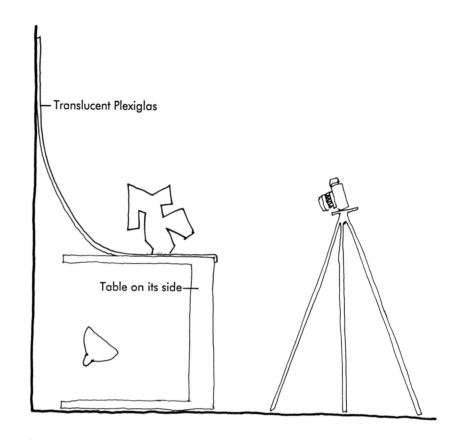

Translucent Plexiglas

Table on its side

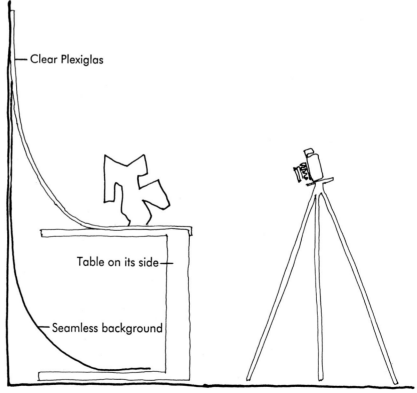

Clear Plexiglas

Table on its side

Seamless background

in the middle of the piece. Shooting from a different angle (try higher) sometimes minimizes or eliminates the spot, but may not represent the piece to your liking. Professional large-format cameras with independently moving backs can be used to prevent the effect, but in 35mm photography, it is very hard to control. When all else fails, it may be possible to retouch it out professionally for reproduction.

Lighting the Tent. Once you've constructed your tent, experiment with the position of the light or lights. Careful placement can make the difference between a metallic artwork that appears flat and washed out and one that looks brilliantly shiny. Lighting the tent from one side may make the other side of the piece darker, helping to preserve a sense of volume. Lighting from the top is a way of avoiding hot spots in a piece with mostly vertical surfaces. Be careful, as always, not to get your bulbs too close to the tenting material, to avoid melting or setting fire to it.

If you use your imagination, you may be able to improvise on the tent theme. Lampshades, large translucent plastic food containers or bottles (cut a strategic hole in them for the camera lens), and the like may be used for smaller objects such as jewelry, particularly if you plan to "shoot down" on them.

A professional shortcut in photographing a highly polished object is to use a commercial dulling spray. It's sold in an aerosol can and is often made by the same companies that manufacture spray-on fixatives. The spray is easily wiped off, provided there aren't a lot of nooks and crannies for it to get trapped in. However, dulling spray can alter the apparent surface characteristics of a piece, making its high polish look almost sandblasted. Use it only as a last resort.

OTHER SETUPS

Shiny three-dimensional work presents another problem. If you're shooting a standing piece against a curved background, its lower portions will often reflect the ground. If you're using a white ground and lighting a metallic piece with a tent or reflectors, this usually isn't a problem. But with a dark or colored ground it's a problem both for metallic work and other kinds of shiny work, such as high-glaze ceramics.

Plexiglas. The solution is to use clear Plexiglas as a background material, as mentioned earlier in the chapter. (If you're shooting against a flat background, as with jewelry, you can use a sheet of glass.) The Plexiglas must be large enough and flexible enough to substitute for the seamless. Once you've secured it, place a paper seamless (white or colored) several feet behind the Plexiglas surface, to mimic the curve of the Plexiglas.

You can't do this on an upright table, obviously, because the table and wall surfaces will be visible behind the Plexiglas. You'll have to turn the table on its side, with the top facing out toward your camera position and the legs pointing toward the wall. You can clamp the Plexiglas to the legs of the table to secure it. (It will have to be roughly the same width as the table for you to do this.) Alternatively, place a couple of sawhorses perpendicular to the wall and rest the sides of the horizontal part of the Plexiglas along each crosspiece. In either case, allow the Plexiglas to curve up the wall as if it were a regular seamless.

The important thing is to allow enough clearance behind the Plexiglas for the seamless (or other background material) to avoid a reflection or shadow. Secure the upper edge of the seamless to the wall behind the Plexiglas. Let it drop at

a steeper incline than the Plexiglas, curving out smoothly beneath it.

Reflection Control. If the seamless or other background is fairly dark in color, the foreground Plexiglas may reflect a faint mirror image of the work. This effect can be quite interesting, but if you don't like it you can minimize it by throwing additional light on the seamless to brighten it, baffling the light so that none of it spills onto the piece. It's not a bad idea to throw extra light on the seamless anyway, so that it will register as a bright, even tone. Don't overdo it, though; a colored ground shouldn't be more than a couple of stops brighter than your gray card reading. The light on the seamless shouldn't affect your gray card reading if you're careful to keep stray light out of the lens.

You may also be able to cut out some of the reflection of an artwork on a clear Plexiglas surface with a polarizing filter. Mount the filter on the lens, look through the viewfinder, and turn the filter's rotating ring until the reflection disappears or is most fully subdued. As always, be sure to keep the filter on the lens when you take your gray-card readings. Because the filter reduces the light reaching the film, it will force you to use slower shutter speeds or wider apertures to obtain proper exposure. Refer to the section on filters in Chapter Seven for further information about this filter. (Don't use top light with a Plexiglas background; it will create a distracting reflection behind the artwork.)

If you want to combine the clear Plexiglas/dropped seamless techniques described above with tent lighting, you're undertaking a very complex setup, even by professional standards. But it's often the ideal technique for artwork such as silver and jewelry. It allows you to use a darker background for heightened contrast and better definition

TENT LIGHTING

Silver and other metalwork can be photographed completely surrounded by a translucent tent, which eliminates any reflection of your working environment. Construct the tent from thin white fabric (sail cloth is excellent) or a commercial diffusion film once you have established your camera position. The tent should extend all the way from the camera to the edges of your background material. Tack or tape it to the edges of the table on which you're shooting.

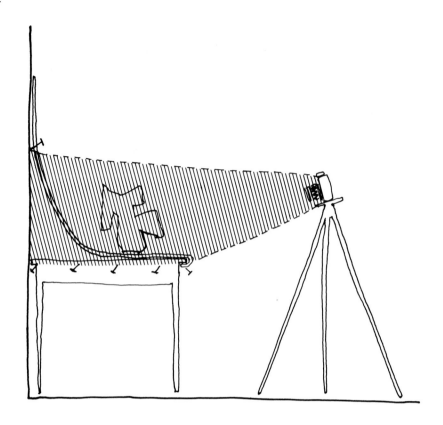

of the shape of a piece — without the risk of distracting reflections.

Transillumination. The clear Plexiglas technique is also quite effective in eliminating the shadow of an artwork, whether reflective or not. As mentioned, the seamless or other background must be far enough away from the Plexiglas and the artwork so that any shadow cast on it will fall out of the picture area. But you can also eliminate shadows by transilluminating, or backlighting, the surface that the artwork sits on. The surface must be translucent for this to work, and you will have to turn your table on its side as previously described. Keep in mind that unlike the clear Plexiglas technique, this approach limits you to a white background.

The ideal material for a transilluminated background is a sheet of translucent (milky) Plexiglas. But if you already have a piece of clear Plexiglas, you can place a large sheet of photographic diffusion film or heavy tracing vellum on it to make it translucent. A sheet of glass can be used to support these materials in a flat, shoot-down setup. If you need a curved background, but don't have either kind of Plexiglas, try placing a sheet of glass across the legs of your table to support the artwork, then run a sheet of diffusion film across it and up the wall, curving it as if it were a seamless. Some diffusion films may be stiff enough to support light artwork on their own.

Even Illumination. Again, you will need to leave enough room under your Plexiglas to illuminate it evenly. One light underneath will usually do, but if you are using a relatively large, curved background, you may need two. Choose bulbs of lower wattage than the 500-watt types you will be using to light the work itself. Careful metering of the front surface of the background will help you make the light both even and of the correct intensity. Don't overilluminate the background; a direct reading off it should be no more than three or four stops brighter than your gray-card reading, depending on whether you want to tone down or eliminate the shadows completely. If the backlighting is too strong, it may cause "fogging" of the artwork, or halation, a lightening of its edges. One advantage to this technique is that multiple light sources can be used without creating confusing double shadows.

SUMMARY/**THREE-DIMENSIONAL WORK**

- The quality of light required to photograph three-dimensional work should ordinarily be softer than the direct light appropriate for two-dimensional work.
- The light from tungsten photoflood bulbs may be softened by bouncing or diffusing it. A photographic umbrella permits controlled bounce lighting; a white plastic bag or shower curtain can make a good diffuser, although commercial diffusion films are available for this purpose.
- Three-dimensional work is usually photographed against a seamless background. The seamless can be of many different materials, but should be of a color or tone that creates good contrast between the artwork and background.
- Telephoto lenses, or zoom lenses set to longer-than-50mm focal lengths, can minimize distortion of the artwork.
- Attach your background material to the wall behind your working surface. It should be of adequate width to fill the viewfinder frame when the camera is at shooting distance.
- Roll out the material so that it forms a gentle curve on its way to the surface where the artwork will sit. The horizontal portion should be at least as generous as the vertical. Cut the length off and secure it to the working surface.
- Place the artwork on the horizontal part of the seamless, making sure it's not too close to where the seamless begins to curve up. Turn it so that the side you want to photograph is facing out.
- Set the camera and tripod at a distance from the work at which it fills the frame. (Don't, however, make it uncomfortably tight.) Adjust the camera height to suit the work.
- Light the work in a way that best describes its shape, contours and textures. With many three-dimensional works, this involves a single soft light source above and to the front and side of the work. Be conscious of how the shadow of the work falls on the ground, as well as of how the light falls on the work itself.
- If the shadows the work casts on itself (especially the shadow on the side opposite the light source) are too dark, fill them in by placing a white or silver reflector off-camera nearby.
- Making sure your camera's film speed control is set to the proper ISO for the film you are using, take a gray-card reading at the work to determine the proper exposure.
- When you take the reading, select an aperture small enough to provide depth of field adequate to encompass the visible depth of the work. Use the shutter speed needed to obtain proper exposure at this aperture.
- To appear shiny, metallic work must have something light to reflect. This may be just a few strategically placed white cards, or involve the construction of a translucent tent around the work.
- If metallic or other shiny artwork reflects the color of the background material it sits on, replace the seamless with a sheet of clear Plexiglas and run the seamless beneath it. (This will require turning your table on its side to create an open area under the Plexiglas.)
- To eliminate the shadow of an artwork, shoot it either on clear Plexiglas with the seamless background underneath, or on a translucent background material that can be lighted from behind.

FIVE EXHIBITION PHOTOGRAPHY

Many artists like to keep a photographic record of their exhibitions. Installed, an artist's work takes on a presence that photographs of individual pieces often don't convey. For this reason, you may even wish to include an installation view or two with a group of slides you submit to a gallery or museum, to give the curator a better sense of how your work will appear on his or her walls.

For some artists, the installation is the only occasion on which an artwork is whole. This is certainly true for artists who do sculptural work that depends on a specific space for structural and aesthetic support. It's also true for environmental artists, for whom the installation and the artwork are one and the same. Even conceptual work, in the absence of a physical "piece," depends on display for its form. For artists working in these areas, good photographs of work on exhibition are all the more imperative.

Although it's hard to generalize about such a broad range of potential subject matter and locations, the technique involved in installation photography is really more akin to that of conventional photography than to the photography of individual works of art. It's usually better, for example, to accept the existing light on installed artwork because of the difficulty involved in lighting large spaces realistically. And in adding your own artificial light to an installation, you may create discrepancies in color temperature, particularly if the existing illumination includes light from windows.

Whether you're shooting inside or out, think about the relationship of your work to its environment, and compose your photograph carefully. Remember that your three-dimensional perspective on the exhibition or installation will be reduced to a flat image, in which spatial information must be conveyed by two-dimensional cues. In photographing outdoor installations, avoid confusing backgrounds; in shooting an exhibition, avoid compositions in which sculptural objects and paintings overlap. Choose angles from which the components of the installation will be clearly separated—for example, from which a piece of sculpture in the foreground can be "placed" against an empty stretch of wall between two paintings. If this kind of separation can't be achieved by a lateral movement of the camera, you may have to shoot from a higher angle, if your tripod has enough extension. (Use a stool or stepladder to look through the viewfinder.)

Suppress your more artful instincts in shooting installation views. Don't compose in a way that distracts from the work on display.

WORK INSTALLED OUTDOORS

If your work is installed outdoors, your task is a relatively simple one. Remember to use daylight film, not tungsten film. Unless the light is very low and/or you can't use a tripod, choose a film of modest speed for its higher sharpness and finer grain: ISO 50, 64, or 100 slide films, ISO 50, 100, or 125 print films. Try to get a sense of how your work appears at different times of day and in different weather conditions, to establish what kind of light is most appropriate or flattering to it. It could be that bright, direct sunlight, seemingly the obvious choice, interrupts its continuity by throwing some parts of it into deep shadow and highlighting other areas too strongly. It's usually better to shoot

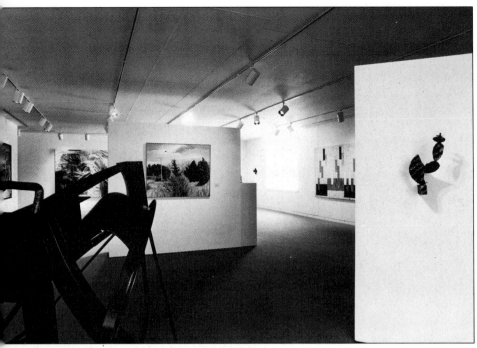

Courtesy Grossman Gallery, Boston Museum School.

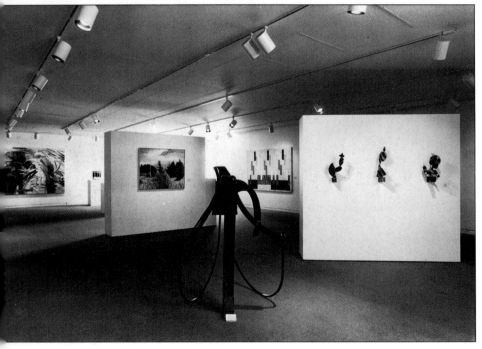

IMPORTANCE OF CAMERA POSITION

In shooting either indoor or outdoor views of an installed work or an exhibition, place your camera so that foreground and background elements don't overlap in a distracting way. The top view suffers from a lack of balance; most of the artworks are bunched up on the left. The bottom view is a more balanced composition. The difference between a clean and a confusing installation view may involve an adjustment in camera position of as little as a couple of feet. In general, avoid cropping artworks. Artwork on display is usually better served by quiet, classical composition.

by the gentler, raking light of a late afternoon or early morning sun, which enhances textures, throws long shadows, and produces an attractive warmth. Even the suffused light of dawn or dusk, just before or after the sun rises or sets, can give three-dimensional work a sense of volume and wholeness that direct light may not. This is also true of the broad, soft illumination of an overcast day. If you do choose either of the latter options, it's a good idea to put a warming filter on the lens to correct the blue cast that slides shot at these times of day can acquire. Either an 81A or 81B filter, both available in glass, is best for this.

While the higher shutter speeds outdoor light permits often make it possible to dispense with a tripod, it's not a bad idea to use one anyway. Using a tripod eliminates your own unsteadiness as a variable should your pictures come out unsharp, and perhaps more important, it tends to make you compose more carefully — to think harder about what points of view represent the artwork most cleanly and interestingly. You can also use slower shutter speeds than are possible if you're handholding the camera, should you need to set smaller lens apertures for better depth of field. This might well be a consideration in photographing a work that extends over a large area, especially if you're shooting it in low light. The improved depth of field available at smaller apertures also lets you create interesting relationships between near and far elements of your work, because you can make both parts sharp. Remember to maximize your depth of field by careful focusing, as described in Chapter Two. Refer to the box on pages 34 and 35 and to the charts on page 37 for details.

LENSES AND OUTDOOR INSTALLATIONS

A wide-angle lens, if available, can provide better depth of field than a normal lens, although you will have to get closer to the artwork to make it fill the frame. More important, it gives a better sense of the setting of an artwork because it allows you to make the piece fill the frame without cutting out as much of the background as will a normal lens. On the other hand, the change in perspective that goes hand-in-hand with a wide-angle lens may cause some artworks to appear attenuated from front to back, or cause the closest parts of the work to seem unnaturally prominent. With sprawling, large-scale works, outside or in, this effect may prove to be a problem even with a 50mm lens, in which event you should use a longer focal length. The greater camera-to-subject distance required by a longer focal length causes an apparent compression in the subject, bringing its elements back into a more natural-looking relative scale.

INTERIOR INSTALLATIONS

Inside, the requirements of installation photography are quite different. It's still advisable to shoot by available light, but because of its reduced brightness you'll need to use a tripod, and faster films. If the light is tungsten, use Ektachrome 160T; if it's from windows, use an ISO 100 or 200 daylight-balanced slide film. (In especially low tungsten light, you have the option of Ektachrome 320T.) If the light is exceptionally bright, you may be able to use slower films — in the case of tungsten light, Fujichrome 64T and Ektachrome 64T. Never use Kodachrome 40 in existing tungsten gallery light because it will render the

Ralph Helmick

EFFECT OF LENS FOCAL LENGTH ON OUTDOOR INSTALLATION VIEWS

It may seem unnecessary to use a wide-angle lens when your work is installed outdoors and you have unlimited space in which to photograph it. But the wide angle often gives a better sense of the environment of the piece. The top picture was taken with a 50mm lens; notice how distractingly prominent the background elements are. In the bottom picture, taken from a closer position with a 28mm wide-angle lens, the artwork is the same size, if not larger, but the background elements have been reduced in size. More of the immediate environment can be seen, including the entire bench at left.

light too warm.

For black-and-white prints, choose between an ISO 400 and an ISO 100 or 125 film. Use the 400 if light is especially dim, the slower speeds if you want the finest grain. If you need color prints, the choice of speed depends partly on whether you're shooting in tungsten light or daylight. In daylight, it's easy; use an ISO 100 or 200 color negative film. But because 35mm color negative films are all balanced for daylight, to shoot them in tungsten light you need to use a heavy blue filter on the lens to make the light's color match that of daylight. The filter reduces the light reaching the film by two stops. To compensate for that loss, go with an ISO 400 color negative film. (For a more detailed explanation, refer to the sections on making prints and using filters in Chapter Seven.) If you're shooting installation views in tungsten light, make your prints from tungsten-balanced slide films.

Even if the artwork in an exhibition area is lighted with tungsten spotlights, *don't* use a tungsten-balanced slide film if there is any significant natural light present; the film will render that component of the light as an objectionable blue color. Use daylight film instead. Even daylight film may pick up a bluish cast in daylighted areas of an inside installation — the effect of window light from an open sky, which is bluer in color than the 5000 degrees the film is typically balanced for. A 81A or 81B warming filter (described in Chapter Seven) may eliminate this cast, but it will make any pockets of tungsten light appear even warmer than the film would normally render them.

WAIT UNTIL DARK
In fact, unless the daylight in an exhibition space is particularly flattering to the installation, or if large windows are an integral part of the space, it's better to shoot at night, by the gallery's artificial light alone. That way, you can use a tungsten-balanced film. (If the space never sees the light of day, then fire at will.) Keep in mind, though, that because tungsten gallery lighting has a slightly lower color temperature than the 3100- or 3200- degree light for which most tungsten films are balanced, it will look a little warmer on film than the light from the color-rated bulbs you'd use to shoot individual works of art. Sticklers can place a cooling filter over the lens, such as an 82 or 82A, to neutralize the cast. But some people feel that it accurately represents the quality of artificial light — and absolute color fidelity is less important in installation photography anyway.

Fluorescent Light. In less well-appointed exhibition spaces you may have to contend with fluorescent lights. If tungsten light or daylight is the principal source, turn the fluorescents off; otherwise, they may create a greenish cast in the slide or color print. If fluorescents are the principal light source, use a magenta filter on the camera to eliminate the greenish cast. Because this filter, described below, will turn other kinds of light pink, you must block windows out or turn off tungsten lights. What's more, because the light produced by garden-variety cool-white fluorescents is closer in color temperature to daylight than tungsten light, use daylight film with the filter. A fluorescent light's type is printed on the end of the tube, and each type requires a different color filter correction to appear "normal" on film. (See the chart "Filtering for Fluorescent Light," page 100, for specific information, and page 110 for examples of the effect of fluorescents on color.)

Many filter manufacturers make a special filter that they claim corrects cool white fluorescent light so that daylight film "sees" it normally. But these filters, designated "FL-Day" and the like, often aren't quite strong enough to kill the green. Cool white fluorescents are quite effectively corrected, however, with a Wratten CC 30 Magenta filter, available in a square optical gelatin from Kodak, in square plastic resin and acetate filters from other manufacturers, and in screw-in glass filters. See Chapter Seven, "Filters," for details.

The best piece of advice is to avoid shooting under fluorescent light unless it's absolutely necessary. In addition to causing color variations, its quality is usually unflattering to the artwork.

LENSES AND INTERIOR INSTALLATION VIEWS
When shooting an indoor exhibition, you may find that your 50mm lens seriously limits how much work you can include in your photographs. Even with your back against the far wall, its relatively narrow angle of view — so well-suited to individual works — isn't wide enough to give a real sense of the scope of the show, or of the relationships between its parts.

A wide-angle lens, or a wide-angle-to-telephoto zoom set to its widest focal length, can solve the problem. Its wider angle of view will encompass, from the same position, a much larger part of an interior space. A 35mm focal length (often the widest setting on a zoom) is okay, but 28mm or 24mm is even better. Lenses with wider angles of view than 24mm should be avoided because of the distortion they can cause.

What's nice about zooms with wide-angle focal lengths is that they allow you to pick and choose your angle of view; you can use the narrowest angle that any given shot requires, to keep distortion at a mini-

Courtesy Grossman Gallery, Boston Museum School.

EFFECT OF LENS FOCAL LENGTH ON INTERIOR INSTALLATION VIEWS

A wide-angle lens is particularly useful for photographing exhibitions in small spaces. Both views above were taken from the same position, as far from the show as possible; the top photograph was shot with a 50mm "normal" lens, the bottom with a 24mm wide-angle lens. The wide-angle lens affords a much fuller view of the exhibition.

mum. To do so, get as far away from the work as the view you want to shoot will allow, then zoom to the focal length setting that covers it. Keep in mind, though, that the closer shooting position afforded by a wider angle of view creates more of a feeling of being surrounded by the show, rather than looking at it from afar.

There are several visual by-products—some might call them drawbacks—of the wide angle's ability to "see" a larger area. One is that it makes an interior appear bigger than it really is. (This effect seems more exaggerated in the camera viewfinder than in the finished slide because you can compare it to the real thing.) The perspective conveyed by horizontal lines seems more forced, and foreground objects seem larger in relation to background objects. This effect is detrimental when it causes foreground objects to overlap important background elements.

Keeping Verticals Plumb. Another wide-angle effect should be more closely watched, because it can be controlled. If the camera isn't kept level—that is, so that the film plane is parallel to the vertical lines in the image—the lens will make those lines appear to lose their parallelism to one another. This effect is a more extreme version of the distortions you correct when squaring up flat artwork. If the lens and camera are tipped upward, for example, vertical lines will converge toward the top of the image; if the lens and camera are tipped down, the lines will converge toward the bottom. Either effect is distracting, and can distort the shapes of the artwork, especially on the edges of the photograph. It happens to a lesser degree with a 50mm lens, so make a real effort to keep the camera level. A carpenter's bubble level or an angle finder

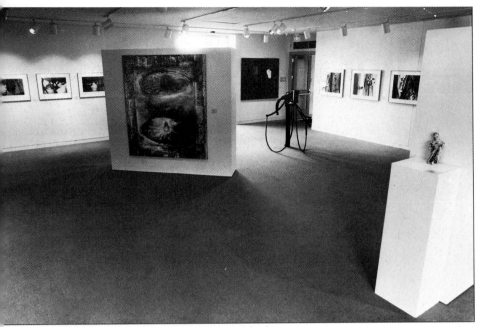

Courtesy Grossman Gallery, Boston Museum School.

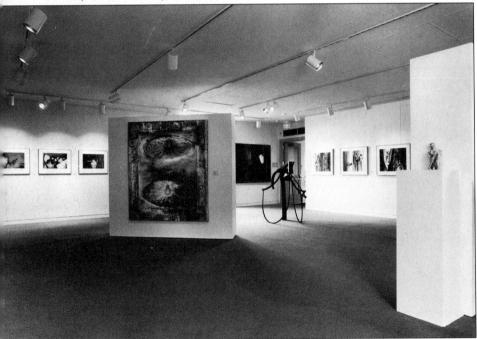

CORRECTION OF VERTICALS IN INTERIOR INSTALLATION VIEWS

One side effect of the wide-angle lens' better coverage is exaggerated perspective. This is usually only distracting when it skews vertical lines. To avoid the effect, shown in the top photograph, keep the camera level so that the film itself is parallel to the subject's vertical lines. This often requires that the height of the camera be lowered, as in the bottom photograph. However, there may be times when a higher camera position provides a clearer overview of the work on display, making the divergence of verticals a worthwhile trade-off.

can be useful for this.

Once you've leveled your camera, if you want to include more at the top of the image, rather than point the camera up, raise the tripod or its center column. If there's too much at the top, lower the camera rather than aiming it down. Your views needn't always be shot at eye-height.

At times, keeping the camera level may force you to include more of a pipe-filled ceiling or inelegant cement floor than you would like. The excess can always be masked out on the finished slide with opaque tape, or cropped or trimmed in a print, as described in Chapter Seven. If this isn't an option, if you feel that the ceiling or floor is too distracting, and lowering or raising the camera position makes the viewpoint too extreme, you may decide to allow a little distortion of verticals. There are trade-offs in any such shooting situation. If you think a high-angle view of the installation makes the most interesting, informative photograph, then you will have to accept the divergence of verticals toward the top of the image that this will cause. Special "perspective-correcting" lenses are designed to eliminate this kind of distortion; they do this by enabling the lens to slide in its mount parallel to the camera body, so as to include more or less of the ceiling or floor while keeping the camera level. So-called "PC" lenses are extremely expensive, however.

Depth of Field. Another argument for using a wide-angle lens in indoor installation photography is that at a given aperture and focused distance, its depth of field is greater than that of a normal lens. This is a real advantage at the closer shooting distances involved in installation photography, at which depth of field is shallower with any lens. But whether you're using a 50mm or

24mm lens, you should set reasonably small apertures whenever possible — especially if you want to show both very close and more distant works clearly. Use the depth-of-field scale on your lens barrel, or the charts on page 37, to determine how deep your zone of sharpness will be at a given lens aperture. Remember, too, that you can maximize your depth of field at a given aperture by focusing about a third of the way into your subject.

SHUTTER SPEED AND INTERIOR INSTALLATIONS

Given the low light levels of interior installations, you'll need to use slower shutter speeds to obtain the correct exposure. Don't hesitate to do so. The tripod will permit them by eliminating the possibility of camera movement. Any moving figures in your installation view will blur, but this can be an interesting effect, if not an entirely controllable one. You have two other options: one, to shoot when there are no people in the scene (you may have to arrange to work when the gallery is closed to the public), and two, to ask any visitors to stand still when you make your exposures. You can also plant some friends in the view. Which you prefer is a matter of taste: some like the spareness of an unpopulated installation view; others think it looks too sterile.

EXPOSING FOR GALLERY LIGHT

Determining proper exposure for gallery light is trickier than exposing for the controlled light you've used to shoot individual works. It tends to be uneven, often much brighter on the work itself than in the surrounding areas. If you let your camera's light meter determine exposure based on the overall scene, it will average these darker surrounding areas into its reading, and recommend or set a combination of aperture and shutter speed that will cause the artworks to be

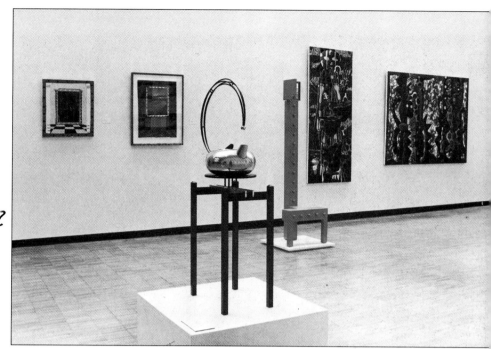

Courtesy Massachusetts Artists Foundation

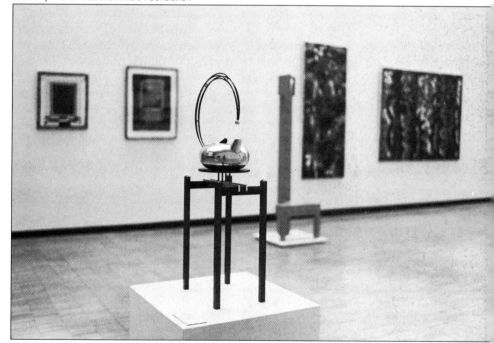

EFFECT OF DEPTH OF FIELD ON INSTALLATION VIEWS

It's usually best to maximize depth of field in an installation view, as in the top photograph, by using a reasonably small lens aperture. This will make all the artworks in the view as sharp as possible (top photograph). But there may be occasions when you want to single out your artwork, such as in a group show. You can do this by focusing on the piece and using a wide aperture to cause the background to be out of focus (bottom photograph). The wide aperture's shallow depth of field requires that you focus especially carefully.

overexposed—that is, too light—in the slide. For this reason, you should take your readings in the light falling on the artworks themselves, following the same procedure that you used in photographing individual works with your own lights.

Hold your 18 percent gray card in the light falling on a prominent piece or an important part of a large-scale work. If it's a painting or a framed work, hold or secure the card in the plane of the work; if the piece is sculptural, keep the card roughly vertical, depending on the orientation of the piece's major planes. Avoid angling the card toward any light source, whether window or spotlight, or you may get a false reading from the resulting glare. Fill your camera's viewfinder frame with the card. There's no need to focus on the card.

The camera will indicate the correct starting exposure for your installation view. If you've forgotten your gray card, either look for a value in the work that corresponds to a medium gray and take your reading off it, or (if your skin color is light) take a reading off the flat of your hand, then increase exposure by one stop to obtain the correct reading. You can either use a one-stop slower shutter speed or a one-stop wider aperture, depending on where these controls have been set. **Manual Vs. Automatic.** If your camera is in its manual exposure mode, simply leave the aperture and shutter speed set as they are, mount the camera back on the tripod, and start shooting, ignoring the camera's probable indication that your picture will be underexposed. If your camera only offers automatic exposure control, it will reset itself when you compose your view. You should override it, and there are several ways to do so, depending on your camera's features. One is to

hold the gray-card reading with the autoexposure lock button. If the button must be held down until the shutter is tripped, however, this makes for an awkward and potentially image-blurring approach.

A better way to override the exposure is by adjusting the autoexposure compensation control, or, if your camera doesn't have one, the film speed (ISO) control. Once you've remounted the camera on the tripod and recomposed the scene, adjust either control until the correct exposure—that is, the combination of shutter speed and aperture indicated by the gray-card reading—is displayed in the camera's viewfinder or LCD panel. This will most often involve adjusting the autoexposure compensation control toward the minus side, or the ISO control toward the higher numbers. Either change causes the camera to give the film less exposure than an averaged reading would have produced—compensating for the overexposure that the darker areas of the view might otherwise cause. In some lighting situations—a gallery view that includes bright windows, for example—you may need to make these adjustments in the direction of overexposure. For a more detailed explanation of overriding an automatic exposure system, refer to Chapters Two and Three.

Spot Readings. Some newer cameras will allow you to take a "spot" reading off a very small area of your subject from far away. This can eliminate the need to remove the camera from the tripod to take light readings. The spot reading is ordinarily calibrated for the 18 percent reflectance of the gray card as well, so be sure you place the viewfinder circle that indicates the "spot" either on the gray card in the light falling on the artworks, or on a middle-gray tone of one of them.

If the light levels on the various artworks in your installation view are radically different, you may have to average them together to determine a starting exposure—and some pieces will end up lighter or darker than others in the finished slide. Take gray-card readings in the center of each piece in the view you want to shoot, then use the median reading for your starting exposure, or split the difference. If one painting needs an exposure of ¼ second at f11, another ½ second at f11, and a third one second at f11, start with the ½ second exposure. If the light on most of the work is fairly consistent, but a few pieces are more brightly or dimly lighted, choose an exposure that favors most of the work.

Whatever your exposure, you should bracket it heavily, as described in Chapters Two, Three and Four. In a manual exposure mode, this involves changing the aperture and/or the shutter speed; in an automatic exposure mode, it means adjusting the autoexposure compensation control or resetting the ISO dial.

OTHER LIGHTING CONSIDERATIONS

Avoid or be wary of an interior installation in which portions are directly sunlit. The difference in brightness between the sunlit and ambient light-illuminated areas will be too great for the film to accommodate; depending on your exposure, the sunlit parts will be washed out, the ambient light-illuminated parts too dark, or both. If the sunlit portions are just small patches on the floor, having them blank may be acceptable if you can avoid taking averaged light readings that might be thrown off by them. But if the sunlit areas are large, important parts of the installation, wait for a time of day when the light on the exhibition is largely indirect.

SUMMARY/**EXHIBITION PHOTOGRAPHY**

- A photographic record of your exhibitions may make an impressive and useful addition to a set of slides of your work (or other supporting materials) that you plan to submit to a gallery.
- Installation views should be composed with the same care and visual thought that you invest in your own artwork. Use a tripod; it aids in composition, and permits the slow shutter speeds needed in the low light typical of exhibition spaces.
- A wide-angle lens or zoom focal length is very useful in shooting installation views. Inside, it lets you include more of the exhibition when limited space won't let you get far enough away to use a 50mm lens; outside, it can subdue a confusing environment, giving the work an extra prominence.
- When using a wide-angle lens, particularly for inside installations with vertical lines, keep the camera back as close to vertical as good composition permits.
- In most cases, exhibitions should be photographed using the light they are illuminated with. If the installation is lighted entirely or partially with daylight, use daylight film; if it's lighted solely with tungsten light, use tungsten film.
- If the lighting in an interior installation is a problematic mix of daylight and tungsten light, try to shoot after dark, when tungsten light is the only source and you can safely use tungsten-balanced film.
- If cool white fluorescent light is the principal light source, eliminate all other light and shoot daylight film with a CC 30 Magenta color correction filter.
- Depth of field is just as important in shooting an exhibition as it is in photographing an individual work of art. Use relatively small apertures to make sure that both the closest and farthest parts of the show are sharp. (Refer to the lens' depth-of-field scale or the charts on page 37 for guidance.) ✔
- To determine a starting exposure for an interior installation view, take a meter reading off the gray card, holding it in the light falling on a prominent work. If the light on the artworks varies greatly, take readings at several works and split the difference.
- If your camera only offers automatic exposure control, once you have established the gray-card reading and recomposed your view, adjust its exposure to match the settings indicated by the gray card, as described in the text.
- Because installation views may include areas of considerably different brightness, bracket your exposures heavily.

Have your film processed by a professional lab or a reputable photofinishing service. The energy you've invested in photographing your artwork is worth far more than the little money you save by patronizing a cut-rate or back-alley processing outfit. A good lab or photofinisher takes pains to ensure that the color of your slides will be true and consistent from one processed batch to the next, by running tests at regular intervals. It keeps its chemicals fresh, and its machinery clean so that it won't scratch your film. It will mount your slides straight, so that your efforts at framing, centering and squaring up won't be cancelled out. If your slides come back off-color, mottled, scratched or cockeyed, the processing and ''finishing'' may be at fault—although even a good lab will make a mistake from time to time. For a more detailed explanation of the sorts of problems you're likely to encounter, and what to expect from the photo lab, read on.

Do a little shopping for a lab or photofinisher. Prices can vary considerably, but professional labs will charge more than high-volume photofinishing services. The difference—a dollar or two per roll for slides—may be worth the individual attention your film receives, and often buys you technical advice as well. Many professional labs specialize in slide processing, while most photofinishers make their money in the snapshot end of the trade, and may not treat your film as well. They often send it to another facility, where it is entirely out of their control.

BLACK-AND-WHITE PROCESSING
Black-and-white processing and finishing is an altogether different story. Even a professional lab that does excellent color work may commit mayhem with your roll of black-and-white film. Because there is less demand for commercial black-and-white processing, the standards for it are lower. The problem is compounded by the more flexible nature of black-and-white materials; film development, for example, can be accomplished with any number of chemical formulations, and each gives a somewhat different result. And printing is as much art as science. Two rolls of film exposed exactly the same way and processed at two different places often produce very different results.

That's why it's a good idea to take your black-and-white film to a lab that specializes in black-and-white work—and once you've established that it's competent, to stick with it. Such labs have appeared in growing numbers in major cities, and will process and print your film with the special understanding required.

HOW LONG WILL IT TAKE?
Let the lab or photofinisher know that you've got important film to process—and that you went to a lot of trouble with to insure its proper color and exposure. If they sense you'll be a stickler, and fear their results might not be up to your standard, they may have the grace point you elsewhere. If you want to give them pause, ask how often they run a color test on their E-6 line—a reference to the standard processing chemistry and procedure for virtually all slide films. (The exception is for the Kodachromes, which still must be processed by specially equipped and licensed facilities.)

If you're in the habit of using one-hour photofinishers for your snapshot processing, you may find that these facilities can't do on-premises slide processing, and send their slide film elsewhere to be processed. This can slow the turnaround time to several days. Don't leave your film at a drugstore or other photo drop where it's likely to sit around for extended periods. Remember that careless storage can have an adverse effect on film color. Prepaid mailers (to which there may be no alternative in remote areas) put your film at risk in transit, since it gets handled like any other mail, and could spend a good part of its trip toasted by a mail truck's differential.

Rush Service. By contrast to most photofinishing services, a professional photo lab can usually turn E-6 process slides around in about three hours. If you're in a hurry for your slides, or if you want a quick result on a test roll so that you can be sure your setup is working before you proceed with the bulk of your photography, this is the way to go. And again, a professional lab's experienced personnel are usually available for advice, should you have questions about your results.

EVALUATING YOUR RESULTS
Don't despair if, in spite of your best efforts, the first film you get back from the photo lab or photofinisher is disappointing. While the techniques and equipment described herein should give you excellent results, a lot of variables are involved. Even professionals often shoot preliminary tests for color and exposure, so that they can make adjustments and corrections if necessary.

If possible, evaluate your results on a photo lab's lightbox. This special viewer has a color temperature of 5000 degrees Kelvin, the industry standard. In fact, many galleries will evaluate your artwork by scrutinizing your slides with a magnify-

ing "loup" on a lightbox, rather than projecting them. If you have access to a projector, by all means look at your slides with it; it can reveal a lack of sharpness that's not apparent when the slides are viewed on a lightbox. But in terms of color, a slide that looks fine in the yellowish tungsten light of a projector may appear somewhat blue in color on a lightbox, so use the box as a color and exposure standard whenever possible. Never evaluate your slides by holding them up to the light of a window, or to an exposed lightbulb. Even severely underexposed slides may appear fine with such a bright light source behind them.

For initial viewing, sorting and masking, you can improvise a lightbox by propping a piece of glass on books or blocks of wood, or between tables, leaving plenty of room underneath for a clip-on light fixture. Use a relatively low-wattage bulb — 60 or 75 watts — and place a sheet of heavy tracing paper over the glass to reduce and diffuse the light. If you have it, translucent Plexiglas can be used instead. Keep in mind that tungsten light will make the slide appear warmer (i.e., yellower) in color than it looks on a lightbox.

Along with lightbox evaluation, a good way to check the color of your slides is by comparing them to the artwork itself. To do this, you must view the slides in the same kind of illumination falling on the work itself. If you've got tungsten light on the piece, for example, hold a neutral white card — the back side of the gray card will do — so that the same light strikes it, then hold the slide in front of it, out of the light's path.

JUDGING COLOR

Look critically at your slides. Does the color seem true to the original? A neutral tone, such as a gray, or a pale or pastel color, is usually the best indication of the correctness of a slide's color. Slight variations in hue are harder to detect in brighter colors. In fact, it's customary in photographs of artwork intended for reproduction to include the gray card that you've been using to determine exposure, butting it up against the side of a painting or print or placing it as unobtrusively as possible in a three-dimensional setup. Any color shift is usually easier to detect in the card's neutral gray than in the colors of the work itself, and its inclusion is particularly helpful to the lab technician making a color print from a negative. He or she can use it as a basis for determining color filtration, then crop it out to make the final print. If included in a slide, the card can be masked out with special tape. But if the slide is intended for submission to a gallery or for other promotional uses, you may prefer to leave it out, and evaluate color on the basis of your knowledge of the work.

COLOR VARIATIONS

Color variations are likely to occur along two lines: one, from yellow to blue, and two, from magenta to green. Yellow and blue are complementary colors in light, as are magenta and green; these relationships form the basis for corrective filtration on the camera.

Slide Too Blue with Tungsten Film. If your slide is too blue, and you're shooting an individual piece in controlled tungsten light with tungsten film, the most obvious culprit is stray daylight. If you think this is the problem, simply baffle out the daylight more carefully. Better yet, shoot at night.

But there may be other causes for a blue cast. One is that you are using bulbs designed to produce 3400-degree light, such as the DXC type recommended in Chapter Two, with a film balanced for 3200-degree light — Fujichrome 64T or one of the tungsten Ektachromes. The most economical solution in this case is to shoot Kodachrome 40 film, which is balanced for 3400-degree light. A second alternative is to substitute bulbs rated for 3200-degree light, such as the EAL type recommended in Chapter Two, and stick with the same film.

The problem can also be fixed with warming filtration. An 81A filter on the lens will warm up the light reaching the film just enough to match that of 3200-degree bulbs — and thus give you good results with any of the "Type B" tungsten films, Fujichrome 64T and the two Ektachromes. In fact, as explained in the box on page 25, it doesn't hurt to use this filter as a precaution against a blue shift, which is sometimes difficult to diagnose. It's an especially good idea if your work is very delicate or pale.

If you're shooting three-dimensional work, you may notice that a white seamless tends to pick up a bluish cast if it recedes from your light source enough to darken. A warming filter may minimize this, but to eliminate it entirely you may have to add more light to the background. Dark grounds are less prone to this effect.

Slide Too Blue with Daylight Film. If your slide is too blue, and you're shooting exhibition views or work installed outdoors with daylight film, blue skylight is usually the cause. Some daylight films are more influenced by it than others; you might want to compare a few different emulsions. Short of switching to another film, corrective filtration may be used on the camera. An 81A or 81B filter will produce a visible warming effect, and even the clear ultraviolet (UV) or skylight filter that many photographers use for lens protection will eliminate some blueness. If you're shooting on an

overcast day, which can also cause a blue result, go with the 81B. Finally, time of day can affect the color rendition of daylight film; if your first results are too blue, try shooting at the end of the day, when the sun's long rays are warmed by atmospheric diffusion.

If you're using daylight film indoors, then you're probably shooting an exhibition of your work in a space that's predominantly or significantly window-lighted. If your result is too blue in these circumstances, you're more limited in the adjustments that can be made—especially if the work is illuminated at the same time by tungsten gallery lights. Often the daylit areas of the space will be rendered too blue, *and* the artificially lighted areas too yellow because of the way daylight film "sees" tungsten light. Using a warming filter to correct the blue area will make the artwork even yellower than it is already, so do so only if you can tolerate the extra warmth. To avoid the problem altogether, shoot at night with tungsten-balanced film.

If your primary light source is daylight, and your slide is exceedingly blue, one other possibility is that you accidentally used tungsten-balanced film. As described on page 23, a tungsten-balanced film "sees" daylight as extremely blue in color. If you must use tungsten film in daylight, an 85B filter will correct this cast—but it's a much better idea to match your film's color balance with the light source.

Slide Too Yellow. If your slide is too yellow, there are several possible explanations. If the cast is strongly yellow-brown, you may have used a daylight-balanced film in tungsten light. If you must shoot daylight film in tungsten light, an 80A or 80B filter will correct this cast. But it's a much better idea to switch to a tungsten-balanced film.

If you know you shot tungsten-balanced film, and the yellowish color is only slight, you may have photographed your work by regular tungsten illumination, rather than the light from the photoflood bulbs described in Chapter Two. Buying and using photofloods will solve this problem. But if you're shooting installation views, or individual pieces by existing tungsten gallery light, you can't change all the bulbs. If you still can't live with the warmth, use a cooling filter on the camera, such as an 82 or 82A.

Another possible cause of a yellowish cast is shooting Kodachrome 40 with tungsten bulbs other than the 3400-degree photofloods it is meant to be used with. If you used 3200-degree photofloods, the result will be slightly yellowish; if you used non-photoflood tungsten bulbs, it will be more so. Be sure to use DXC or EBV photofloods with Kodachrome 40.

Slide Too Green or Magenta. The other "axis" along which color variations may occur is the green-magenta. Although less frequent, color shifts of this variety are often due to processing problems. If you're using a professional lab, check with them to see if they've been experiencing any problems with their E-6 line. If they won't confess to any, consider the following possibilities; if none of them is a factor, shoot another roll and see if the color cast appears again.

Fluorescent light will definitely cause a greenish cast in your photographs if it contributes any significant part of the light in them. Turn fluorescents off, if possible. If you can't, use corrective filtration on the camera such as that described in the section on filters, and eliminate all other light, or else the portion of the lighting it contributes will be colored by the filter.

A magenta or reddish cast is more difficult to pinpoint. Both daylight and tungsten versions of Kodachrome can sometimes pick up a pinkish tint, for reasons not always easy to establish. But if you want to correct a consistent magenta tinge, you can use a green color compensating filter. In fact, almost any cast can be eliminated with proper filtration; for more details, see the next chapter. Before resorting to corrective filtration, though, try to eliminate the cause of the cast.

OTHER COLOR FACTORS
Another factor in the color of a slide may be the color of the room you took it in. If the room is small, some of the light illuminating the artwork may have first reflected off its walls, ceiling and floor—and if any of these surfaces has a strong hue, it can color the slide. Even light bouncing off a shiny wooden floor can contribute some warmth to the artwork. If you suspect the room, move to another of more neutral color, or cover the offending surfaces with white sheets. Remember that if you want to use a room's walls or ceiling as bounce-light surfaces in shooting three-dimensional work, they must be of neutral tone, preferably white, or else they will cause a color cast in the slide.

There may be times when you can't diagnose a chronic color problem, and in such cases it may be easier to use corrective filters on the camera. While some are available in the familiar screw-in glass types, specific corrections may require the purchase of gelatin, acetate, or plastic resin filters. See the section on filters for more information.

OTHER PROBLEMS
Color problems are more difficult to diagnose than any of the other complaints you may have about your finished slide. Solutions to problems not having to do with color fidelity

are usually more self-evident. Lack of squareness in a slide of a flat artwork, for example, can be avoided in your next attempt by more careful squaring up. Refresh your memory as to the proper procedure by reviewing the box on page 43, and be more patient next time.

If in the finished slide an artwork is shifted to one side or the other in spite of your having centered it in the viewfinder, you will have to get into the habit of placing it off-center in the other direction when framing and squaring it up. That way, it will end up in the center of the frame. This isn't ordinarily a problem, but if it is, know that the degree to which the image is off-center can vary greatly from one camera to the next.

Before you blame your camera or yourself for such results, also check to make sure the problem isn't in the slide mount. If the artwork is off-center to one side, tap the *other* side of the mount against a table to shift the piece of film. If the artwork is cockeyed relative to the inside edges of the slide mount, tap one corner of the mount, or turn the piece of film by gripping it on either side with your fingers, protecting it from smudges with a clean tissue.

This often solves the problem—but it may also reveal that the lab trimmed the film carelessly. If the mount is heat-sealed, usually the case with the cardboard type, pry it apart to evaluate it, then remount the film in a new plastic mount, available at most photo stores.

LACK OF SHARPNESS

Lack of sharpness in a slide or print can have a number of causes. One of the most common, yet most frequently ignored, is a dirty or smudged lens or filter. While a small sprinkling of dust will have a negligible effect on the image, a greasy fingerprint can make the sharpest lens render your artwork with a romantic fog. Grime can build up slowly, too. Refer to the box on page 18, Chapter One, for an explanation of how to clean a lens, and check yours frequently for cleanliness.

If your lens is clean and your slide is still unsharp, you may have focused incorrectly. At the smaller lens apertures that are advisable in photographing artwork, depth of field should be adequate to compensate for small errors in focus. But improper focus is a likely suspect in an unsharp image if some parts of your subject seem clearer than others. In a three-dimensional artwork, for example, if the closest part of the piece is sharp but none of the rest is, you focused in front of the piece, rather than a third of the way into it, as suggested earlier. If the background in an installation view is sharp, but the foreground fuzzy, you didn't focus close enough. (Flat work's lack of depth usually means the entire work will be either in focus or out.) If your camera offers autofocus, turn it off and focus manually.

Bad Vibes. An overall lack of sharpness is often due to camera movement during the exposure. If you hand-held the camera, your own unsteadiness is probably at fault. If you insist on holding the camera, you may need to use a faster shutter speed to avoid the problem—although this will force you to use wider apertures to obtain proper exposure and thus reduce your depth of field. It's better to use a tripod, so that you can set slower shutter speeds and rule yourself out as a variable.

Even with a tripod, there are a couple of ways that vibrations can reduce the sharpness of your slide. One is manual triggering of the shutter, that is, with your finger on the button, rather than with a cable release. Any hand pressure will shake the camera at the slow shutter speeds necessary in photographing artwork by tungsten light. If you've lost or forgotten the cable release, use the camera's self-timer to trip the shutter, setting it at its longest interval so that any vibrations have time to subside.

Vibrations also occur when you advance the film to expose successive frames. It's important to wait at least ten seconds after advancing the film before you trip the shutter again, to give the vibrations a chance to dissipate. Do it even if your camera has a built-in film winding motor.

Other less likely causes of lack of sharpness have to do with the lens itself. If it's been abused, its internal glass elements may have loosened, making it impossible for the lens to resolve an image clearly. The only solution to this problem is a costly repair. And older lenses can develop internal hazing, for which the only probable solution is to buy a new lens. Also, lenses tend to produce less sharp images at very small or very wide apertures. This has to do with certain optical properties of the lens, not with depth of field—and you're unlikely to notice it unless your lens is of very low quality.

Finally, if you're shooting color or black-and-white negative film, the print itself can sometimes come back unsharp even when your negative is fine. This doesn't happen often—it's usually due to a smudged or improperly focused enlarging lens—and the symptom is a complete and overall lack of sharpness. (Film processing errors can't cause a lack of sharpness; if an original slide or negative is unsharp, the problem is at your end.)

EXPOSURE PROBLEMS

Exposure problems—that is, results that are too dark or too light—are unlikely if you observe the rec-

ommendations made in these pages, and if you are careful to bracket your exposures. But sometimes they can be caused by a bad light meter, an inaccurate shutter, a sticky lens aperture diaphragm, or less often, a malfunctioning lens-to-camera coupling. A lens with an aperture diaphragm or coupling problem *must* be fixed. But if the culprit is your shutter or meter, you can attempt to determine just how far off the result is, and adjust for that difference when you calculate the proper exposure. If the result seems a stop darker—that is, less exposed—than it should be, you can add a stop to the exposure indicated by your gray-card reading by setting a slower shutter speed or a wider aperture. If you're using an automatic exposure system, simply set the autoexposure compensation control to +1 and leave it there. If your result seems a half-stop lighter—more exposed—than it should be, then decrease your indicated exposure by a half-stop, by setting a faster shutter speed or a smaller lens aperture. If you're using an autoexposure system, simply set the autoexposure compensation control to –½.

The problem with making these adjustments consistently is that a meter may be more or less accurate at certain light levels, and a shutter more or less accurate at certain speeds. Of course, in shooting artwork you're using a narrower range of speeds and light levels. But if you suspect a mechanical or electronic problem, you're better off getting it fixed than trying to predict its behavior.

As always, be sure to bracket your exposures, however you adjust them. Bracket them heavily if you're nervous about the result. Better to waste a little film than have to repeat the entire operation.

SUMMARY/**EVALUATING YOUR RESULTS**

- Have your color film processed by a reputable professional lab or photofinisher.
- Have black-and-white film processed by a professional lab specializing in black and white, if possible.
- The turnaround time on slide film processing is often short enough so that you can leave your setup intact and reshoot if necessary.
- When possible, use a 5000K lightbox to evaluate your slides. Don't hold them up to a window to judge exposure and color; the person you're sending them to probably won't.
- If you shoot tungsten film and your slide comes back too blue, it's due either to the presence of daylight or to using 3400-degree photofloods with film balanced for 3200-degree light. Eliminate extraneous light, use compatible bulbs and film, and/or put a warming filter on your lens. (If your result is extremely blue, you may have used tungsten film in daylight.)
- If you shoot daylight film and your slide comes back too blue, the problem is usually due to the presence of blue skylight, as in indirect window light or open shade. Use a warming filter if you must shoot in the same light again.
- If your slide is too yellow, you either shot daylight film in tungsten light, or tungsten-balanced film in light of lower color temperature than the film is designed for. If the problem can't be corrected by matching light and film more closely, consider blue filtration on the camera.
- If your slide is too green, it's often due to the presence of fluorescent light. (Fluorescent light will produce a bluish-green cast on tungsten film.) Use a CC 30 Magenta filter with daylight film if you must shoot under fluorescent light, and eliminate all other light sources.
- Shifts toward magenta or green are on occasion due to film processing problems. To determine this, shoot another roll to see if the problem disappears.
- The color of the room you're shooting in can contribute a cast to the work, particularly if the room is small and brightly colored.
- Color filters may be used on the camera to correct a chronic color problem. Consult your local lab if you're unable to determine which to use.
- Lack of sharpness can be caused by a dirty or smudged lens or filter; improper focus and/or inadequate depth of field; or camera movement.
- Incorrect exposure can be caused by improper light-metering technique and mechanical or electronic problems in the camera. If your slides are always underexposed, increase your exposure; if they are overexposed, reduce it. Always be sure to bracket your exposures, which may make up for such problems.

PHOTOGRAPHING SMALL ARTWORK

The 50mm "normal" lens that probably came with your camera doesn't focus much closer than two feet. And with longer lenses, and a good many zooms, you must be even farther away from a subject to focus it sharply. This limited close-focusing capability can prevent you from filling the viewfinder frame with small artworks such as jewelry and small prints. That means the work will be too small in the finished slide. Some photography labs can make a "custom" duplicate slide in which a portion of your original slide — your artwork — is enlarged to fill the frame. And in a custom print the image can always be enlarged and cropped to size. (If you're having a commercial print made, ask for a larger size and trim it down.) But any time you enlarge and/or duplicate the original image you compromise its quality, so it's better to make the original as much to your liking as possible. With small artwork, this may require the use of additional equipment, some of it moderate in price, some of it more expensive.

"Macro" Zooms. The solution, however, may be as close at hand as your all-purpose zoom lens. Many zooms offer a "macro," or close-focusing mode. If you own a zoom lens that has this capability, consult your lens manual to find out how it works. The macro mode on some zooms allows you to shoot a subject area as small as an index card, depending on what focal length is set. Set the longer focal lengths — 85mm, 105mm — if you have the choice; these will let you fill the frame more fully, and reduce the risk of distorting three-dimensional artwork. Longer focal lengths also place the camera farther from the artwork, which gives you more room for lighting paraphernalia. One word of caution: some zooms that tout themselves as "macro" won't get you especially close, and you'll still need additional hardware to do the job. Make sure a "macro" zoom gets you close enough to your work before buying it with that purpose in mind.

Macro Lenses. On the other extreme, the most expensive way to shoot small artwork is with a macro lens. A macro is a high-quality single-focal-length lens that can usually focus close enough to produce a life-size image of a subject on film. The most common focal length is 50mm, 55mm, or 60mm, but macros are also available in longer lengths — 90mm, 100mm, and 105mm, depending on brand. If you think you might buy one — and they aren't cheap — longer focal lengths may be more practical for very small artwork because of the additional working distance they put between the piece and you. On the other hand, the shorter focal lengths can double as a "normal" lens. (Macro lenses focus from their closest focusing distance all the way to infinity.)

In fact, if you're in the market for a new camera, and you create small artwork that you plan to photograph regularly, you might want to substitute a macro lens for the standard 50mm lens that is most often supplied with the camera. This will entail an additional cost, because macro lenses are more expensive than lenses of conventional design, but the lens' quality and ease of use may be worth the price. You may also be able to rent a macro lens, when you need it, from a local photo store.

Close-Up Lenses. A far less expensive alternative to the macro lens is the use of supplementary close-up lenses. Close-up lenses usually come in sets of three, and screw into the front thread of your camera's lens just like filters. (They're sized like filters, too.) Each one allows your 50mm (or longer) lens to resolve subjects in a specific distance range. Combining them gives the lens even higher close-focusing power, but may reduce the sharpness of the image. Check the instructions and experiment to see which lens or combination of lenses is best for your work's particular size. Special highly-corrected supplementary close-up lenses are available for longer focal lengths, but these are more expensive than the sets described above, which cost as little as ten or fifteen dollars. Use smaller lens apertures to avoid a loss of sharpness with any supplementary close-up lens.

Other Close-Up Equipment. Finally, you can increase the close-focusing capability of any lens by placing one or more *extension tubes* between it and the camera body. These hollow cylinders, which achieve their effect simply by placing the lens elements farther from the film than the lens alone can move them, must fit the particular lens-mounting system of your camera. More costly than most supplementary close-up lenses, they pose no threat to the sharpness of the image.

A similar option involves an actual bellows with hardware at either end that may or may not permit the usual automatic operation of the lens. But these units are more suited to the photography of very small objects, and can cost as much as a lens. Unless your work is literally postage-stamp size, you're better off purchasing a good macro lens. If need be, you can extend a macro's close-focusing range even

further with the use of the attachments described previously.

The Copy Stand. Unless your small artwork is freestanding, consider the use of a copy stand, described on page 51. In addition to its two-dimensional applications, the copy stand is also quite handy for small three-dimensional work on which you want to "shoot down"—jewelry or bowls, for example. It's awkward to shoot down with a tripod because you often have to overextend one leg, and that makes your rig unsteady.

Choice of Aperture. One of the most important things to remember in shooting small artwork (especially if it's three-dimensional) is that you must set smaller apertures than larger artwork would require. This is because at close focused distances, any lens' depth of field is shallower—and this creates the risk that part or all of the subject will be out of focus.

Smaller apertures lessen that chance. Stopping the lens down to an aperture of f16, or, if your camera offers it, even f22—a macro lens goes all the way to f32—may require the use of slower shutter speeds. You can make up for this by moving your lights closer to the work for additional brightness—an option because smaller work can be lighted evenly from closer distances. Be careful not to put delicate artwork at risk from the heat that the lights generate.

Focusing Close-Up Subjects. Because depth of field is shallow at such close distances, proper focusing becomes much more critical. A one-inch error in focusing a large work will be more than compensated for by the depth of field provided by moderate lens apertures (f8, f11). But in a small work, it can mean the difference between sharpness and fuzziness.

FILTERS

If the color temperature of your light source matches the color balance of the film you're using, in theory the colors in your slide should be true to your artwork. In practice, this isn't always the case. If you're convinced you're observing every precaution, and the color of your slides is still off, then you may find it easier to use filters over the lens to adjust the color.

HOW FILTERS WORK

Any colored filter works by blocking varying amounts of light complementary in color to the filter. (Color relationships in light are somewhat different than those in pigment. Red and green make yellow in light, mud in paint.) A yellow filter, for example, will reduce the amount of blue light reaching the film, thereby producing a yellower color slide. This is how the 81-series filters described in the box on page 25 work. In a black-and-white image, a yellow filter will make any blue object's tone darker relative to other values.

A magenta-colored filter will, for the same reason, reduce the amount of green light reaching the film. That's why it is recommended for shooting in fluorescent light, which produces a greenish cast on daylight film. The amount of complementary light a colored filter blocks is proportional to the strength of its color—and the stronger the color, the greater the "correction."

KINDS OF FILTERS

There are basically two categories of filters for color film, although they overlap and can be interchanged to some extent. One is the color conversion or light-balancing series, designated by a number in the eighties plus (in most cases) a letter/letter combination from A to EF. The color of these filters is based on differences in the color temperature of light, as discussed in Chapter Two. The 81 and 85 series filters are yellowish or yellowish-orange in color; the 80 and 82 series are bluish. The 85 series filters have stronger color, and a more pronounced effect on color film, than the 81 series, and the 80 series has a stronger effect than the 82 series.

Use of an orangy 85B filter, for example, will allow you to shoot tungsten-balanced film outdoors, because it makes daylight "look" like tungsten light to the film. A strong blue 80A filter will do just the opposite: produce correct color when you shoot daylight film in tungsten light. The 80A filter is useful when you want to shoot color negative film, which in 35mm is balanced only for daylight, in 3200-degree tungsten light.

A Delicate Balance. The 81 and 82 series light-balancing filters are more useful. As mentioned, an 81 series filter will give varying degrees of warmth to a slide, from the slight effect of an 81 to the strong warming of an 81C or 81EF. If your slides have a bluish cast, these filters will eliminate it if all other factors are the same the next time you photograph your work. If your slide has a yellow cast that you'd like to avoid next time, an 82 series filter will usually take care of it. The warm result that conventional low-intensity tungsten light will produce on tungsten film can be minimized or eliminated, for example, by using an 82A or an 82B filter over the lens. As with the 81 series filters, the effect of these filters is stronger with each successive letter. (See pages 114 and 115.)

Color Compensation. The other option in color filtration is the color-compensating filter, often designated with a "CC." These filters come in three sets of complementary colors: yellow and blue, ma-

genta and green, and cyan (blue-green) and red. Each color is available in a wide range of strengths, indicated by numbers, and will reduce the presence of its complement in a slide according to the size of its number. A CC 30 Magenta is more intense, for example, than a CC 05 Magenta, which is why it corrects the strong greenish cast caused by fluorescent light.

Filters of a given CC number have equal strength. A CC 30 Red will cancel out a CC 30 Cyan, for example, producing a neutral gray density. In fact, you can combine filters to achieve a given level of correction. A CC 20 Blue with a CC 05 Blue equals CC 25 Blue, while a CC 20 Blue with a CC 05 Yellow (the complement of blue) equals CC 15 Blue. The latter could also be achieved by combining a CC 10 Blue and a CC 05 Blue, of course.

Use of CC filters is, as with all color filtration, a somewhat subjective thing. A slide that someone else considers too yellow may look fine to you. But again, if you aren't happy with the color of your results, can't diagnose the problem, and plan to shoot again in the same situation, use a filter. The effect of any colored filter can be observed by placing it over the offending slide on a lightbox, as described in the last chapter. Consult with a professional lab if you want help determining the needed correction. (A chart for achieving color balance under fluorescent lighting is on page 100.)

OTHER FILTERS

If you're shooting outdoors, consider using a clear glass UV or skylight filter. It will eliminate the ultraviolet component of daylight that your film records, but that your eye doesn't see. Depending on conditions, ultraviolet can make a photograph of something look bluer or hazier than it actually appeared. Many photographers keep one of

these filters over the lens at all times to protect it, but if you're using other glass filters, it should be taken off to avoid loss of sharpness. Numbers 2A and 2B filters will cut out even more UV, but can make the image appear overly warm. (The 2A is the stronger of the two.) Ultraviolet filters are almost colorless, and their anticipated effect on a subject can't be observed on a lightbox.

In shooting black-and-white film outdoors in sunny conditions, a medium yellow filter will produce a more normal-looking sky in the print, improving cloud definition by deepening the surrounding blue areas. This filter is specifically designed for black-and-white work, and goes by such designations as "Y," "K2," or "Wratten #8" (the Kodak term), depending on the brand.

Polarizing Filter. A polarizing filter does the same thing for color film that a yellow filter does for black and white, deepening blue sky. But it is more useful, in both black and white and color, as a means of controlling or eliminating unwanted reflections. It works the same way as Polaroid sunglasses, minimizing the glare that can occur on the sides of high-gloss or heavily textured paintings, even when they're carefully lighted. (It is also useful in reducing glare on cracks and crazing in older paintings.) A polarizing filter will not, however, eliminate a direct reflection; the angle at which the light glances off the surface must be quite oblique. And because the filter is actually a microscopic grid, it must be oriented in a certain way relative to the light source in order to work. For this reason, it's designed to be rotated in its mount, and the effect of that movement can be observed through the camera's viewfinder. Turn it until glare, or an unwanted reflection, is at a mini-

mum. (The effect of this filter can't be observed on a lightbox either.)

The polarizing filter is even more effective if used in combination with polarized light sources. You can polarize your lights by placing a sheet of polarizing film (available from the mail order suppliers listed on page 125) in front of them. Make sure all light falling on the subject area passes through the sheet, but keep the sheet far enough away from the lamp to avoid melting or burning it. (Lighting polarizers are designed to withstand considerable heat.) If you orient the sheet so that its grid is perpendicular to that of the lights, reflection can be virtually eliminated.

The effect, called *cross-polarization,* can be observed in the camera's viewfinder. But you will notice an overall darkening of the image in addition to the change in the reflection or glare. Indeed, it reduces the light reaching your film dramatically, requiring a three- or four-stop increase in exposure time and/or lens aperture size to obtain correct exposure. (More light or higher-speed film will counteract this to some extent.) Cross-polarization may also turn specular highlights (the actual reflection of the light source) a violet color, and will increase the contrast of your slide considerably. Both single- and cross-polarization tend to increase the intensity of colors in your work. Nevertheless, the technique can be useful in eliminating the reflection of your light source on shiny non-metallic, three-dimensional pieces, such as high-glaze ceramics.

EXPOSURE CORRECTION WITH FILTERS

Any filter will reduce the total amount of light reaching the film. With filters of moderate density or color, such as the 81 or 82 series, or the lower numbers of color-correcting filters, this reduction is very

FILTERING FOR FLUORESCENT LIGHT

The most frequently used fluorescent lamp is the cool white type. Its effect on your artwork's color will be reasonably accurate if you use daylight film and a CC 30 Magenta filter as described in the text. The chart below tells you the film to use and the proper color filtration for other kinds of fluorescent light. If only one film type is given, it is because it is much closer in terms of color balance to the lamp's light, and thus requires the least amount of corrective filtration. (If you want color negatives for prints, consider Fujicolor Reala film, which has an ISO of 100. Its emulsion is specially designed to produce more accurate color in mixed and fluorescent lighting, without filtration.)

Fluorescent Lamp Type	Film Type and Color Filtration
Cool White	Use daylight film with CC 30 Magenta filter
Cool White Deluxe	Use Type A film (Kodachrome 40) with CC 10 Red + CC 10 Yellow filters or Type B film (tungsten Ektachrome) with CC 10 Red + 20 Yellow filters
Warm White	Use Type A film (Kodachrome 40) with CC 20 Magenta + CC 10 Red filters or Type B film (tungsten Ektachrome) with CC 10 Magenta + CC 20 Red filters
Warm White Deluxe	Use Type A film (Kodachrome 40) without filter or Type B film (tungsten Ektachrome) with CC 10 Yellow filter
White	Use Type B film (tungsten Ektachrome) with CC 40 Red filter
Daylight	Use daylight film with CC 30 Red + CC 10 Magenta filters

slight. With a color conversion filter such as an 80A, however, it is as much as two stops, a reduction that may force you to use overly wide f-stops or awkwardly slow shutter speeds. If you're using such filters, consider the use of higher-speed films or extra light.

Your camera's through-the-lens meter will compensate reasonably well for the addition of a filter of moderate effect (and/or of neutral color, such as the polarizing filter), indicating the need for slight adjustments in aperture or shutter speed.

Just take your gray-card readings with the filter in place, and follow the camera's recommendations. With filters of strong color, the filter's effect on the colors of your artwork — particularly if a single color predominates in it — may begin to throw off your camera's meter. In this case, it's advisable to bracket your exposures even more heavily than you ordinarily would.

If you want to be sure the increase in exposure that your camera recommends (or sets) is correct, check the *filter factor* of the filter you want to use. For a glass filter, it will usually be indicated in the literature supplied. A filter factor of 2, for example, means that exposure must be increased by a stop (i.e., doubled) if the filter is used; if it's 3, by a stop and a half; if it's 4, by two stops. In fact, you have the option of taking your gray-card readings without the filter in place, then increasing the indicated exposure by the factor recommended for the filter.

GLASS VS. OTHER MATERIALS

Most commonly used filters are available in glass-mounted, screw-in types. The main advantage of glass filters is that they are relatively scratch-resistant and can be easily cleaned when they become smudged or dirty. Be sure you buy them in a size that fits the front thread of your lens.

If you can't get a specific filter in glass, you may have to buy it in one of several other forms, all square rather than circular. The most common is the optical gelatin, manufactured by Kodak. "Gel" filters come in different sizes; choose the three-inch square. It will cost as much as a glass filter, but is much more delicate. Gelatins can't be cleaned, so treat them with extra care, returning them to their foil package when you've finished using them. Store them in a cool, dry place; heat and

humidity can cause them to warp and buckle.

Because gelatin filters aren't rigid, you'll have to improvise a cardboard frame for them, or purchase a commercial cardboard frame, a clip-on filter holder, or a metal filter frame. A cardboard or metal frame will then have to be taped to the lens. (The clip-on type eliminates that awkwardness; screw-in holders are also available. Check your thread size first.) One advantage to gelatin filters is that you can use as many as three sandwiched together when a specific color correction demands it. That's a bad idea with glass filters. The other advantage is that virtually every kind of filter is available in gelatin.

Several manufacturers produce square filters out of other materials. One type, made of plastic resin, is rigid and can be cleaned and even polished to eliminate scratches. Optical polyester filters (not to be confused with the acetate type designed for use in an enlarger) are thinner and more like gels, except that they're less susceptible to heat and humidity and can be cleaned. Polyester and resin filters will both require some sort of mounting solution, and their manufacturers offer proprietary holders.

Which brings us to the bottom line: cost. Glass filters vary quite a bit in price, depending on their size, type and manufacturer. For your purposes, there's no need to spend a lot; for under fifteen dollars you should be able to get a colored filter made by a company that specializes in filters. (Camera makers' filters tend to be pricier.) A polarizing filter is usually twice as expensive because of its special design. Plastic resin and polyester filters vary in price, but the polyester type is cheaper. For practicality's sake, buy filters in glass whenever possible.

DUPLICATING SLIDES

It's hard to predict just what the demand for slides of your work will be, and there may be times when you have to make duplicates. Although a dupe is never as high in quality as a good original slide, a reputable professional lab will have its duplicating process down to a science that brings it pretty close. One of the drawbacks to duping a slide is that it can increase the contrast of the original, making a slide with subtle hues and tonalities look harsher in quality. If the original is rather flat-looking, on the other hand, duping can give it the extra snap it needs. (Pushing film, described later in this chapter, is a way of increasing the contrast of an *original* slide.)

If you have a choice of lighter and darker exposure brackets, dupe the darker one, provided it's of acceptable exposure. This is particularly important if the slide has light highlights, because the increase in contrast in the dupe can cause them to be washed out. Keep in mind, too, that duplicating a slide necessarily crops a small part of the outside of the image area. For this reason, if you're making a slide specifically for duping, you may want to leave a little more margin than you ordinarily would.

CUSTOM DUPING

Duping can also be a way of correcting problems in an original slide, although you will have to pay the lab "custom" prices — usually two or three times the cost of a regular dupe — for this service. If your slide has an unwanted color cast, the lab can make a duplicate in which filtration is used to compensate for it. (See "Color Compensation," page 98.) A bluish cast can be corrected with yellow filtration, for example. A lab can also lighten a dark original.

A duplicate slide can also be made in which a portion of your original is enlarged to full-frame 35mm size. This service may be useful if, for some reason, you weren't able to get close enough to your artwork to make it fill the frame — for example, if you had to shoot small artwork with a 50mm lens and no close-up attachments. But excessive enlargements of this sort should be avoided. They compromise the quality of the original.

A custom lab can also make an *enlarged* duplicate transparency for you, blowing up your 35mm slide to 4×5-inch or even 8×10-inch size. You will pay prices many times higher than those for 35mm-size duplicates for this service, but it may make for a more impressive presentation in cases when larger formats are acceptable. An enlarged duplicate is never a substitute for a good large-format transparency, the quality of which it can never approach. For reproduction purposes, you're better off using an original slide than an enlarged duplicate.

MASKING SLIDES

The two-to-three ratio of the 35mm format — a rather long rectangle — is often unsuited to the proportions of your artwork. If your work is two-dimensional, the closer it is to a square, the more empty area there will be on either side of it in the finished slide. This can also be a problem with three-dimensional work, although if the background material fills the frame, it may still look presentable. Black paper behind a two-dimensional work will eliminate extraneous details, and give the artwork more brilliance in the contrast it provides. (With a dark work it may be better to substitute white paper or a white sheet.) If projected, however, even the blackest background will transmit some light, showing the surface texture of the material.

Masking a slide.

You can prevent this by masking these areas out with a thin, opaque tape made especially for use on slides. Leitz produces it in a shiny silver version, Kodak in a black, somewhat thicker one. Buy it in as narrow a roll as possible.

RIGHT SIDE UP

When you mask a slide, you must always place the tape on the *base* side of the film, never the *emulsion* side. If you try to reposition tape placed on the emulsion side of the film, you may tear the image off. The base side of the film is the side that faces you when your subject is correctly oriented (not reversed) in the mount. It is also completely smooth, in contrast to the emulsion side, which looks bumpy when you hold it at an angle to the light.

To mask the slide, cut a piece of tape quite a bit longer than the short side of the slide's image area, which is probably the side you'll be masking. This will give you a "handle" to grip when positioning it. If you have to cut the tape lengthwise to make a narrower strip, always orient the precut edge (the edge from the outside of the roll) toward the artwork, so that its line will be perfectly straight. Place the tape against the slide, letting it run over the mount on the long side of the image area, and keeping it parallel either with the edge of a two-dimensional work, or in the case of a three-dimensional work, with the inside edge of the slide mount. If the tape's cockeyed, pull it up and reposition it. If you'd rather, put a second piece over it to correct the edge. (This will also eliminate occasional pinholes in the tape.) If you're fussy about the look of the result, you can take the slide out of the mount to mask it, then remount it.

Cut off any excess tape, letting it extend onto the slide mount from the image area. Don't trim it at the inside edge of the mount. Keep the roll of tape in a plastic bag; if you don't, the edges will pick up lint and dust, which if projected will be magnified many times.

Don't mask slides before duping them. Although a professional lab may be able to produce a good dupe from a masked slide because each original is assessed by hand, a commercial photofinisher's automated averaging system may try to adjust the dupe for what it sees as an extremely dark original slide. The result may be an overexposed dupe.

CLEANING SLIDES

If you want to dupe an original slide that's seen a few fingers in its day, you should clean it carefully beforehand. Commercial film cleaning solvents are available in small bottles; be sure you get one that's designed for color film. Apply it with a surgical-quality cotton ball; wet each side of the slide with a circular motion, then buff the slide lightly with a dry cotton ball.

SHOOTING NEGATIVE FILM

Nine times out of ten you will be making slides of your work. On some occasions you will need prints, though, and this may require the use of different films than those discussed earlier in the book. "Print" films, as they are sometimes called, reverse the tones and colors of the subject, and from the resulting *negative* any number of positive prints can be made. A slide, by contrast, is the film that you actually ran through the camera.

A high-quality color print can easily be made from a slide, and if you're shooting by tungsten light this is probably the best route to take. Commercial photofinishers usually make a throw-away internegative from the slide, then make the print from it. A professional lab can also make a print from an internegative of your slide (this is sometimes called a *C-print*), but they'll charge you at least ten dollars for one internegative, and as much for the print. They can also make a *reversal print* directly from

the slide, but that's not cheap either. You get what you pay for; the quality of a lab's print is better because it's made by a human being instead of a machine. The choice depends partly on how you're using the print.

PRINT GRADES

Professional labs usually offer several grades of print, whether color or black and white. The least expensive buys you a limited amount of darkroom manipulation, should it be needed. But tricky or poor-quality negatives (or slides) may require extra work, and this costs more. It behooves you to be meticulous in your lighting and film exposure technique. The extra money also usually gets you a print over which you have final approval; within reason, the lab will reprint it as many times as necessary to make it to your liking.

There are limits to what a color or black-and-white printer can do, however. Printing is a somewhat interpretive science; color can be added or subtracted at will, and exposure can be varied to make the image lighter or darker. Because the printer has never seen your work, he or she may print it wrong. This is a particular risk for a color negative, which bears little resemblance to its subject. A slide, on the other hand, is its own positive standard; if it's accurate, the printer simply needs to make the print match it as closely as possible. In fact, if you're having a print made from a color negative (even a black-and-white negative), it's not a bad idea to leave a good slide of your work with the lab.

Gray Card. If you're planning to make a slide or negative specifically for printing and/or for reproduction, it's also a good idea to leave the gray card you've been using for light readings *in* the photograph, if this can be done discreetly. With a two-

dimensional work, simply butt the card up against the edge of the piece. With a three-dimensional work, prop it up along the edges of the frame so that it can be cropped out in the print. Make sure it's in the same light as the piece itself, not in shadow. Even a narrow strip of the card can be useful to the printer; its neutral gray gives him a known value and color standard on which to base his exposure and color filtration. Mention to the lab's clerk that you've included the gray card in the photograph.

BLACK-AND-WHITE FILM

Black-and-white film reduces the colors of your artwork to shades of gray, making a black-and-white print an imperfect record of your artwork at best. But you will have to supply black-and-white prints of your work at times, usually for publicity purposes and newspaper reproduction. And in an inexpensive halftone reproduction, a good print can mean the difference between a reproduction that is pure mud and one that is crisp and clear.

Getting a good black-and-white print is easier said than done because of the often poor quality of commercial black-and-white work. Professional color labs that do excellent color work can botch your black-and-white film, canceling out your time and effort. As described in the last chapter, your best bet is to seek out a photo lab that specializes in black and white. As an alternative, consider having a photography student do the necessary darkroom work. If neither of these options is available, you may be better off sending your film to Kodak than entrusting it to a color lab.

B&W and Light. One advantage to black and white is that for all practical purposes, the film doesn't "see" the differences in the color of light that can create such problems when you're shooting color. You can use

tungsten light, daylight, or a combination of the two, although the tungsten lamps recommended in Chapter Two permit greater control over evenness and brightness when you're shooting individual works. In a pinch, you can shoot by window light, in overcast, or in open shade, without corrective filtration—provided the light's quality is appropriate to the subject. And with installation views, you needn't worry about mixed lighting.

As with color, you should choose a black-and-white film with fine grain and good sharpness. That way your artwork will be clearly and smoothly rendered in the print. An ISO 100 or 125 film, such as Kodak's T-Max 100 or Plus-X Pan, is a good choice because it offers reasonable speed in addition to fine grain. It's not a bad idea to give black-and-white film a little extra exposure by setting your camera's ISO control to 80 (for an ISO 100 film) or 100 (for an ISO 125 film), or even lower, because many processors give the film less than optimum development. Nonetheless, you should bracket your exposures just as you would when shooting color film, to give the printer a choice of negative densities. Bracket in half stops.

"Faster" black-and-white films may be useful in photographing installation views in low light. Even in an 8 × 10-inch enlargement, today's ISO 400 films display surprisingly fine grain. But if you're using a tripod, longer exposures should make the ISO 100 or 125 film practical even for this application.

COLOR NEGATIVE FILM

All 35mm color negative films are balanced for daylight. Shooting them in tungsten light results in a negative that, if uncorrected, will produce a print with a strong brownish-yellow cast. The negative can be made to produce a normal-

looking print through careful filtration in the enlarger—not very likely with a machine-made, mass-produced print. A custom lab may charge you a premium for a print requiring such an extreme correction. If you want to shoot color negative film, it's best to filter it on the camera with an 80A color conversion filter, which makes tungsten light "look" like the daylight the film wants to see. (If your prints come back with a blue cast in the highlights, substitute an 80B, a slightly less strong filter in the 80 series.)

Because the 80A filter reduces the light reaching the film by two stops, you may want to use a relatively high-speed film. Today's ISO 400 color negative films are sharp and fine-grained, so that speed is a good choice. When filtered with an 80A filter, a film with an ISO of 400 will require exposure settings equal to those of an unfiltered ISO 100 film. The camera's through-the-lens meter should indicate these settings when the filter is in place, so you should set the film speed dial to the recommended ISO 400 if you use such a film.

If you're concerned that the colors in your work might throw off a through-the-filter meter reading, take a gray-card reading without the filter and increase the indicated exposure by two stops for filtered photographs. (Refer to page 98 for an explanation of filters.) If you elect to use a color negative film with finer grain, such as an ISO 100 or 200 film, be prepared to set slower shutter speeds to make up for the light loss caused by the filter. As always, bracket your exposures to give the printer a good range of negatives to choose from.

Color negative films yield finer grain if overexposed slightly; an extra third- or half-stop of exposure actually makes the negative print

better. Bracketing your exposures will produce such a negative if your starting exposure is correct. But if you want to build this extra exposure into your ISO setting, reduce it by one notch or number from the film's nominal ISO. For ISO 400 film, for example, set the film speed control to ISO 320; with an ISO 200 film, set it to ISO 160.

"PUSHING" FILM

"Pushing" is the popular term for giving photographic film extra development to compensate for underexposing it. The technique lets you take acceptable pictures in light that otherwise might be too dim to permit good exposure. In better light, it lets you use higher shutter speeds or smaller apertures—an important consideration in photographing art, as you know by now.

You push film by setting a higher ISO number than the one the manufacturer recommends. That makes the camera's meter think the film is more sensitive to light than it really is, and thus recommend less exposure than the film would ordinarily need. If film exposed this way is developed normally, the result is a slide that's too dark. But if the film is given extended development, chemical action adjusts for the underexposure—making the finished slide's density acceptable, although with certain trade-offs.

Pushing film *one stop* will allow you to use a one-stop faster shutter speed, a one-stop smaller lens aperture, or a half-stop combination of the two. (The smaller aperture can be especially helpful in improving depth of field with three-dimensional artwork, as you know.) Set your camera's film speed (ISO) control to a number double that of the recommended ISO for the film; with Ektachrome 64T, for example, set the control to 125 instead of 64. When you deliver the film to the

photo lab, specify that it be pushed one stop. Keep in mind that it's very important to bracket your exposures when you intend to push your film—and that when you decide to push-process, you must expose the whole roll at the higher ISO!

One side effect of pushing film that can be either an advantage or a drawback is the increase in image contrast that it causes. Even when you don't need the extra speed, the technique can be used to produce a better slide of an artwork with very close values and low inherent contrast, as illustrated in the color plates on page 111. If a one-stop push produces too contrasty a result, try a one-third or one-half stop push. For a third stop push, set your ISO control one notch or number higher than the film's recommended ISO (increase Ektachrome 160T's setting from 160 to 250, for example) and ask that the film be pushed a third stop. Because film speed is calibrated in third stops, to get an accurate half-stop push you should reduce the exposure manually; either set the aperture one-half stop smaller or the shutter speed one-half stop faster. Most custom photo labs will push film to exact specifications, but do so either in one-third or one-quarter stop increments. Check with them before you make any adjustments.

Be sure to patronize professional labs for this service, confining the technique to E-6 process films like the Ektachromes and Fujichromes. Note that pushing film will make an already contrasty subject—such as an installation view with spotty light—even more contrasty, reducing detail in either the highlights, the shadows or both. Pushing film may also change the slide's color slightly.

SUMMARY/**PROFESSIONAL TIPS**

- Since conventional lenses usually won't focus close enough to let you fill the frame with small artwork, you'll have to resort to other methods. If you have a zoom lens with macro capability, it may solve the problem; otherwise, you'll have to use supplementary close-up lenses, lens extension tubes, or a special macro lens.
- Depth of field is extremely shallow at close focusing distances, making correct focus even more important. Small apertures should be used to increase depth of field.
- Filters may be used on the camera to control or alter the color rendition of a slide; they usually work by reducing the amount of light of complementary color reaching the film. The stronger a filter's color, the more light of complementary color it blocks.
- A polarizing filter may be used to control some kinds of reflections and glare, and will darken a blue sky. Its effect can be observed in the viewfinder, and controlled by rotating the filter in its mount.
- A filter reduces the total amount of light reaching the film. In most cases, your camera's through-the-lens metering system will adjust the exposure it recommends or sets to compensate for that reduction. Taking the light reading off a gray card will prevent any error.
- If you're shooting in tungsten light and want color prints, it's better to have them made from a tungsten-balanced slide than from a color negative. (Thirty-five millimeter color negative films are only balanced for daylight.)
- If you need to shoot color negative film in tungsten light, an 80A or 80B filter's deep blue color will make the light "look" like daylight to the film. Because the filter substantially reduces the amount of light entering the camera, it must be compensated for by the use of longer shutter speeds, wider lens apertures, or brighter light. Your camera's meter should indicate these corrections.
- When you're shooting color negative films, leaving a gray card along the edge of the artwork will help the printer establish the correct color filtration and exposure for the print.
- Negative films generally produce better prints if given a little more exposure than the gray-card reading would indicate. You can build this extra exposure into your reading by setting a slightly lower ISO than that recommended for the film you are using.
- "Pushing" film means extending a film's development time to adjust for deliberate underexposure of the film.
- To expose film for "push" processing, you set a higher ISO than that recommended for the film. Because that makes the camera think the film is more sensitive to light than it actually is, it will recommend (or set) smaller apertures and/or faster shutter speeds.
- Pushing film also increases the contrast of a slide or print, which may produce a crisper image of an artwork with close values.

STAINED GLASS

Stained glass is among the most difficult two-dimensional artwork to photograph because it must be evenly backlighted. Pieces that contain opalescent or hand-painted glass, such as this handsome nineteenth-century window by John LaFarge, above, benefit from additional frontlighting, which in this case shows off the work's intricate leading and wooden frame.

TOP LIGHT AND THREE-DIMENSIONAL WORK

Top light is often an effective alternative to side light, and some artworks are better served by it. Its quality can be controlled with the same techniques used for side lighting. In the photograph at bottom right, the light source has been diffused with a sheet of translucent sailcloth; commercial diffusion film would have worked as well. Notice the soft shadow directly beneath the wooden bowl. The background is gray Formica bent into a gentle curve, and the light source has been carefully baffled to create a gradual dropping off of light toward the upper portions of the background.

In the Egyptian head, at top right, a single, undiffused light was used. The light color of the piece serves as a natural "fill," keeping the resulting shadows from being too dark; this lighting would not have been as effective with a darker piece. This treatment even suggests the bright, direct sun of the work's origin.

Courtesy Boston Museum of Fine Arts

Gary Gilman

Most of the principles and techniques illustrated on these pages are just as applicable to three-dimensional work as to flat work, but for reasons of space and clarity have been shown primarily in terms of their effects on two-dimensional work. The photographs illustrating three-dimensional lighting technique, however, are only pertinent to three-dimensional work.

SHOOTING WORK UNDER GLASS

If at all possible, remove glassed artwork from its frame to photograph it. If you must shoot it under glass, baffle the camera to keep it from being reflected in the glass, as described in Chapter Three. Dark artwork presents the biggest problem because it turns the glass into a mirror, as in the photograph at bottom left. In the photograph at top left, a sheet of black poster board with a hole cut in it for the lens has blocked out the reflection of photographer and copy stand.

MATCHING THE FILM TO THE LIGHT

These pictures show the effect of shooting film of the wrong color balance for the light being used. The yellow-orange rendition, top, illustrates the common mistake of using daylight-balanced film in tungsten light. The blue cast in the version at center shows the effect of shooting tungsten-balanced film in daylight. (Shooting daylight film by blue skylight, such as in open shade or by a window, will also produce a blue result, although usually less extreme than this.) The photograph with correct color, bottom, was produced by shooting Type B film (Ektachrome) in the 3200 degrees Kelvin light it is balanced for.

MATCHING THE CORRECT BULB WITH TUNGSTEN-BALANCED FILM

As explained in Chapter Two, tungsten-balanced films and the photoflood bulbs made for them are actually designed for two different color temperatures of light, rated 3200 degrees and 3400 degrees on the Kelvin scale. These examples show the effect of mismatching the two. The top photograph illustrates the effect of shooting Type A film (Kodachrome 40), which is balanced for 3400-degree light, in 3200-degree light. The center photograph shows the effect of shooting Type B film (Ektachrome) which is balanced for 3200-degree light, in 3400-degree light. The photograph with correct color, at bottom, shows the effect of shooting Type B film in 3200-degree light, or Type A film in 3400-degree light.

EFFECT OF FLUORESCENT LIGHT

These three pictures show the effect of fluorescent light on color rendition. The top left photograph was made on tungsten-balanced film (Ektachrome), which "sees" fluorescent light as extremely blue. Daylight film, top right, usually yields better color, but still records a strong greenish cast. When this cast is eliminated by shooting through a CC 30 Magenta filter, bottom right, the color recorded by daylight film in cool white fluorescent light is fairly accurate, but the diffuse quality of the light tends to reduce image contrast.

Celie Fago

EFFECT OF "PUSHING" FILM

As explained in Chapter Seven, "pushing" film involves setting a higher ISO than the one the manufacturer recommends, then having the color lab compensate for the resulting underexposure of the film by developing it longer. This technique lets you set smaller lens apertures or faster shutter speeds than the light would otherwise require. But it will also increase the contrast of the finished slide—useful if the original artwork has close values, whether light or dark. The top slide was exposed at the recommended ISO for the film and processed normally. The bottom slide was exposed at double the recommended ISO and pushed one stop. This technique has its trade-offs; here it has improved the sense of texture, but caused the colors to change slightly. Keep in mind that push-processing is best done with E-6 process films such as the Ektachromes.

Ektachrome 64.

Ralph Helmick

Kodachrome 64.

Fujichrome 50.

Ektachrome 64
with 81B filter.

Kodachrome 64
with 81B filter.

COLOR AND OUTDOOR INSTALLATION VIEWS

The color rendition of different brands and types of daylight-balanced slide films varies quite a bit, as shown in the pictures on the left, all taken in the same light. The photographs on the right, above, show the effect of using an 81B warming filter with the Ektachrome, top, and Kodachrome, bottom. This filter is useful for shooting color film outdoors on an overcast day, because it eliminates the bluish cast the film usually records in that light.

No filter.

Pina

81 filter.

EFFECT OF WARMING FILTERS IN TUNGSTEN LIGHT

This series shows the effect of 81 series filters on color rendition. The top left photograph was taken on Kodachrome 40 in 3400-degree light, without filtration. The bottom left photograph was taken with the same combination of light and film, using an 81 filter on the lens; top right, with an 81A filter; and bottom right, with an 81B filter. Notice how the blues are weakened and warm colors enriched with stronger filtration. For this painting, which has both sides of the spectrum, an 81 or 81A seems the best choice.

81B filter.

81A filter.

IMPORTANCE OF DETAILS

The people who review slides of your artwork often don't project them. For this reason, if your work is difficult to "read" when it's reduced to the tiny area of the 35mm slide, you should supply them with details of it as well. In two-dimensional work, this may give a sense of detail or texture that an overall view can't provide; in three-dimensional work, as here, it can give a sense of structure and articulation in a piece that may appear to lack them in the overall view.

Hope Ricciardi

Jon Neprud

EXPOSURE FOR DARK ARTWORK

Whether two- or three-dimensional, an artwork composed primarily of dark values sometimes requires exposure above and beyond that indicated by the gray card. The top photograph was given the exposure indicated by the gray card; the center photograph, one-half stop of extra exposure. The bottom photograph, which was given a full stop of additional exposure, shows the surfaces and colors of the artwork most clearly. When in doubt, bracket your exposure for a dark work in half-stop increments up to one and a half stops *over* the indicated exposure.

One stop
underexposed.

Diefo

One-half stop
underexposed.

Slide exposed for
gray-card reading.

One-half stop
overexposed.

One stop
overexposed.

IMPORTANCE OF BRACKETING EXPOSURES

These photographs show the differences in color and density created by "bracketing" an exposure—here, in half-stop increments on both the "over" and "under" side of the gray-card reading. Sometimes bracketing will produce at least two acceptable exposures, as here, where both the gray-card exposure and the one-half stop "under" exposure are acceptable. Notice the loss of color in the overexposed slides. *Always* bracket your exposures.

Susan Morrison

EFFECT OF SLIDE DUPLICATION

With careful technique, a good color lab can make a duplicate slide that is very close to the original—but a dupe will usually display subtle color changes and an increase in contrast. If the original slide seems flat, the added snap can actually make the dupe look better than the original; but more often than not, any such changes are undesirable. Here, the top left photograph is from the original slide; the top right photograph, from a duplicate of the original; and the bottom right photograph, from a duplicate of the duplicate slide. Reproduction tends to minimize the differences, but notice the increase in the intensity of the colors in each generation; also notice how each successive dupe crops out more of the original. Avoid duping slides except in a pinch. Instead, make as many originals as you think you will need.

Susan Mampre

COLOR-CORRECTED DUPLICATE SLIDES

For an additional charge, a professional lab will make a duplicate slide to adjust the color of the original. This art was photographed with daylight-balanced slide film in a mixture of daylight and tungsten light. The tungsten component of the light caused a strong, yellow cast in the original slide, top. The color lab added blue to the light used to make the corrected duplicate, bottom, restoring the neutral white of the wall. A good lab can also make a duplicate in which part of the original is enlarged to fill the frame, a correction that may be useful if you were too far away from your artwork when you photographed it.

APPENDIX USEFUL ACCESSORIES

The bare essentials needed to take good photographs of your artwork are discussed early in the book. They include a 35mm camera, a tripod, clip-on light fixtures, color-rated photoflood bulbs, metal reflectors if you're not using reflector-style bulbs and a photographic gray card. Other supplies that you probably won't want to be without are a cable release, a warming filter (81A), and, if your work is three-dimensional, background and light-diffusion materials.

However, there are other items—some as basic and inexpensive as masking tape—that can simplify the task of photographing your work. They're listed here, along with their uses and, where appropriate, their approximate price. Also included is a list of mail-order suppliers of these materials.

Adjustable Arm. A jointed and/or sliding rod designed to hold light-control materials in place. It clips or clamps to the shaft of a lightstand (or other support), and its business end features a clip to which you can attach black cards (to keep unwanted light off the camera or subject), reflectors (to bounce light), or diffusion film (to soften the light). Often fitted and sold with a filter holder, it costs from twenty-five to sixty dollars.

Archival Slide Files. Slide storage pages made of materials other than PVC (polyvinyl chloride), typically polyethylene and polypropylene, that prevent the long-term damage PVC can cause. (PVC releases harmful gasses and can stick to the surface of your slides. Identify it by its plasticky smell.)

Background Stand. A system of two vertical poles supporting a horizontal crossbar onto which you slip a roll of seamless background paper. Some such systems use telescoping lightstands for support; others feature poles that are held in place between floor and ceiling by spring tension. (Don't use the latter with dropped ceilings!) Paper can be rolled out as needed. A simple unit can cost as little as sixty-five dollars.

Baffling/Reflecting Materials. Black matboard, poster board or construction paper, or black cloth, can be used to eliminate the reflection of the camera and you in glassed or shiny work; also, to block light that otherwise would fall across the camera lens' front element and cause image-degrading glare. White matboard, poster board or heavy paper, or white cloth, can be used to create needed reflections in shiny work. Any neutral material (black, white or gray) can also be used to cover surfaces adjacent to the work that otherwise might contribute a color cast to it.

Barn Doors. Hinged, heat-resistant black metal flaps designed to clip to the rim of a metal reflector. The flaps can be adjusted to control the beam's coverage and keep unwanted light from striking the subject or camera. Barn doors may also incorporate a filter holder, but it's unwise to place diffusion or filtering materials so close to a tungsten bulb. (Filter holders for use on lenses sometimes have small barn doors, which keep stray light off the lens and filter.) Barn doors can cost as little as twenty dollars a set.

Black Foil. A heavy, flexible matte-black aluminum sheeting, usually sold in small rolls by mail-order outfits. Because it is heat-resistant, it's particularly useful in controlling lighting. It can, for example, be used to fashion a "snoot" around a metal reflector if you want a narrower beam of light. And you can use it to improvise barn doors (see above). It costs about twenty-five dollars for a roll measuring 12 inches by 50 feet or for a roll measuring 24 inches by 25 feet.

Black Photographic Tape. An opaque tape available at well-stocked photography stores. More expensive than regular masking tape, it's especially good for securing baffling cards to your camera or lens when shooting work under glass, because it doesn't reflect. Also good for stopping light leaks.

Bubble Level or Angle Finder. Useful in shooting flat artwork that is leaning against a wall; matching the camera's tilt to the artwork's simplifies squaring up. An angle finder is more difficult to find, more expensive—and more precise.

Clamps and Clothespins. Although gaffer tape will suffice, clamps are the most secure way to hold lighting paraphernalia in position. They come in a huge variety of designs, and prices can range from a few dollars to thirty. Clothespins can be clipped to wooden dowels to hold lightweight baffling and reflecting materials.

Copy Stand. Described in detail in the box on page 51, the copy stand is a useful and time-saving alternative to the tripod for shooting small-to-medium size flat artwork. It's also good for smaller three-dimensional artwork (such as jewelry or ceramics) that you plan to "shoot down" on. Make sure the copy stand's column is tall enough to allow you to place the camera far enough away from the work to fit it all in. Cost: seventy dollars and up.

Extension Cords. Make sure they're in good condition and that they are designed to withstand a 500- or 1000-watt load.

Filter Holder.

1) A lens attachment that allows you to mount non-threaded gelatin, plastic resin, or polyester square filters on your camera. Some models clip onto the lens barrel, and will work with different-sized lenses; others screw into the filter thread, so they must fit the lens exactly. Holders often incorporate barn doors (see above); they cost as little as five or ten dollars, as much as thirty or forty dollars.

2) A square bracket designed to hold large sheets of filtering and diffusing materials in front of a light. Often sold as a unit (for thirty-five to sixty dollars) with an adjustable arm (see above), which permits attachment to the shaft of a light stand.

Gaffer Tape or Duct Tape. A heavy-duty, very sticky tape useful for securing lighting hardware when you don't want to invest in fancy clamps.

Lens Cleaning Fluid/Tissue. Good to have on hand in case you smudge your lens or filter. (See "How to Clean Your Lens," page 18.) Well-padded Q-Tips are helpful for polishing out streaks. Never use cloth, Kleenex, or eyeglass cleaners!

Light Boom. A telescoping rod designed to mount horizontally on top of a lightstand. A boom lets you place a light directly above your artwork when the seamless background prevents you from moving the lightstand any closer. A counterweight (usually adjustable) keeps the stand from tipping over. Expect to pay from thirty to seventy-five dollars.

Masking Tape. Good for securing lightweight work on a wall, marking the location of tripod legs (or light stands) on the floor for future reference, or making register marks for speedier photography of more than one work.

Photographic Light Stands. Although you can clip your light fixtures to ladders, chair backs and the like, these collapsible, telescoping metal stands make adjusting the height and position of your lamps much easier. The sleeved coupling on some clip-on fixtures is designed to fit over the stand's uppermost rod. (You simply remove the clip portion.) Expect to pay twenty-five dollars apiece for lightweight stands.

Photographic Umbrella. Useful for softening light when photographing three-dimensional work, and described in more detail in that section. Bulbs are aimed into the umbrella, and the light from them is bounced back at the artwork in a much more diffuse form. Silver-lined umbrellas are more efficient reflectors. (Flat panels with high efficiency for bounce lighting are also available.) Umbrellas are easier to use with mounting hardware for a light stand. Cost: twenty to seventy-five dollars.

Slide Masking Tape. A thin, heat-resistant mylar adhesive tape used to crop out distracting backgrounds in slides. Available in silver and black.

Supplementary Close-up Lenses. Simple positive lenses in filter-type mounts, which screw into the front thread of your lens to increase its close-focusing range. Usually sold in sets of three. The lowest power lens alone will often get you close enough to do the job. You'll have to pay from fifteen to thirty dollars for the set.

Tape Measure. Can be handy for positioning camera and lights symmetrically, which makes lighting two-dimensional work much faster and easier.

Velveteen/Velour. Vertical-pile materials sold in a wide roll for use as seamless backgrounds. The surface is dead matte, eliminating any distracting sheen. Black velveteen or velour is especially useful when you want the darkest background possible. Price is usually around two dollars a running foot for a 52-inch roll width. (Fabric shops will charge more!)

MAIL-ORDER SUPPLIERS

It's sometimes easier to order supplies by mail rather than hunting around for them locally. With the exceptions noted, each of the following mail-order companies carries a full inventory of film, filters, cable releases, clip-on light fixtures and photoflood bulbs, plus most items described in this appendix.

These suppliers also sell cameras and lenses, and at prices that may be considerably lower than what you'd pay at mom-and-pop stores. But you have to know exactly what you want before calling them. Most of them aren't in the business of answering detailed questions about their products—and they can't show you how something works over the phone.

The extra attention you receive at your local camera store may justify paying the higher prices it charges. The salesman can walk you through the operational details of a camera or other piece of equipment. And if something goes awry, you can return for an explanation or an off-the-shelf exchange. Mail-order companies will replace defec-

tive merchandise, but be sure to inquire about their policies before you buy.

Call the 800 numbers listed and request a catalog. The companies may charge you three to five dollars for one, refundable against your first purchase. It's worth it because the catalog describes products in detail, often shows pictures, and lets you compare pricing.

Abbey Camera
1417-25 Melon Street
Philadelphia, PA 19130
(800) 252-2239
(215) 236-1200 inside Pennsylvania

Adorama
42 West 18th Street
New York, NY 10011
(800) 223-2500

B&H Photo
119 West 17th Street
New York, NY 10011
(800) 221-5662

Calumet Photographic
890 Supreme Drive
Bensenville, IL 60106
(800) 225-8638

Light Impressions
439 Monroe Avenue
Rochester, NY 14607
(800) 828-6216
(*Slide presentation, viewing and storage materials*)

Peach State Photo
1706 Chantilly Drive
Atlanta, GA 30324
(800) 766-9653

Porter's Camera Store
Box 628
Cedar Falls, IA 50613
(800) 553-2001

Visual Departures
1641 Third Ave. Suite 202
New York, NY 10128
(800) 628-2003
(*Metallized cardboard reflector kits, collapsible fabric reflectors, specialty gear*)

INDEX